DED
ANDY

FROM TOPPS

**STAR WARS
RETURN OF THE JEDI**

THE ORIGINAL TOPPS TRADING CARD SERIES
VOLUME THREE

INTRODUCTION AND
COMMENTARY BY GARY GERANI

Abrams ComicArts
New York

STAR.WARS

RETURN OF THE JEDI

™

TO ARTHUR T. SHORIN OF TOPPS,
OUR PEERLESS LEADER AND THE COOLEST CIGAR-CHOMPER EVER

ACKNOWLEDGMENTS: Special thanks to Len Brown and Charles Lippincott, who lived the adventure with me. Thanks also to Ira Friedman at Topps; J. W. Rinzler and Carol Roeder at Lucasfilm; and Harris Toser and Roxanne Toser at *Non-Sport Update*. At Abrams, thanks to Orlando Dos Reis and Charles Kochman (editorial), Pamela Notarantonio (design), Michael Clark (managing editorial), and Alison Gervais (production). And thanks to Jonathan Beckerman (photography).

Images courtesy of Robert V. Conte, with assistance from Dave Streicher, from the *Rebuilding Robert* Collection

Photography by Jonathan Beckerman: cover, endpapers, and pages 6, 9, 10, 12, 15, 18–21, 322–325, and 528

Front endpaper: detail, Topps sell sheet for *Star Wars: Return of the Jedi* candy, 1983

Editor: Orlando Dos Reis
Project Manager: Charles Kochman
Designer: Pamela Notarantonio
Managing Editor: Michael Clark
Production Manager: Alison Gervais

Library of Congress Cataloging-in-Publication Data

Star Wars. Return of the Jedi : the original Topps trading card series, volume three /
 introduction and commentary by Gary Gerani.
 ISBN 978-1-4197-2092-5 (hardcover)
1. Star Wars films—Collectibles. 2. Trading cards.
I. Gerani, Gary. II. Topps Chewing Gum, Inc. III. Lucasfilm, Ltd.
 PN1995.9.S695 S824 2016
 DDC 741.6—dc23
2015043874

Cover design by Pamela Notarantonio
Case photography by Geoff Spear

Published in 2016 by Abrams ComicArts®, an imprint of ABRAMS. All rights reserved. No portion of this book may be reproduced, stored in a retrieval system, or transmitted in any form or by any means, mechanical, electronic, photocopying, recording, or otherwise, without written permission from the publisher.

Abrams ComicArts is a registered trademark of Harry N. Abrams, Inc., registered in the U.S. Patent and Trademark Office.

Printed and bound in China
10 9 8 7 6 5 4 3 2 1

Abrams ComicArts books are available at special discounts when purchased in quantity for premiums and promotions as well as fund-raising or educational use. Special editions can also be created to specification. For details, contact specialsales@abramsbooks.com or the address below.

THE ART OF BOOKS SINCE 1949
115 West 18th Street
New York, NY 10011
www.abramsbooks.com

STAR WARS

RETURN OF THE
JEDI

INTRODUCTION

THE ONCE AND FUTURE JEDI: AN EPIC CONCLUDES

BY GARY GERANI

With the unprecedented success of *Stars Wars* in 1977, creator George Lucas triggered the public's addiction to big-screen grand fantasy adventure. In 1980, *The Empire Strikes Back* continued this giddy trend, keeping the serial-like franchise white hot and inspiring even more cinematic imitations. In 1983, Lucas would conclude his landmark trilogy with a film that promised to be the most spectacular of all—*Return of the Jedi*. This much-awaited epic of epics would boast a final confrontation with the nefarious Empire, resolve the dangling fate of Han Solo (who had been frozen in carbonite), and bring a certain father-son relationship to its explosive conclusion.

As Topps and other *Star Wars* licensees began to limber up for the third and (at the time) final act, a comforting familiarity settled over us. Getting merchandise produced and out the door in 1977 amounted to a wild, makeshift miracle since the movie's astonishing popularity and transformative effect on pop culture had taken everyone by surprise. But by the time *Empire* rolled around, Lucas's once fledgling company, Lucasfilm, had evolved into an

up-and-running enterprise. Now, with *Jedi* looming as a monumental release in 1983, his bigger, more corporate-style California operation was running more smoothly and efficiently than ever.

As with the previous installments in the series, I was invited to mull over visual materials and read the top-secret screenplay quite a bit in advance. It was the old "lock Gary in a room and have him sign a release" routine, with Lucas reps once again taking me through the basics of this brand-new *Star Wars* extravaganza. "But wasn't it supposed to be called *Revenge of the Jedi*?" I remember asking, after seeing some official announcements using that title. Like many fans, I thought "revenge" was an edgier word, for a more exciting movie moniker, but at the same time I understood that the progressive ethics of Jedi Knights precluded ignoble acts of retribution. Besides, science fiction fans didn't have to look very far for a full-fledged dramatization of vengeance: Khan was delivering his own seething version of it in the latest *Star Trek* (1982) movie.

My first taste of *Return of the Jedi* at Lucasfilm was an impressive slide show and video presentation. Two years earlier, when I was first introduced to *The Empire Strikes Back*, it was a photogenic little gnome, Yoda,

who jumped off the screen and made the most striking impression on me. The tiny Jedi Master would go on to become a genuine superstar and provide toy manufacturers with another cool character to work with (not that the villain Boba Fett and his bounty hunter comrades were chopped bantha liver). For *Return of the Jedi*, that special something—the one unforgettable character everyone would be talking about—now stood before me in the form of a projected slide image. In almost every way except star appeal, he was the exact opposite of wise little Yoda.

It was legendary "vile gangster" Jabba the Hutt, of course, current caretaker of carbon-frozen Han Solo. Not only would this infamous entity be visualized on screen for the first time, he'd link directly to the heartbreaking subplot of Captain Solo's plight (left unresolved in the previous film) and the daring rescue efforts of Han's rebel friends.

Of course, I had already seen slides of the original actor who was cast as Jabba (Declan Mulholland) in a sequence cut from the first *Star Wars* film. (The brief scene where the Hutt chats with Han Solo on Tatooine would be revisited by Lucas in the twentieth-anniversary *Star Wars Trilogy: Special Edition* in 1997, with computer-generated imagery [CGI] replacing the human performer.) Lucasfilm personnel were nice enough to share these rare images with me back in 1977, although we weren't

permitted to print them as behind-the-scenes cards. Some secrets were intended to remain secret—at least for a while longer.

Now I was looking at Jabba the way Lucas had truly envisioned him: as a monstrous and slimy super slug with the persona of infamous movie heavy Sydney Greenstreet (*The Maltese Falcon*, *Casablanca*). This was pre-CGI, of course, so an enormous on-set puppet inhabited by a small team of operators was required. Beyond Jabba himself, his sinister throne room on Tatooine would be populated by equally bizarre, jaw-dropping entities calculated to match or surpass the agreeable weirdness of those Cantina denizens from the first film.

And this time, we were told, none of the motley monsters would be held back for use on our trading cards. Conveniently, many of Jabba's picturesque guests came equipped with partially developed backstories and colorful names. Fans knew who Droopy McCool and Sy Snootles were right out of the gate. I remember speculating that Snootles, with her inviting red lips and sexy chanteuse voice, was a fanciful takeoff on Blondie pop diva Debbie Harry.

And these far-out critters weren't the only alien life forms being readied for big-time exploitation. Certain residents of Endor's forested moon had a merchandiser's spotlight turned their way . . .

As many fans had learned from interviews, Lucas's original plan was to

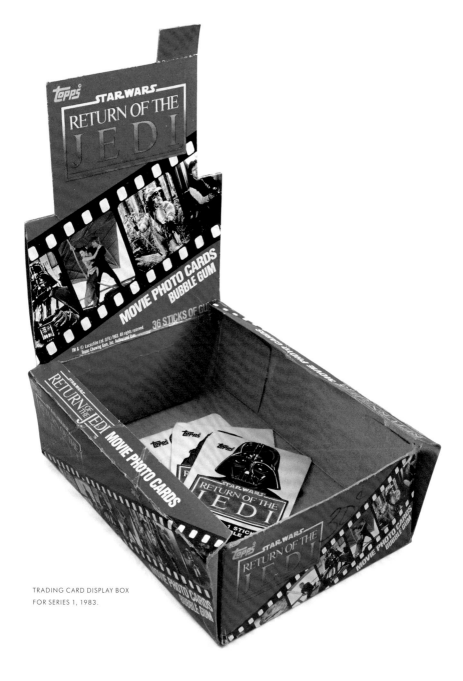

TRADING CARD DISPLAY BOX
FOR SERIES 1, 1983.

have the evil Empire defeated by fearsome Wookiees on Chewbacca's native world of Kashyyyk. This David and Goliath–style battle would depict a high-tech military juggernaut overwhelmed by primitive warriors who cleverly use their environment to gain tactical advantage, making the fight a veiled parallel to America's failure in Vietnam.

The problem was, copilot Chewbacca had already established Wookiees as a tech-savvy species. Lucas still intended to

dramatize his worthy theme, only now with a different, newfangled alien race that would invert the equation. Towering Wookiees became diminutive Ewoks, a breed of fuzzy, teddy bear–like spear jabbers who wind up befriending the rebels and aiding in their ground efforts to defeat Imperial foes. These new creatures would be prominently featured in the third act of the film, providing action that would dramatically crosscut with the Alliance Fleet's space

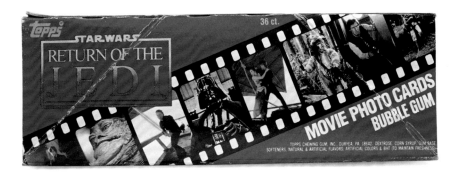

SIDE PANELS FROM TRADING CARD DISPLAY BOXES, 1983.

attack and the fateful Luke-Vader-Emperor confrontation.

When my introductory session was over, I was led from a Lucasfilm conference room into an empty office, where the screenplay for *Return of the Jedi* (codenamed *Blue Harvest*) sat invitingly on a table. Locked away with it for a couple of hours, I got to work and promptly read it, recording significant plot events and dialogue in my notepad. The first thing that hit me (on page one!) was the presence of a new, even more powerful Death Star battle station. Since this second terror globe was still under construction, I imagined small spaceships zipping in and around the partial structure, bringing girders and other components into the work areas where they'd be fitted into place. What an amazing first shot this will be, I remember thinking at the time. The production unit of Industrial Light & Magic (ILM) existed to serve Lucasfilm projects, but ILM also lent its expertise to other science fiction movies (such as *E.T. the Extra-Terrestrial* and *Star Trek II: The Wrath of Khan*). The artists and technicians of the production house were always pushing the envelope of creative visual effects. Expectations were understandably high, because their work was that good.

To be honest, I can't recall if any major aspects of *Jedi*'s plot were omitted in the draft I read. Leia being Luke's sister may have been a secret for a while, but this played as a variation of the biological connection revealed so shockingly in *Empire*. The element of surprise was present but logically subdued—we had already been told that there existed "another," and the camera moving in on a Force-entranced Leia at the end of *Empire* hinted at a greater revelation to come. Conveniently, making the princess Luke's long-lost twin sister cleared the way for Leia and Han's romance, once the smitten Corellian was rescued from carbonite.

With the script now resonating in my brain, I was led into the Lucasfilm still library and shown hundreds of slides. This on-set unit photography skillfully captured the essence of most scenes, although certain material (the rancor attack, for example) wasn't ready at this juncture. There was wonderful coverage of several key action sequences, especially the sail barge skirmish, and the material in Jabba's palace boasted all manner of unearthly entities, starting with the outlandish Hutt himself. Some images of Princess Leia in a surprisingly sexy metal bikini caught my attention, as did one particular shot of Darth Vader using the Force to strangle a guard—a moment cut from the finished film but present in the draft I had just read. About a dozen line illustrations were also cleared for trading card use, and, as always, one or two visual-effects frames of space battles were airbrushed into printable shape.

Hunkering down, I selected several hundred images, thinking ahead to Series 2.

UNOPENED TRADING CARD PACK WRAPPERS, SERIES 1, 1983.

Duplicate slides were promptly processed in a nearby lab, destined to be in my hot little hands about two weeks later.

Feeling like a million bucks after my all-in-one-day *Return of the Jedi* indoctrination, I phoned Topps and happily filled everyone in. Len Brown, creative director of New Product Development (NPD), was genuinely excited—he had liked *Empire* even more than the first film—and Topps chairman Arthur Shorin was properly pleased, envisioning more spectacular profits from this funky, *Flash Gordon*–like franchise.

But the person at Topps headquarters who was the most excited by my report was Abe Morgenstern, product manager of NPD, a resourceful, ever-enthusiastic gent and a former salesman of Bartons Confectioners, who facilitated the smooth operation of whatever projects our department chose to develop. Securing the right manufacturers for Topps candy containers was a high priority for Abe, and he was very proud of the plastic *Star Wars* heads we had created for *The Empire Strikes Back*. The first thing he wanted to know from me at this point was what new characters might be included in our upcoming roster. Jabba the Hutt was a heavily promoted given, although sizing him down to the scale of a mass-market candy item took a little imagination. One movie earlier, we had to shorten Yoda's ears to meet similar production-mold limitations.

Amusingly, what enchanted Abe the most about *Return of the Jedi* was the baby Ewok. This little creature winds up with just a few seconds of screen time, usually eliciting a response of "awww" from audiences. But Abe recognized its charm potential based just on my brief description. Yoda had been a big seller for us, and so had Steven Spielberg's E.T., one of the most unlikely candy containers in Topps history (a misshapen cranium on a stalk); we even concocted an E.T. plastic figure filled with powdered candy, equipped with a head that swiveled. All made money for the company, which was now committed to producing odd little movie characters in this format (the ill-fated *Howard the Duck* would briefly put an end to the trend in 1986). At the moment, however, cute or what passed for it seemed to be king. And so, with my blessing and Len Brown's approval, a rather well-sculpted baby Ewok was set to join Jabba, Sy Snootles, Admiral Ackbar, Wicket, and *Empire* holdover Darth Vader in our candy container lineup.

Back home in Brooklyn, it wasn't very long before those wonderful slides arrived and our work began in earnest. Once again we utilized the traditional storyboard approach to a picture card series, arranging images in sequential order and telling the tale with limited text as efficiently as possible. Repeating our *Empire Strikes Back* strategy, we planned on high-numbered series (132 subjects for Series 1 and a selection of thirty-three colorful stickers to go with them). I remember toying with several

different designs for borders and captions, finally settling on a rather futuristic and oddly dimensional treatment. We decided to use the same visual approach for both the character and the story cards, with no "making of" material this time around—just a clean first take on *Return of the Jedi*, focusing on the story.

It's hard to explain the feelings of nostalgia I experienced as the creative elements of this project began to take shape. We'd certainly come a long way since I personally had drawn the blast graphic as a logo-and-number holding device for the card design of the first series back in 1977. In-house artist Augie Napoli, who rendered the well-received line art of the card packs for our original *Star Wars* release, as well as the illustration on the display box, wasn't with the company anymore. Very little original art for movie-related projects was being generated by Topps during the 1980s, save those candy container designs, box graphics, and spot art for a few sticker albums. Lucasfilm provided preapproved poster paintings and a series of line art renderings of all the main characters, which we used on both the card backs and the wrappers. This made life easier for all concerned, saving a good deal of time on approvals as well as expense. But, just as those quaint Lucasfilm bungalows of '77 evolved into rather indifferent corporate buildings, the fly-by-the-seat-of-your-pants aspect of crafting these *Star Wars* projects

had gradually, inevitably transformed into a superefficient process of submission and approval. No one at either company was dissatisfied, of course; we all appreciated and understood that this was, after all, the final installment of Lucas's unique, culture-altering brainchild . . . the very last time these endearing characters from a galaxy far, far away would take a bow. It might also be the last time *Star Wars* representatives and licensees would be working together. Like *Jedi* itself, there was a feeling in the air of sentimental closure.

That said, Topps had the first of two major trading card sets to get into the marketplace, along with a sticker album, and that meant rolling up my editorial sleeves and getting to work. For our Series 1 display box, we decided to go blue, with a diagonal film-strip graphic containing exciting color photos . . . the amazing portrait of Luke and Leia on the sail barge being a personal favorite. Card no. 1 boasted *Jedi*'s evocative teaser poster painting, rendered by Drew Struzan. We were still using the headline "A Topps Picture Card Series" and related data on all title cards in the mid-1980s. This design—and, ultimately, the title cards themselves—would disappear completely from our trading cards in less than a decade.

As for the stickers? We offered thirty-three of them in Series 1—or sixty-six if you counted the duplicate images with different border colors (available in yellow, purple, blue, red, orange and green). Designs were

UNOPENED TRADING CARD PACK WRAPPERS, SERIES 2, 1983.

relatively clean—no fancy or problematic die-cuts, for a change. Just simple shapes for a variety of colorful photographs.

At the same time that we were preparing this first series, I was also designing, writing, and art directing the *Return of the Jedi* sticker album for Topps. It had been just a few years since the company had assigned me to reconceptualize European sticker albums for the American market. These were mostly horizontal booklets that came to life when you placed colorful stickers into designated areas. The bland, cheaply produced Euro "albums" were often given away, as they were basically empty vessels. Customers spent money on the stickers, which were sold in packs and traded until an album was filled with a complete set.

After being re-imagined for a vertical presentation—so it had a chance of being placed in magazine racks—the album's content was structured logically and entertainingly. Essentially a sticker album was a card set with pages and covers, providing collectors with an overview of the film much as a storybook would, including some colorful behind-the-scenes material. Artists were hired for simple spot illustrations, and I made sure the sticker spaces on each page were pleasingly arranged. *Annie* and *E.T.* were the first of these that we prepared in tandem with a card set's development, followed by *Return of the Jedi* and, a year later, *Gremlins*. By the end of the decade,

Topps would turn over all sticker album projects to its English counterparts, taking the albums' creation out of my hands altogether (though I did return to the form in the late 1990s with *The Lord of the Rings*).

In any event, the same unit photography that we utilized for the *Jedi* trading cards was called into play for our corresponding photo album. One of the benefits of this format was that a photo could be divided up into several stickers (say, four, stacked horizontally or vertically) to increase drama on the album page, with an emphasis placed on certain images over others—something that's harder to do in a trading card series, where all pictures are more or less equal in size. Needless to say, some of *Return of the Jedi*'s most important moments—such as the barge battle and the *Millennium Falcon*'s climactic Death Star penetration—were presented in multiple sticker segments.

With Series 1, the candy containers, and a sticker album under control, attention was turned to a preordained second series of picture cards. We had smartly designed Series 1 so that simple color changes could easily be implemented for the follow-up: The blue box became a yellow one, and the red-bordered cards became blue.

Significantly, the number of subjects in Series 2 dropped from 132 to eighty-eight—and the number of stickers decreased too, from thirty-three to twenty-two. While I'm sure we were

running into a picture redundancy problem, I'm just as sure that this had nothing to do with management's decision to make Series 2 shorter. A smaller set cost less to manufacture, and there was a general feeling that interest in *Star Wars* would reach its peak with the release of *Return of the Jedi*, then taper off as the realization that it was "all over" settled in. For the most part, this was sound reasoning and a sharp business judgment. I'm not sure if other *Star Wars* licensees predicted and prepared for a post-*Jedi* dip, but it said a lot about the curious sense of relief we all felt. *Star Wars* had dominated and in some cases defined our lives for more than seven years. It was an amazing and fortifying ride, but we were a little tired . . . just like filmmaker George Lucas. We all needed a relaxing vacation from *Star Wars*, especially after the breathless, impossible-to-ignore, and inevitable conclusion known as *Return of the Jedi*.

This hiatus, however, wouldn't last forever. Before long, *Star Wars* would rise from the shadows of nostalgia and reemerge in the dazzling form of a new generation of Topps trading cards . . . ones designed for the more sophisticated collector's market that had emerged in the interim. A decade later, art-driven sets known as *Star Wars Galaxy* and photo cards dubbed Widevision would take the classic Lucas trilogy to a whole new level of trading card creativity.

But right then, I felt a little bit like Luke Skywalker at the conclusion of *Return of the Jedi*: I wanted to lean back and nod approvingly at the property that had given us the greatest ride at the movies we'd ever experienced. Unleashing the fanboy or -girl in everyone, *Star Wars* had changed everything . . . and it's still going strong— perhaps even stronger than ever, with a twenty-first-century rebirth that seems all but guaranteed to propel it into infinity.

It'll certainly outlast your humble writer and trading card editor, who feels privileged to have worked on even a piece of this pop cultural uprising. For all of you out there who have enjoyed our Topps *Star Wars* trading cards over the decades, I can only say, with heartfelt gratitude . . . thank you. And never stop collecting!

GARY GERANI, author of *Star Wars: The Original Topps Trading Card Series, Volume One*; *Star Wars: The Empire Strikes Back: The Original Topps Trading Card Series, Volume Two*; and *Star Wars Galaxy,* is a screenwriter, author, noted film and TV historian, and children's product developer. He is best known as the co-writer of the film *Pumpkinhead*; the author of the book *Fantastic Television*; and the creator, editor, and writer of literally hundreds of Topps trading card sets since 1972. He lives in California.

topps

STAR WARS
RETURN OF THE
JEDI

™

10 CARDS • 1 STICKER
1 STICK BUBBLE GUM

STAR WARS

RETURN OF THE JEDI

™

**10 CARDS • 1 STICKER
1 STICK BUBBLE GUM**

STAR·WARS

RETURN OF THE
J·E·D·I

™

**10 CARDS • 1 STICKER
1 STICK BUBBLE GUM**

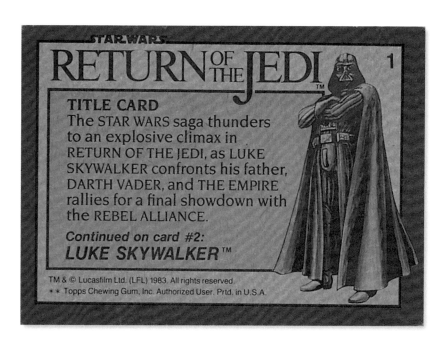

STAR WARS
RETURN OF THE JEDI
1

TITLE CARD
The STAR WARS saga thunders to an explosive climax in RETURN OF THE JEDI, as LUKE SKYWALKER confronts his father, DARTH VADER, and THE EMPIRE rallies for a final showdown with the REBEL ALLIANCE.

Continued on card #2:
LUKE SKYWALKER ™

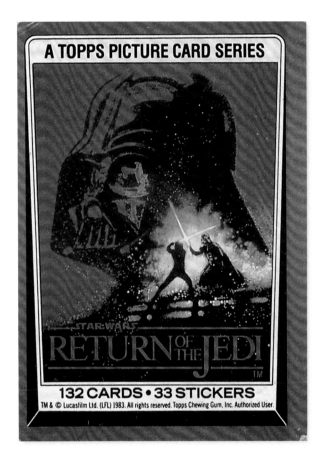

The concept of a title card was still important to Topps in the mid-1980s. We made use of this evocative poster art by Drew Struzan that focuses on the Luke-Vader conflict to start off our series. (A collage of popular characters would be featured in the official one-sheet poster rendering by Kazuhiko Sano.) This painting was used on the famous advance poster from Lucasfilm with the soon-to-be-changed title, *Revenge of the Jedi*.

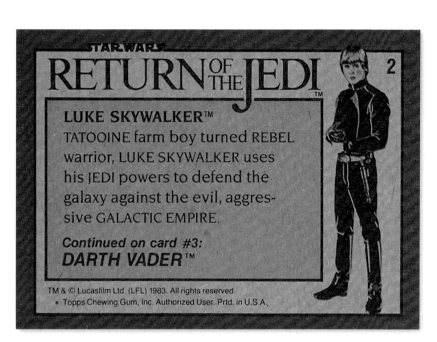

STAR WARS

RETURN OF THE JEDI

2

LUKE SKYWALKER™

TATOOINE farm boy turned REBEL warrior, LUKE SKYWALKER uses his JEDI powers to defend the galaxy against the evil, aggressive GALACTIC EMPIRE.

Continued on card #3:
DARTH VADER™

LUKE SKYWALKER™

Luke Skywalker, way smoother and more self-confident than ever as a full-fledged Jedi, is the first subject covered up-front in seven character-themed cards. Interestingly, we decided against a different design for these specific profiles, which gave the set a slick uniformity.

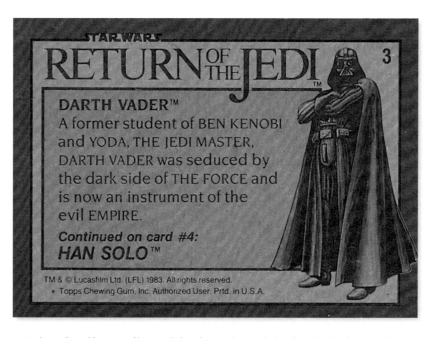

STAR WARS

RETURN ^{OF}_{THE} JEDI ™

3

DARTH VADER™
A former student of BEN KENOBI
and YODA, THE JEDI MASTER,
DARTH VADER was seduced by
the dark side of THE FORCE and
is now an instrument of the
evil EMPIRE.

Continued on card #4:
HAN SOLO™

Limited text allowed for a Lucasfilm-provided rendering to be included on the right side of each card back.

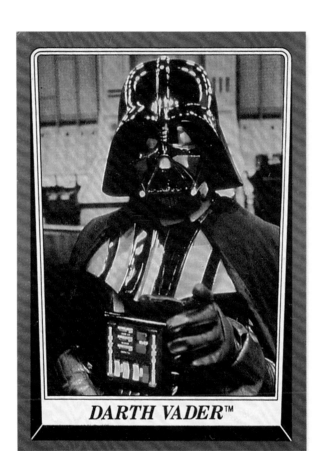

DARTH VADER™

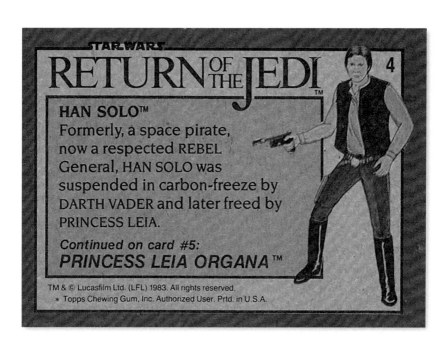

STAR WARS

RETURN OF THE JEDI

4

HAN SOLO™
Formerly, a space pirate, now a respected REBEL General, HAN SOLO was suspended in carbon-freeze by DARTH VADER and later freed by PRINCESS LEIA.

Continued on card #5:
PRINCESS LEIA ORGANA™

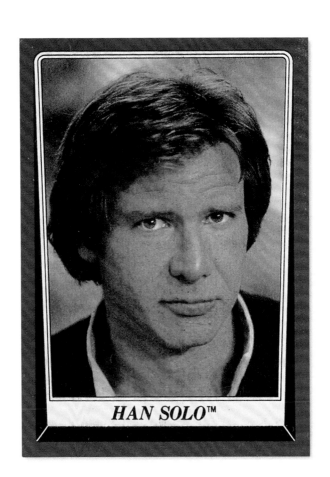

HAN SOLO™

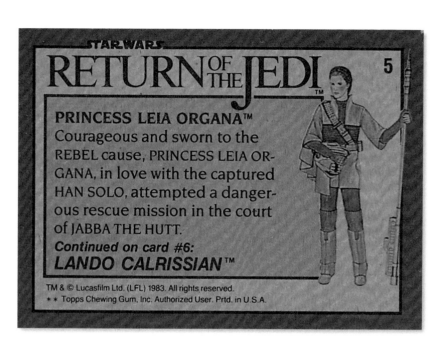

STAR WARS

RETURN OF THE JEDI™

5

PRINCESS LEIA ORGANA™
Courageous and sworn to the REBEL cause, PRINCESS LEIA ORGANA, in love with the captured HAN SOLO, attempted a dangerous rescue mission in the court of JABBA THE HUTT.

Continued on card #6:
LANDO CALRISSIAN™

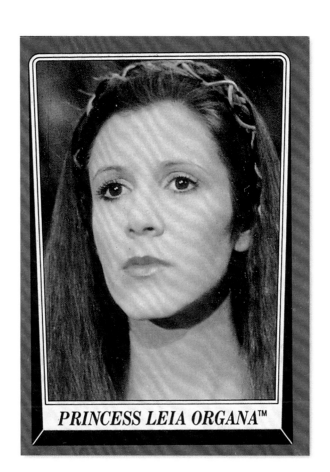

PRINCESS LEIA ORGANA™

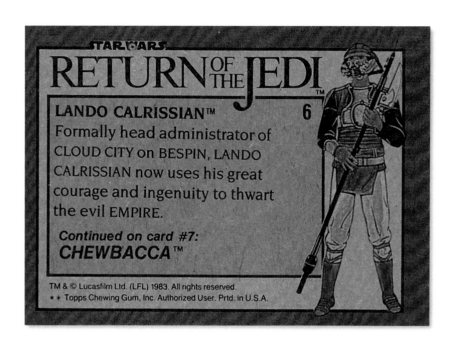

STAR WARS

RETURN OF THE JEDI ™

LANDO CALRISSIAN™ 6

Formally head administrator of
CLOUD CITY on BESPIN, LANDO
CALRISSIAN now uses his great
courage and ingenuity to thwart
the evil EMPIRE.

Continued on card #7:
CHEWBACCA™

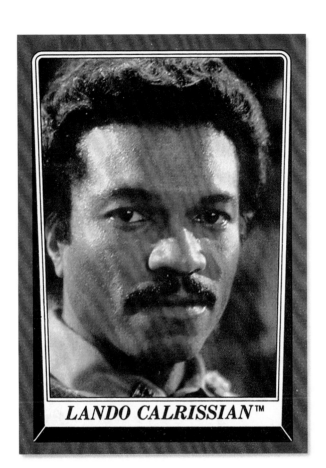

LANDO CALRISSIAN™

STAR.WARS

RETURN OF THE JEDI

7

CHEWBACCA™

HAN SOLO's trusted friend and
sidekick, CHEWBACCA the
WOOKIEE works with his REBEL
allies to free the galaxy
from the grasp of the evil
EMPIRE.
Continued on card #8:
C-3PO™ AND R2-D2™

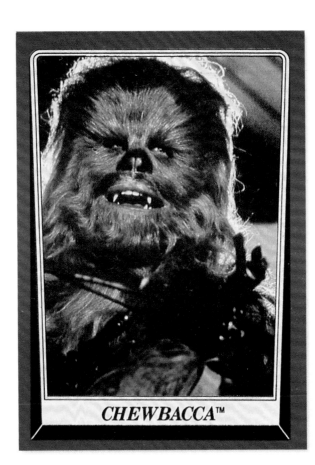

CHEWBACCA™

STAR WARS

RETURN OF THE JEDI ™

8

C-3PO™ AND R2-D2™
The lovable DROIDS, SEE-
THREEPIO and ARTOO-DETOO,
share the incredible adventures
and perils of their REBEL friends
as the EMPIRE prepares for a
final assault against the forces
of freedom.

Continued on card #9:
THE NEW DEATH STAR™

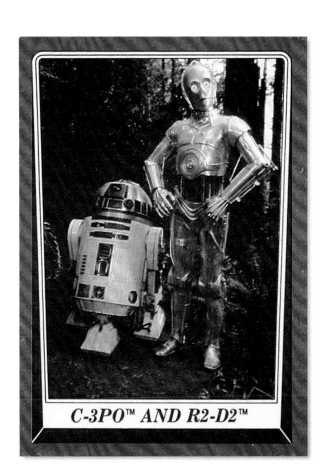

C-3PO™ AND R2-D2™

STAR WARS
RETURN OF THE JEDI

9

THE NEW DEATH STAR™

Above the Moon of ENDOR, a STAR DESTROYER discharges an IMPERIAL SHUTTLE toward the new, unfinished DEATH STAR while four TIE FIGHTERS patrol the sky.

Continued on card #10:
THE INSPECTION

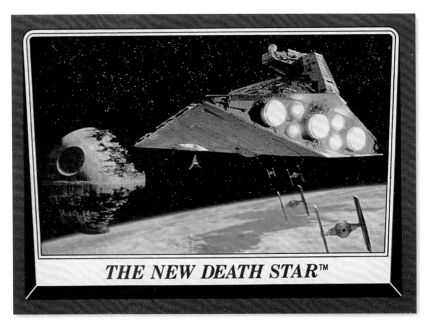

THE NEW DEATH STAR™

The story line begins. Here's one of a handful of visual-effects space shots prepared by Lucas's licensing team; it sets up the beginning of the film dramatically and succinctly.

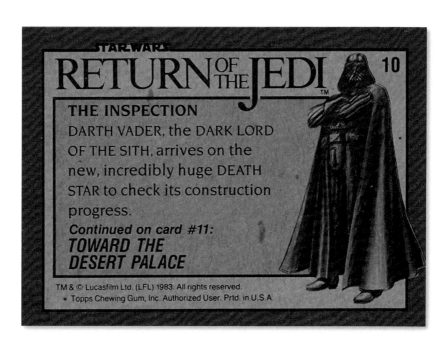

STAR WARS
RETURN OF THE JEDI
10

THE INSPECTION

DARTH VADER, the DARK LORD OF THE SITH, arrives on the new, incredibly huge DEATH STAR to check its construction progress.

Continued on card #11:
TOWARD THE
DESERT PALACE

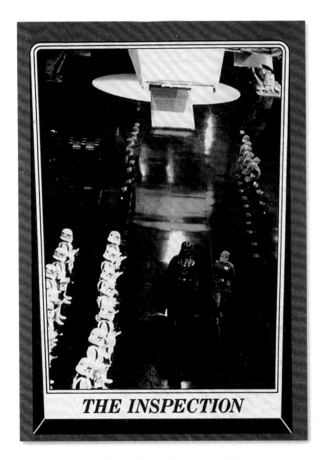

THE INSPECTION

Here's an imposing angle of Vader's arrival on the Death Star.

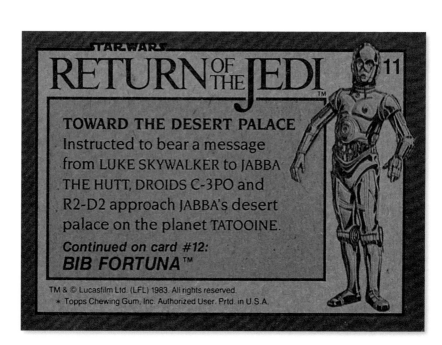

STAR WARS

RETURN OF THE JEDI ™ 11

TOWARD THE DESERT PALACE

Instructed to bear a message from LUKE SKYWALKER to JABBA THE HUTT, DROIDS C-3PO and R2-D2 approach JABBA's desert palace on the planet TATOOINE.

Continued on card #12:
BIB FORTUNA™

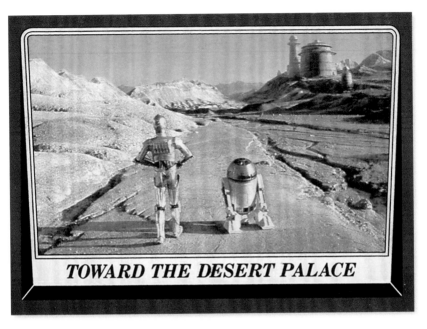

TOWARD THE DESERT PALACE

ILM created this matte painting vista of Jabba's Tatooine palace, one of a few doctored visual-effects shots released for licensee use.

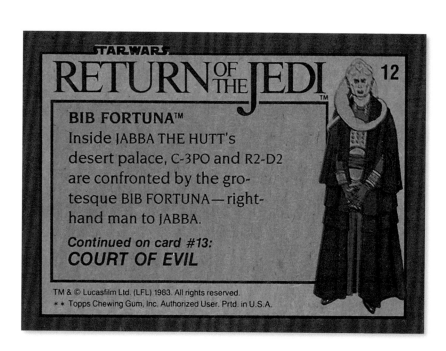

STAR WARS

RETURN OF THE JEDI

12

BIB FORTUNA™
Inside JABBA THE HUTT's desert palace, C-3PO and R2-D2 are confronted by the grotesque BIB FORTUNA—right-hand man to JABBA.

Continued on card #13:
COURT OF EVIL

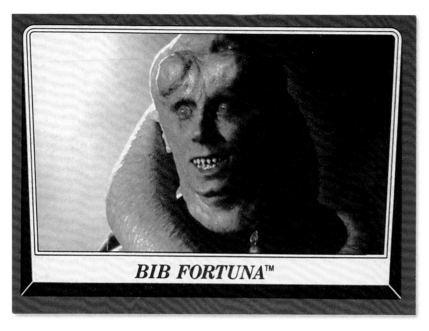

BIB FORTUNA™

A nice close-up of Jabba's sinister majordomo, Bib Fortuna, on the front of this card can be compared with the official line art rendering of the character on the back.

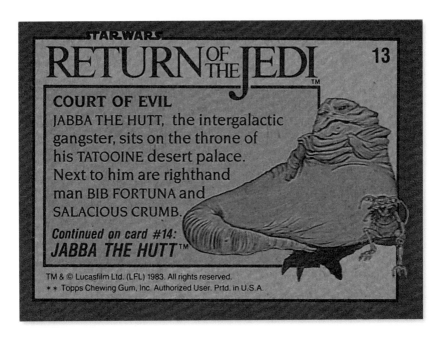

STAR WARS

RETURN OF THE JEDI

13

™

COURT OF EVIL

JABBA THE HUTT, the intergalactic gangster, sits on the throne of his TATOOINE desert palace. Next to him are righthand man BIB FORTUNA and SALACIOUS CRUMB.

Continued on card #14:
JABBA THE HUTT™

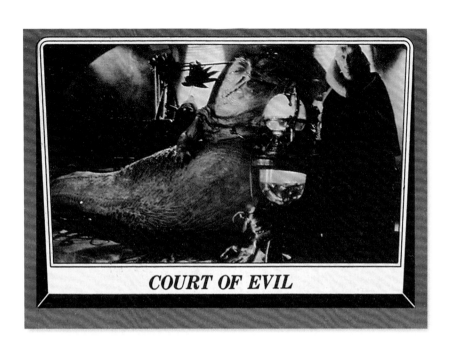

COURT OF EVIL

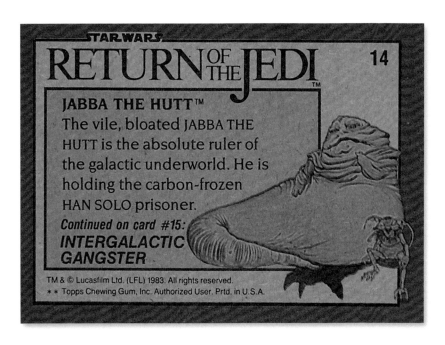

STAR WARS

RETURN OF THE JEDI

14

JABBA THE HUTT™
The vile, bloated JABBA THE
HUTT is the absolute ruler of
the galactic underworld. He is
holding the carbon-frozen
HAN SOLO prisoner.
Continued on card #15:
INTERGALACTIC
GANGSTER

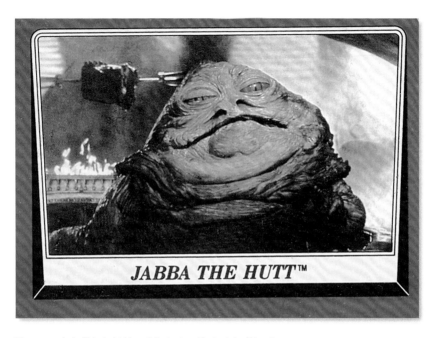

JABBA THE HUTT™

The money shot of bloated Jabba—Tatooine's resident criminal kingpin.

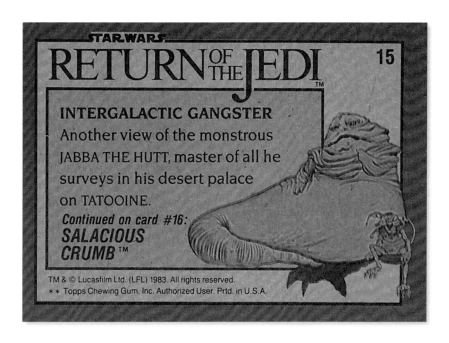

STAR.WARS

RETURN OF THE JEDI™

15

INTERGALACTIC GANGSTER

Another view of the monstrous JABBA THE HUTT, master of all he surveys in his desert palace on TATOOINE.

Continued on card #16:
SALACIOUS CRUMB™

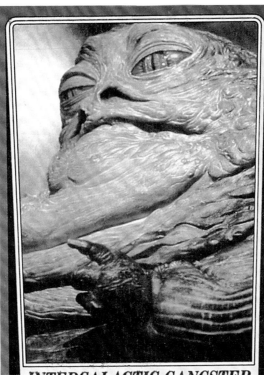

INTERGALACTIC GANGSTER

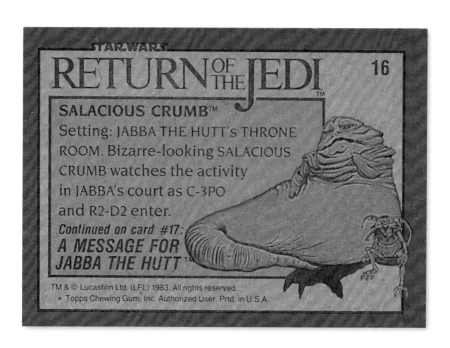

STAR WARS

RETURN OF THE JEDI™

16

SALACIOUS CRUMB™

Setting: JABBA THE HUTT's THRONE ROOM. Bizarre-looking SALACIOUS CRUMB watches the activity in JABBA's court as C-3PO and R2-D2 enter.

Continued on card #17:
A MESSAGE FOR JABBA THE HUTT™

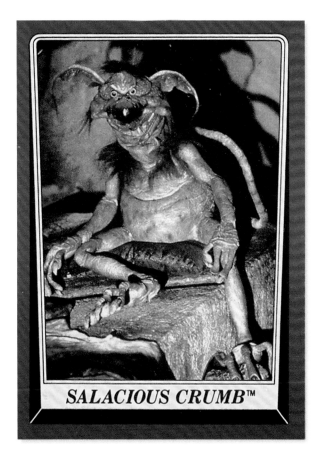

SALACIOUS CRUMB™

Jabba's cackling sidekick, Salacious B. Crumb, gets his own card—a vertical one at that.

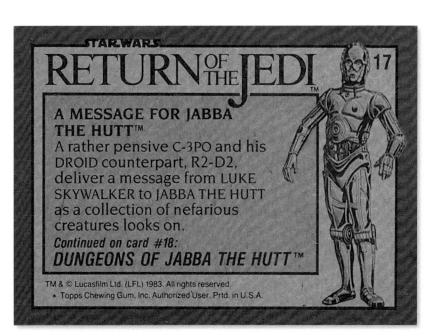

STAR WARS

RETURN OF THE JEDI

17

A MESSAGE FOR JABBA THE HUTT™

A rather pensive C-3PO and his DROID counterpart, R2-D2, deliver a message from LUKE SKYWALKER to JABBA THE HUTT as a collection of nefarious creatures looks on.

Continued on card #18:
DUNGEONS OF JABBA THE HUTT™

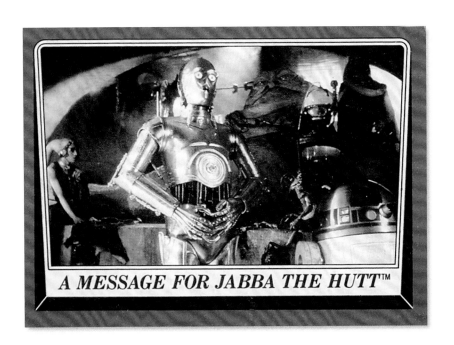

A MESSAGE FOR JABBA THE HUTT™

STAR WARS

RETURN OF THE JEDI ™

18

DUNGEONS OF JABBA THE HUTT™

In the vile, dreaded dungeon of JABBA THE HUTT's palace on TATOOINE, a DUSTBIN ROBOT is tortured by 8D8. *Continued on card #19:* ***BEEDO*™ *AND A JAWA*™**

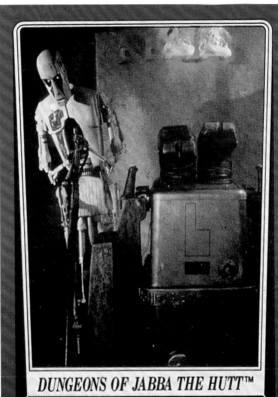

DUNGEONS OF JABBA THE HUTT™

STAR WARS

RETURN OF THE JEDI

19

BEEDO™ AND A JAWA™
BEEDO, a relative of GREEDO (killed by HAN SOLO in the Cantina some time ago), sits with a JAWA on the stairs in JABBA THE HUTT's palace.

Continued on card #20:
SY SNOOTLES AND THE REBO BAND ™

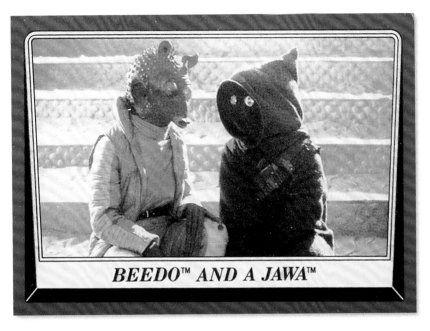

BEEDO™ AND A JAWA™

You'd never know it from watching the movie, but the blue-skinned Rodian chatting with a Jawa in Jabba's monster-filled palace is actually a relative of the bounty hunter Greedo, famously slain by Han Solo in the first film.

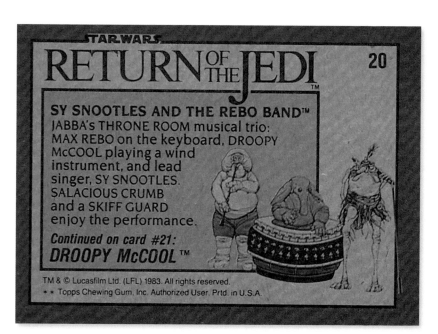

STAR.WARS

RETURN OF THE JEDI

20

™

SY SNOOTLES AND THE REBO BAND™
JABBA's THRONE ROOM musical trio: MAX REBO on the keyboard, DROOPY McCOOL playing a wind instrument, and lead singer, SY SNOOTLES. SALACIOUS CRUMB and a SKIFF GUARD enjoy the performance.

Continued on card #21:
DROOPY McCOOL ™

SY SNOOTLES AND THE REBO BAND™

STAR WARS
RETURN OF THE JEDI

21

DROOPY McCOOL™
Much to the delight of JABBA
THE HUTT's unsavory subjects,
DROOPY McCOOL cuts
loose with a hot
number on his
wind instrument.

Continued on card #22:
***SY SNOOTLES*™**

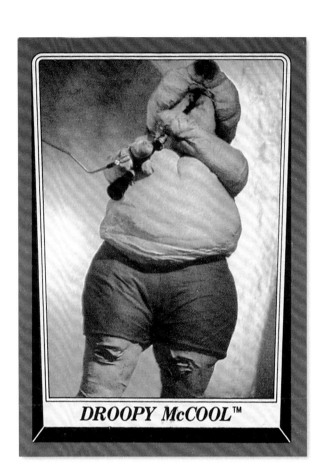

DROOPY McCOOL™

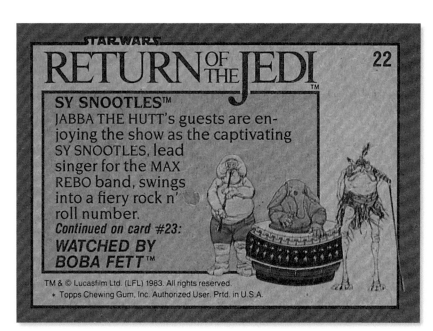

STAR WARS
RETURN OF THE JEDI

22

SY SNOOTLES™
JABBA THE HUTT's guests are enjoying the show as the captivating SY SNOOTLES, lead singer for the MAX REBO band, swings into a fiery rock n' roll number.
Continued on card #23:
WATCHED BY BOBA FETT™

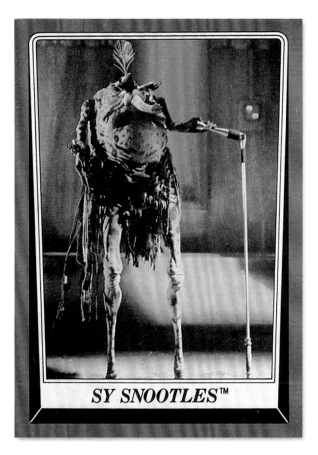

SY SNOOTLES™

A nice full-figure view of Sy Snootles, lead singer of Max Rebo's band.

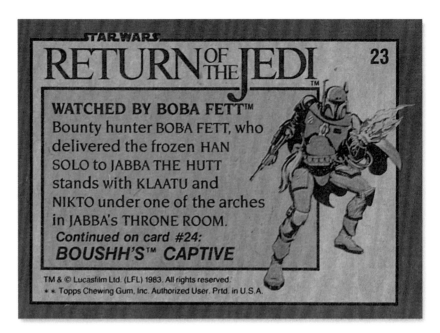

STAR WARS

RETURN OF THE JEDI

23

WATCHED BY BOBA FETT™
Bounty hunter BOBA FETT, who
delivered the frozen HAN
SOLO to JABBA THE HUTT
stands with KLAATU and
NIKTO under one of the arches
in JABBA's THRONE ROOM.
Continued on card #24:
BOUSHH'S™ CAPTIVE

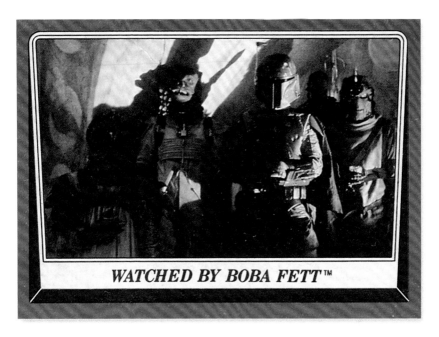

WATCHED BY BOBA FETT™

Infamous bounty hunter Boba Fett spends some time in Jabba the Hutt's palace after delivering Han Solo, his most wanted prisoner, frozen in carbonite. Fett is flanked by characters who will come into their own during the upcoming prison barge battle.

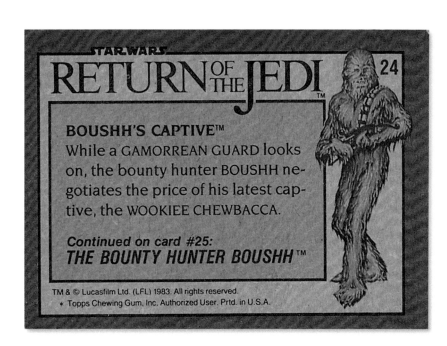

STAR WARS

RETURN OF THE JEDI™

24

BOUSHH'S CAPTIVE™
While a GAMORREAN GUARD looks on, the bounty hunter BOUSHH negotiates the price of his latest captive, the WOOKIEE CHEWBACCA.

Continued on card #25:
THE BOUNTY HUNTER BOUSHH™

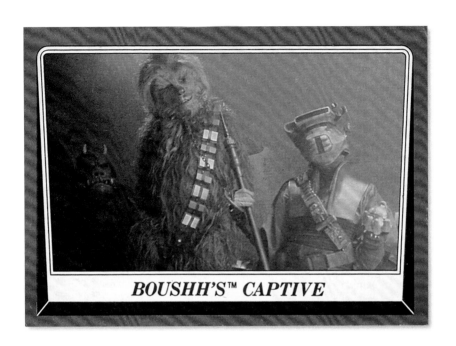

BOUSHH'S™ CAPTIVE

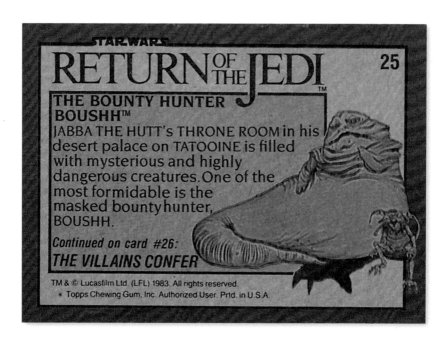

RETURN OF THE JEDI ™

25

THE BOUNTY HUNTER BOUSHH™

JABBA THE HUTT's THRONE ROOM in his desert palace on TATOOINE is filled with mysterious and highly dangerous creatures. One of the most formidable is the masked bounty hunter, BOUSHH.

Continued on card #26:
THE VILLAINS CONFER

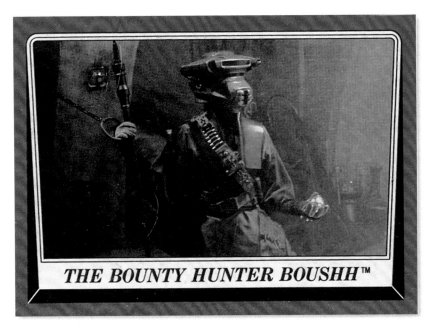

THE BOUNTY HUNTER BOUSHH™

Isn't she a little short for a bounty hunter? Under heavy armor and with a disguised voice, Princess Leia pretends to be famed tracker Boushh; she and "captive" Chewbacca infiltrate Jabba's palace to rescue Han Solo.

STAR.WARS

RETURN OF THE JEDI

26

THE VILLAINS CONFER

The frightening BIB FORTUNA, JABBA THE HUTT's major-domo, confers with BOUSHH, a mysterious bounty hunter who arrives in JABBA's court with a captured CHEWBACCA.

Continued on card #27:
HAN SOLO'S™ PLIGHT

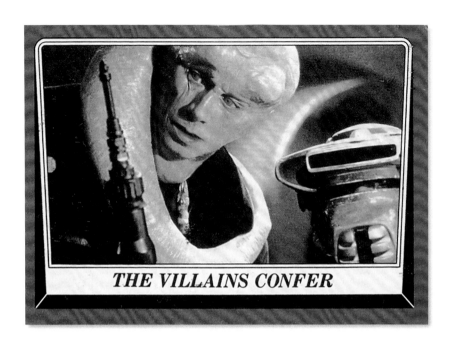

THE VILLAINS CONFER

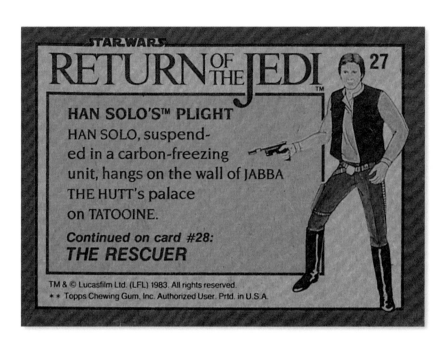

STAR WARS

RETURN OF THE JEDI

27

HAN SOLO'S™ PLIGHT

HAN SOLO, suspend-
ed in a carbon-freezing
unit, hangs on the wall of JABBA
THE HUTT's palace
on TATOOINE.

Continued on card #28:
THE RESCUER

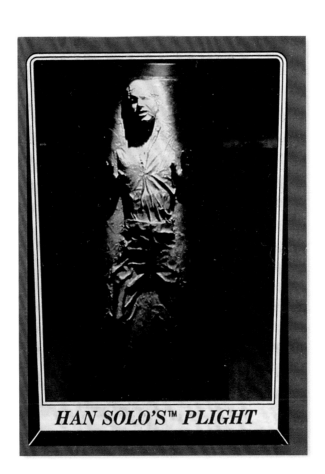

HAN SOLO'S™ PLIGHT

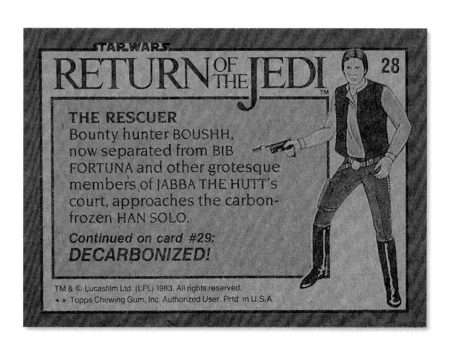

STAR WARS

RETURN OF THE JEDI

28

THE RESCUER
Bounty hunter BOUSHH, now separated from BIB FORTUNA and other grotesque members of JABBA THE HUTT's court, approaches the carbon-frozen HAN SOLO.

Continued on card #29:
DECARBONIZED!

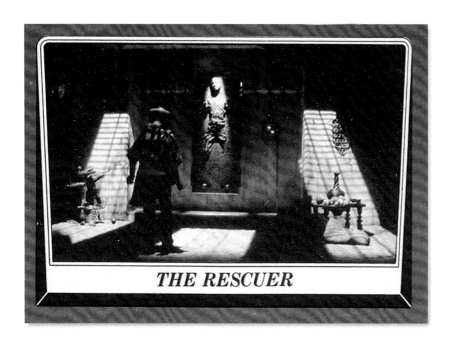

THE RESCUER

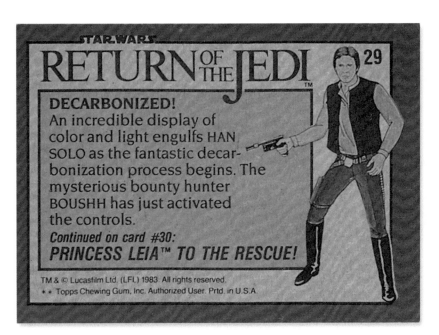

STAR WARS

RETURN OF THE JEDI

29

DECARBONIZED!
An incredible display of color and light engulfs HAN SOLO as the fantastic decarbonization process begins. The mysterious bounty hunter BOUSHH has just activated the controls.

Continued on card #30:
PRINCESS LEIA™ TO THE RESCUE!

DECARBONIZED!

I was most pleased to receive this slightly enhanced optical shot from ILM, which depicts Han Solo's colorful defreezing.

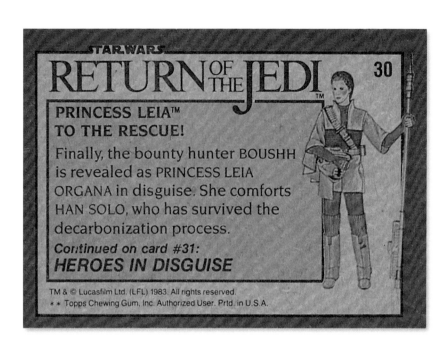

STAR WARS

RETURN OF THE JEDI

30

PRINCESS LEIA™
TO THE RESCUE!

Finally, the bounty hunter BOUSHH is revealed as PRINCESS LEIA ORGANA in disguise. She comforts HAN SOLO, who has survived the decarbonization process.

Continued on card #31:
HEROES IN DISGUISE

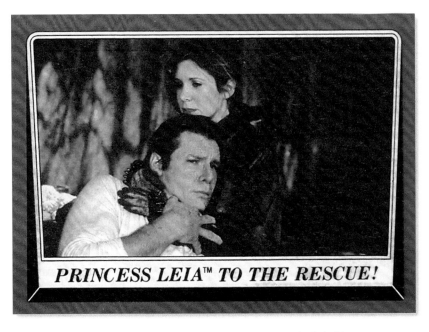

PRINCESS LEIA™ TO THE RESCUE!

Han Solo's rescuer, Boushh, is finally revealed as Princess Leia, once again in the thick of danger.

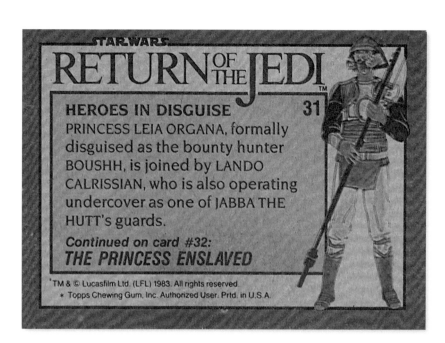

STAR WARS

RETURN OF THE JEDI ™

HEROES IN DISGUISE 31

PRINCESS LEIA ORGANA, formally
disguised as the bounty hunter
BOUSHH, is joined by LANDO
CALRISSIAN, who is also operating
undercover as one of JABBA THE
HUTT's guards.

Continued on card #32:
THE PRINCESS ENSLAVED

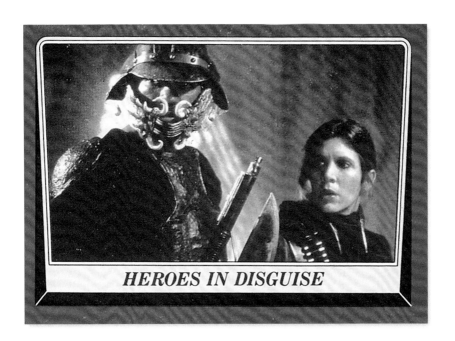

HEROES IN DISGUISE

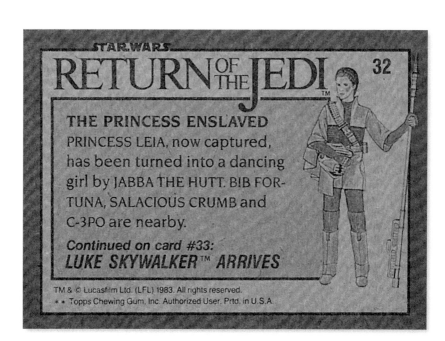

RETURN OF THE JEDI™

32

THE PRINCESS ENSLAVED

PRINCESS LEIA, now captured, has been turned into a dancing girl by JABBA THE HUTT. BIB FOR- TUNA, SALACIOUS CRUMB and C-3PO are nearby.

Continued on card #33:
LUKE SKYWALKER™ ARRIVES

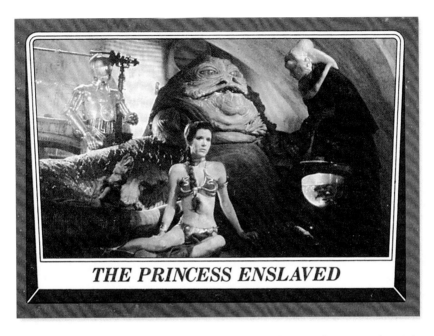

THE PRINCESS ENSLAVED

From plucky princess to passive slave girl: Leia bides her time in Jabba the Hutt's palace, awaiting the arrival of young Jedi Luke Skywalker.

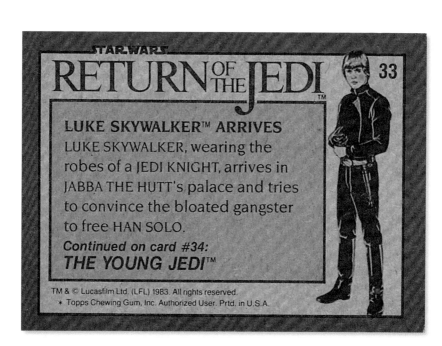

STAR.WARS

RETURN OF THE JEDI™

33

LUKE SKYWALKER™ ARRIVES

LUKE SKYWALKER, wearing the robes of a JEDI KNIGHT, arrives in JABBA THE HUTT's palace and tries to convince the bloated gangster to free HAN SOLO.

Continued on card #34:
THE YOUNG JEDI™

TM & © Lucasfilm Ltd. (LFL) 1983. All rights reserved.
★ Topps Chewing Gum, Inc. Authorized User. Prtd. in U.S.A.

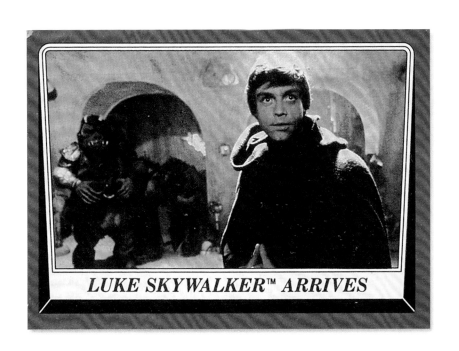

LUKE SKYWALKER™ ARRIVES

RETURN OF THE JEDI

34

THE YOUNG JEDI™

LUKE SKYWALKER has come a long way since his boyhood days as a moisture farmer. Now, in the court of JABBA THE HUTT, he demonstrates his courage and skill as he confronts JABBA.

Continued on card #35:
THE COURT IN CHAOS!

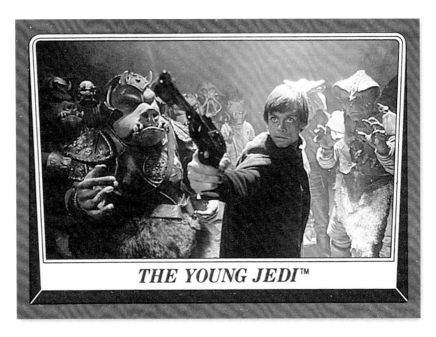

THE YOUNG JEDI™

Here's a great shot of Luke Skywalker, newly minted Jedi warrior, proving to gawkers in Jabba's throne room that he's learned the ways of the Force well.

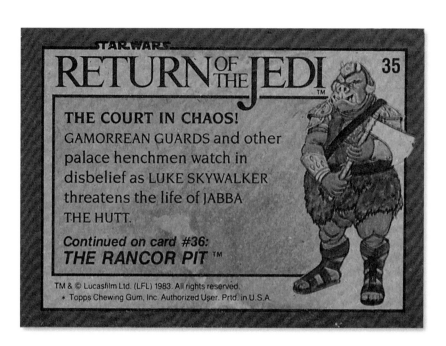

STAR WARS

RETURN OF THE JEDI

35

THE COURT IN CHAOS!
GAMORREAN GUARDS and other palace henchmen watch in disbelief as LUKE SKYWALKER threatens the life of JABBA THE HUTT.

Continued on card #36:
THE RANCOR PIT ™

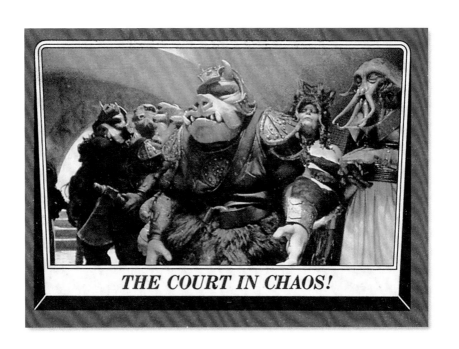

THE COURT IN CHAOS!

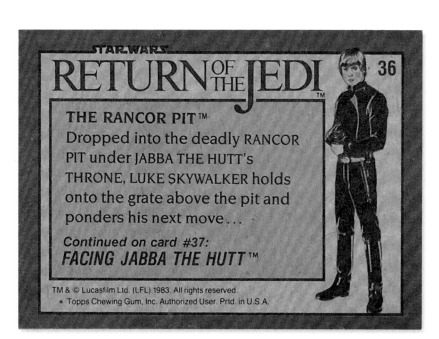

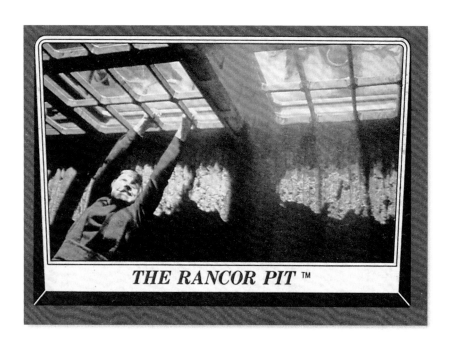

THE RANCOR PIT ™

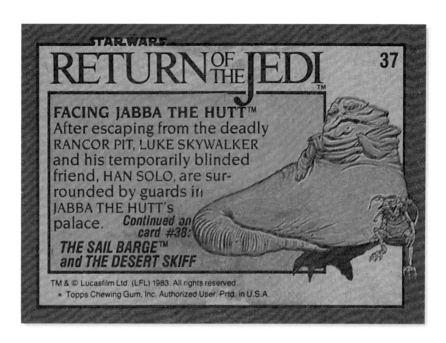

STAR WARS

RETURN OF THE JEDI™

37

FACING JABBA THE HUTT™
After escaping from the deadly
RANCOR PIT, LUKE SKYWALKER
and his temporarily blinded
friend, HAN SOLO, are sur-
rounded by guards in
JABBA THE HUTT's
palace. *Continued on*
card #38:
THE SAIL BARGE™
and THE DESERT SKIFF

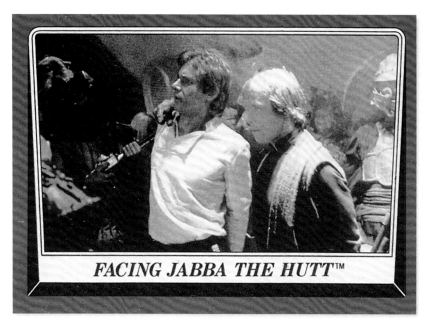

FACING JABBA THE HUTT™

Luke and the rescued Han Solo are reunited. Images of the monstrous rancor and its battle with Skywalker weren't available for Series 1.

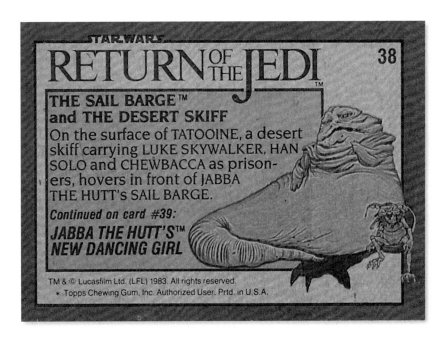

STAR WARS

RETURN OF THE JEDI

38

THE SAIL BARGE™
and THE DESERT SKIFF
On the surface of TATOOINE, a desert
skiff carrying LUKE SKYWALKER, HAN
SOLO and CHEWBACCA as prison-
ers, hovers in front of JABBA
THE HUTT's SAIL BARGE.

Continued on card #39:

JABBA THE HUTT'S™
NEW DANCING GIRL

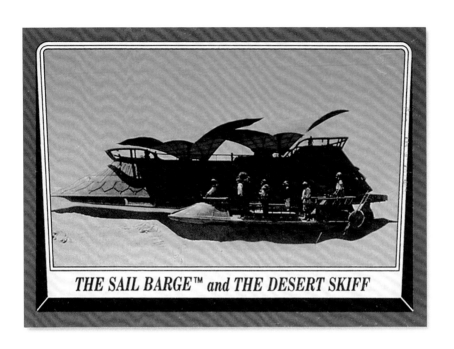

THE SAIL BARGE™ *and THE DESERT SKIFF*

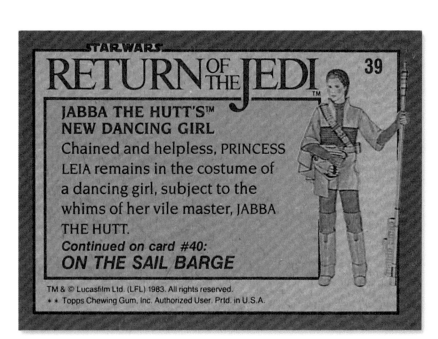

STAR.WARS

RETURN OF THE JEDI

39

**JABBA THE HUTT'S™
NEW DANCING GIRL**

Chained and helpless, PRINCESS
LEIA remains in the costume of
a dancing girl, subject to the
whims of her vile master, JABBA
THE HUTT.

Continued on card #40:
ON THE SAIL BARGE

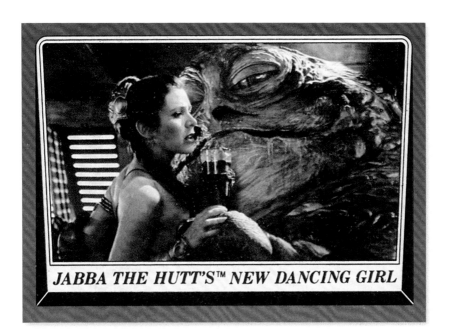

JABBA THE HUTT'S™ NEW DANCING GIRL

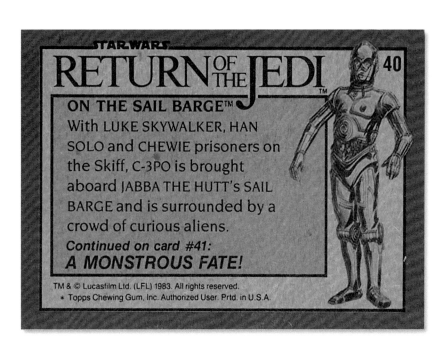

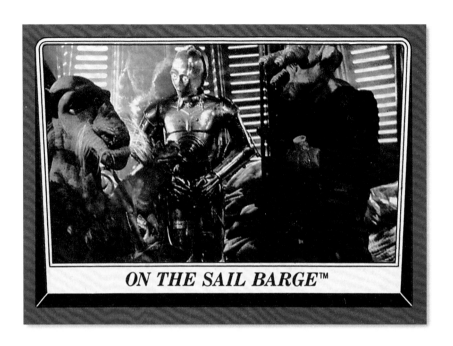

ON THE SAIL BARGE™

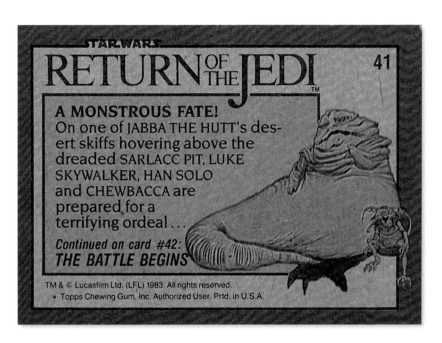

STAR WARS

RETURN OF THE JEDI

41

A MONSTROUS FATE!
On one of JABBA THE HUTT's desert skiffs hovering above the dreaded SARLACC PIT, LUKE SKYWALKER, HAN SOLO and CHEWBACCA are prepared for a terrifying ordeal...

Continued on card #42:
THE BATTLE BEGINS

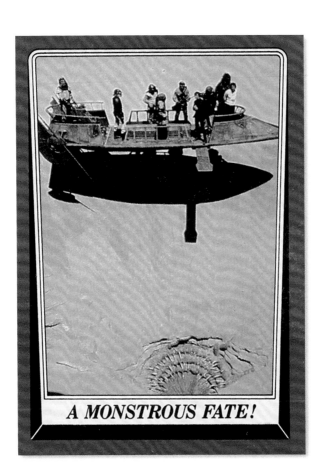

A MONSTROUS FATE!

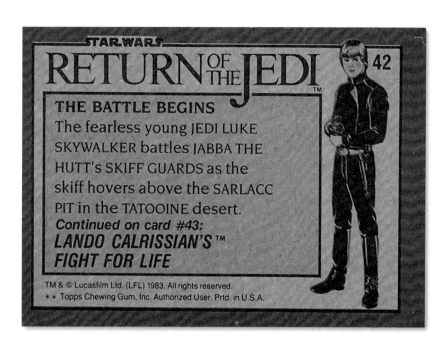

STAR WARS

RETURN OF THE JEDI

42

THE BATTLE BEGINS
The fearless young JEDI LUKE
SKYWALKER battles JABBA THE
HUTT's SKIFF GUARDS as the
skiff hovers above the SARLACC
PIT in the TATOOINE desert.
Continued on card #43:
LANDO CALRISSIAN'S ™
FIGHT FOR LIFE

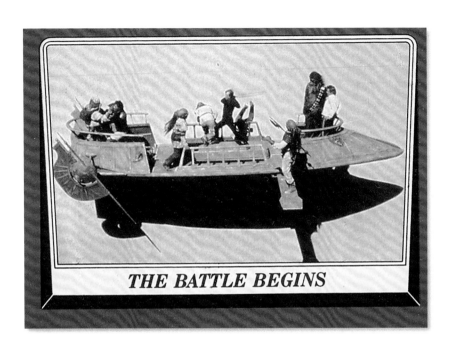

THE BATTLE BEGINS

RETURN OF THE JEDI™

LANDO CALRISSIAN'S™ FIGHT FOR LIFE 43

As the REBEL heroes battle against JABBA THE HUTT's nefarious guards, LANDO CALRISSIAN engages in a hand-to-hand struggle to the death with one of the SKIFF GUARDS.
Continued on card #44:
FURY OF THE JEDI™!

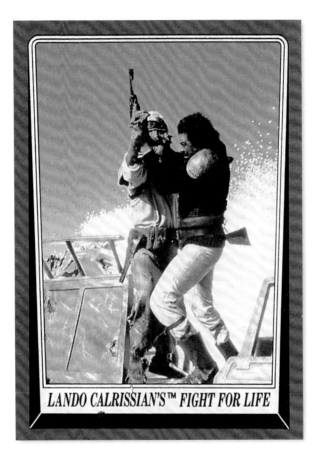

LANDO CALRISSIAN'S™ FIGHT FOR LIFE

Here's a colorful, dramatic photo of Lando Calrissian in action aboard Jabba's besieged sail barge.

FURY OF THE JEDI™!
On the top deck of JABBA THE HUTT's SAIL BARGE, young JEDI LUKE SKYWALKER brandishes his LIGHTSABER. Immediately his enemies fall back as the deadly yet elegant weapon is put to use...

Continued on card #45:
PRINCESS LEIA™ STRIKES BACK!

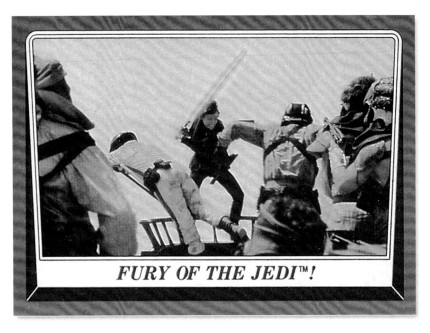

FURY OF THE JEDI™!

An airbrushed lightsaber adds to the excitement as fearless Luke takes on Jabba's minions on Tatooine. The green saber was used for *Return of the Jedi* to stand out from the glaring blue sky of Endor's forest moon later in the film.

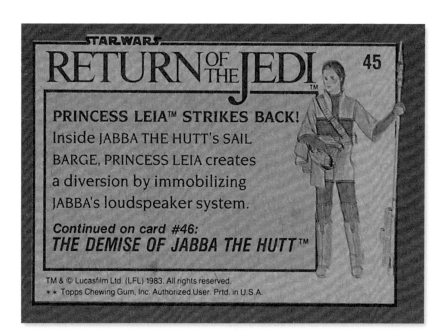

STAR.WARS

RETURN OF THE JEDI

45

PRINCESS LEIA™ STRIKES BACK!
Inside JABBA THE HUTT's SAIL
BARGE, PRINCESS LEIA creates
a diversion by immobilizing
JABBA's loudspeaker system.

Continued on card #46:
THE DEMISE OF JABBA THE HUTT™

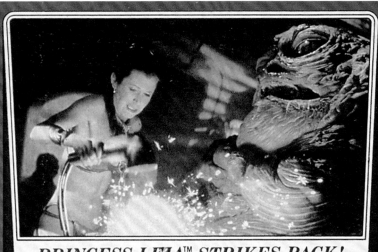

PRINCESS LEIA™ STRIKES BACK!

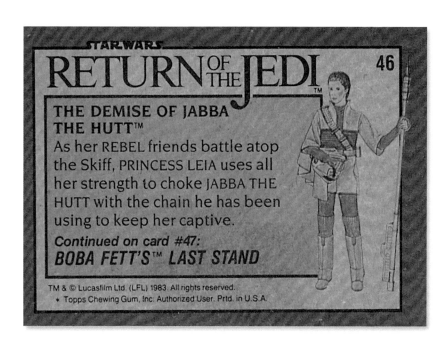

STAR WARS

RETURN OF THE JEDI

46

THE DEMISE OF JABBA THE HUTT™

As her REBEL friends battle atop the Skiff, PRINCESS LEIA uses all her strength to choke JABBA THE HUTT with the chain he has been using to keep her captive.

Continued on card #47:
BOBA FETT'S™ LAST STAND

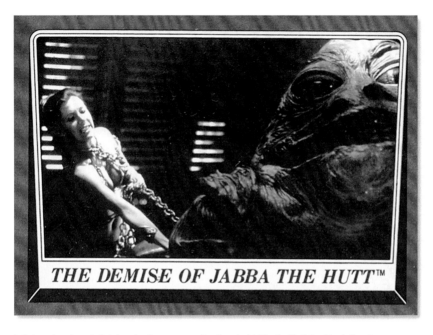

THE DEMISE OF JABBA THE HUTT™

Leia turns her slave chain into a deadly weapon, using it against Jabba the Hutt, her bloated captor.

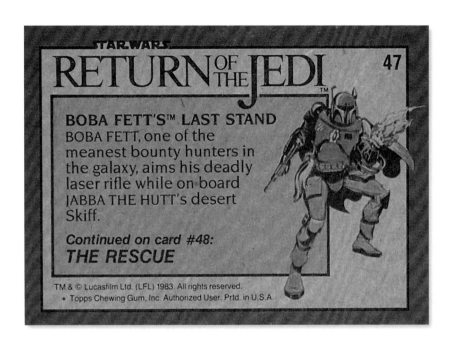

STAR WARS

RETURN OF THE JEDI

47

BOBA FETT'S™ LAST STAND
BOBA FETT, one of the
meanest bounty hunters in
the galaxy, aims his deadly
laser rifle while on board
JABBA THE HUTT's desert
Skiff.

Continued on card #48:
THE RESCUE

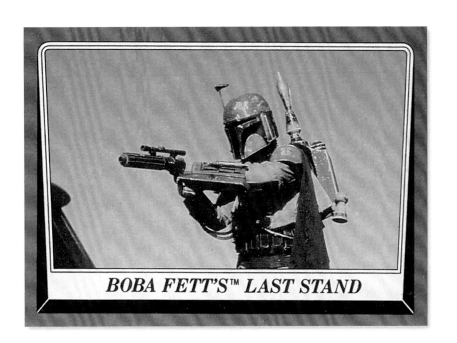

BOBA FETT'S™ LAST STAND

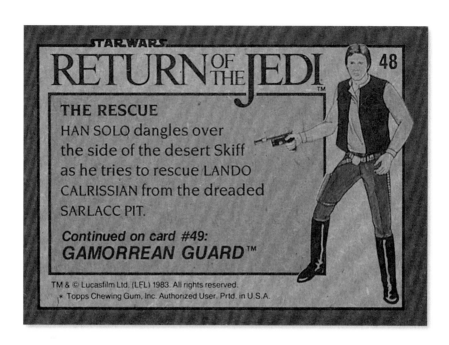

STAR WARS

RETURN OF THE JEDI™

48

THE RESCUE

HAN SOLO dangles over the side of the desert Skiff as he tries to rescue LANDO CALRISSIAN from the dreaded SARLACC PIT.

Continued on card #49:
GAMORREAN GUARD™

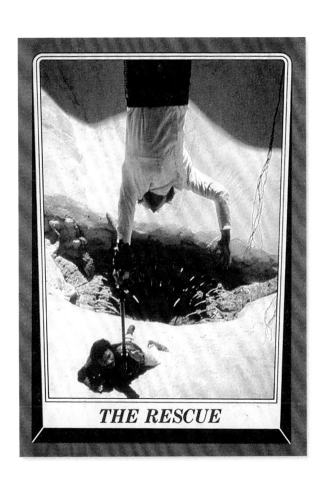

THE RESCUE

STAR WARS

RETURN OF THE JEDI

49

GAMORREAN GUARD™
As our heroes clash with JABBA
THE HUTT's nefarious forces,
a GAMORREAN GUARD on the
top deck of JABBA's SAIL BARGE
observes the battle.

Continued on card #50:
THE DEADLY CANNON

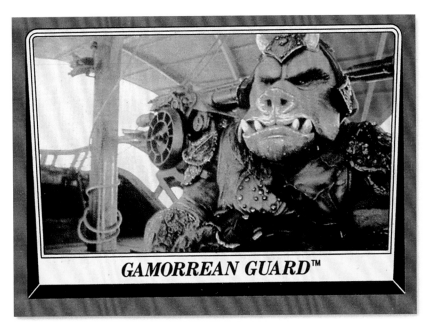

GAMORREAN GUARD™

These brutal, pig-faced hulks make quite an impression in the first act of *Return of the Jedi*.

STAR WARS

RETURN OF THE JEDI ™

50

THE DEADLY CANNON
The TATOOINE desert explodes
with laser fire. On the top deck
of JABBA THE HUTT's SAIL BARGE,
a NIKTO guard takes aim
and prepares to fire
his cannon.

Continued on card #51:
THE RAGING
BATTLE

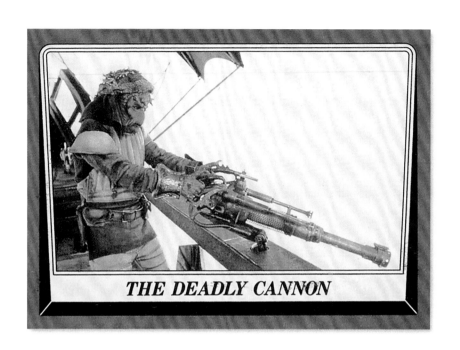

THE DEADLY CANNON

RETURN OF THE JEDI ™

51

THE RAGING BATTLE

The young, courageous JEDI KNIGHT LUKE SKYWALKER fights for his life aboard JABBA THE HUTT's desert SAIL BARGE. Meanwhile, friends HAN SOLO, LANDO CALRISSIAN and CHEWBACCA also have their hands full thwarting JABBA's guards.

Continued on card #52:
PRINCESS LEIA™
SWINGS INTO ACTION!

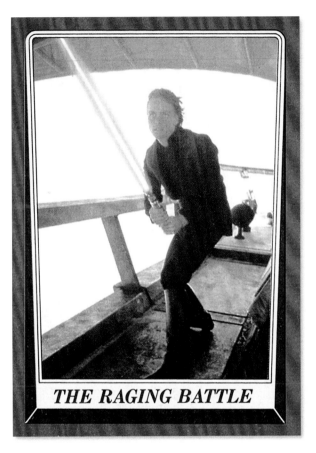

THE RAGING BATTLE

Here's a gorgeous portrait of Luke aboard the sail barge, his green lightsaber flashing (airbrushed for publication by Lucasfilm).

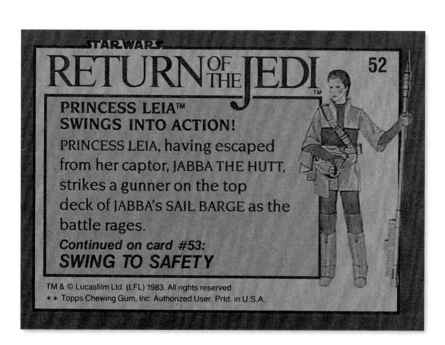

STAR WARS

RETURN OF THE JEDI

52

PRINCESS LEIA™ SWINGS INTO ACTION!

PRINCESS LEIA, having escaped from her captor, JABBA THE HUTT, strikes a gunner on the top deck of JABBA's SAIL BARGE as the battle rages.

Continued on card #53:

SWING TO SAFETY

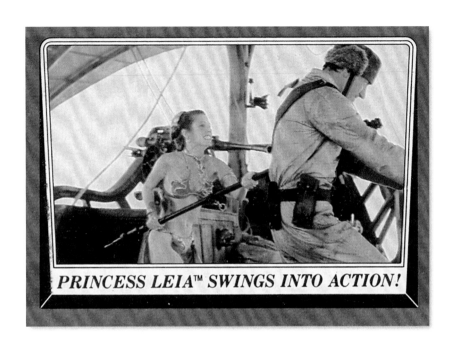

PRINCESS LEIA™ SWINGS INTO ACTION!

RETURN OF THE JEDI

53

SWING TO SAFETY

PRINCESS LEIA has successfully escaped the vile grasp of JABBA THE HUTT. Now, she and young JEDI LUKE SKYWALKER prepare to swing to safety from the top deck of JABBA's desert SAIL BARGE.

Continued on card #54:
ON THE DEATH STAR™

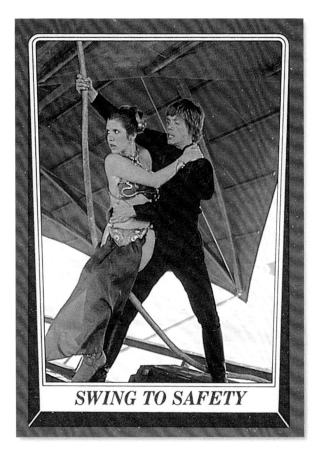

SWING TO SAFETY

Recalling a similar moment from the original *Star Wars*, Luke and Leia prepare to do exactly what the caption says. This beautiful photo was used extensively by Topps and other licensees.

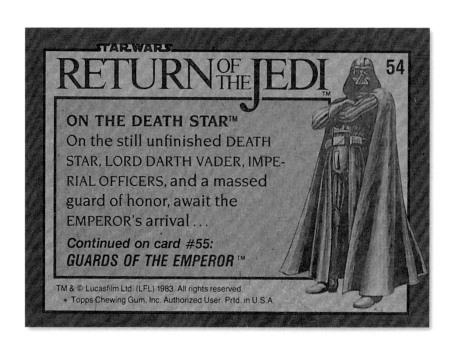

STAR WARS

RETURN OF THE JEDI

54

ON THE DEATH STAR™
On the still unfinished DEATH
STAR, LORD DARTH VADER, IMPE-
RIAL OFFICERS, and a massed
guard of honor, await the
EMPEROR's arrival . . .

Continued on card #55:
GUARDS OF THE EMPEROR™

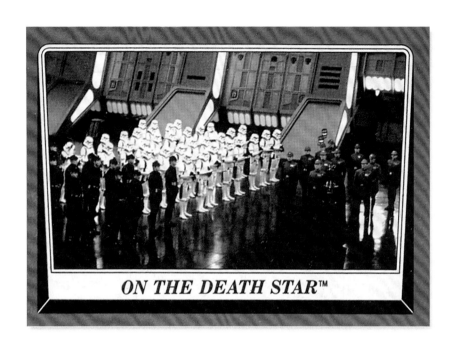

ON THE DEATH STAR™

STAR WARS

RETURN OF THE JEDI™

55

GUARDS OF THE EMPEROR™
On the still unfinished DEATH
STAR, the EMPEROR's ROYAL
GUARDS descend the ramp of
the IMPERIAL SHUTTLE as DARTH
VADER, the DARK LORD OF THE
SITH, watches for the arrival of
his master.
Continued on card #56:
THE DECIDERS

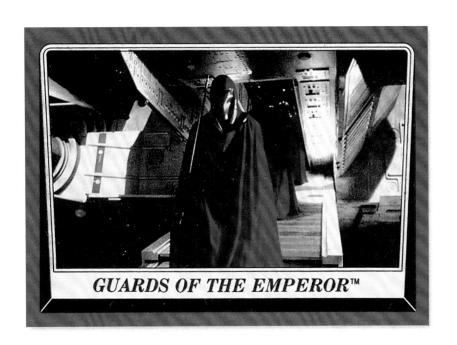

GUARDS OF THE EMPEROR™

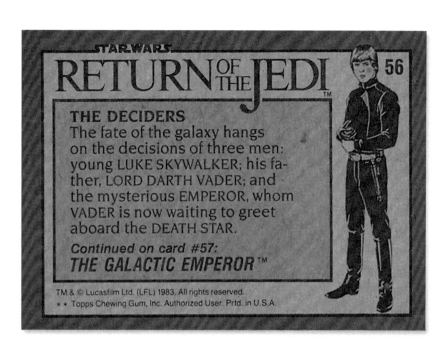

STAR WARS
RETURN OF THE JEDI

56

THE DECIDERS
The fate of the galaxy hangs
on the decisions of three men:
young LUKE SKYWALKER; his fa-
ther, LORD DARTH VADER; and
the mysterious EMPEROR, whom
VADER is now waiting to greet
aboard the DEATH STAR.

Continued on card #57:
THE GALACTIC EMPEROR™

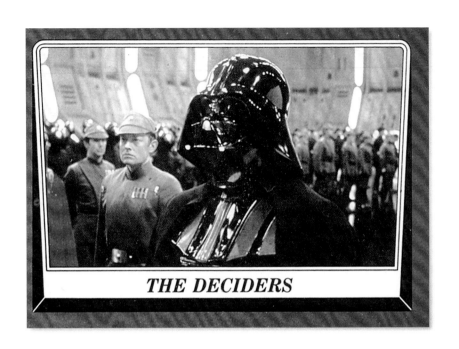

THE DECIDERS

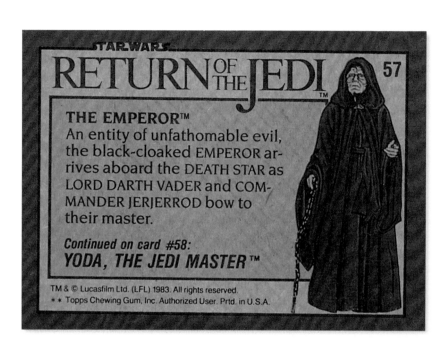

STAR WARS

RETURN OF THE JEDI

57

THE EMPEROR™
An entity of unfathomable evil, the black-cloaked EMPEROR arrives aboard the DEATH STAR as LORD DARTH VADER and COMMANDER JERJERROD bow to their master.

Continued on card #58:
YODA, THE JEDI MASTER™

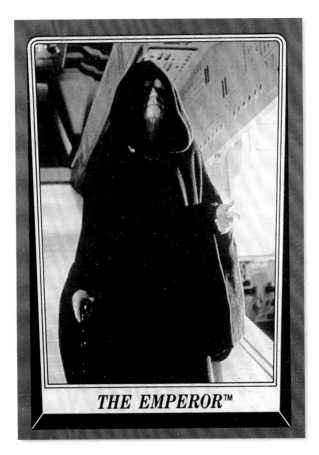

THE EMPEROR™

An imposing view of the evil Emperor, who is never identified as Palpatine in any of the three original movies. Luckily we had a line rendering to match for the card back.

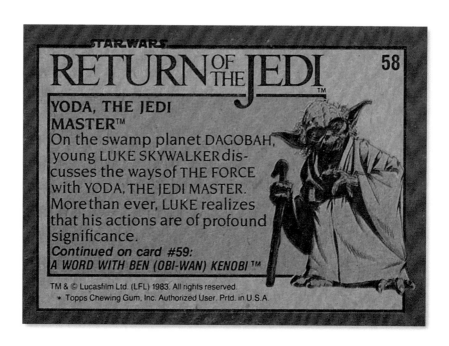

STAR WARS

RETURN OF THE JEDI

58

YODA, THE JEDI MASTER™
On the swamp planet DAGOBAH, young LUKE SKYWALKER discusses the ways of THE FORCE with YODA, THE JEDI MASTER. More than ever, LUKE realizes that his actions are of profound significance.
Continued on card #59:
A WORD WITH BEN (OBI-WAN) KENOBI™

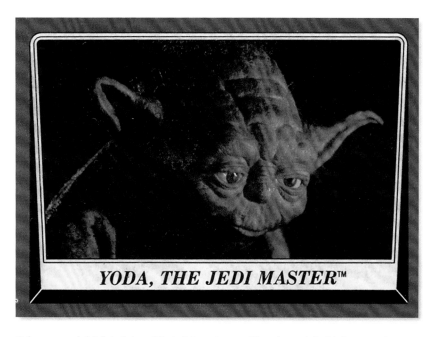

YODA, THE JEDI MASTER™

Yoda appears only briefly in *Return of the Jedi*, becoming something of a guest star this time around.

STAR WARS
RETURN OF THE JEDI

59

A WORD WITH BEN (OBI-WAN) KENOBI™
While on DAGOBAH, LUKE SKY-
WALKER encounters his old friend
and mentor, BEN (OBI-WAN) KENOBI.
Angered that BEN never revealed
the truth about DARTH VADER,
LUKE learns more about his special
destiny as a JEDI KNIGHT.
Continued on card #60:
THE ALLIES MEET

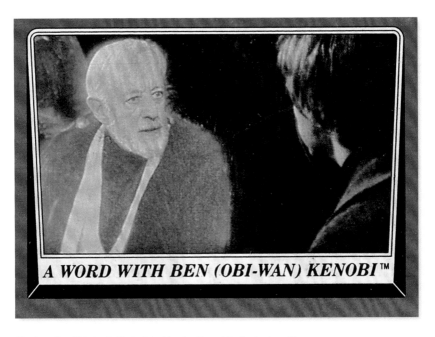

A WORD WITH BEN (OBI-WAN) KENOBI™

Here's another ILM visual-effects shot airbrushed for publication by Lucasfilm.

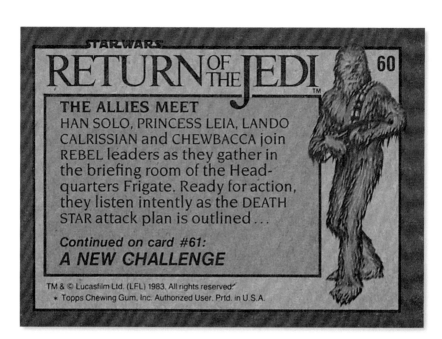

STAR WARS

RETURN OF THE JEDI

60

THE ALLIES MEET
HAN SOLO, PRINCESS LEIA, LANDO CALRISSIAN and CHEWBACCA join REBEL leaders as they gather in the briefing room of the Headquarters Frigate. Ready for action, they listen intently as the DEATH STAR attack plan is outlined...

Continued on card #61:
A NEW CHALLENGE

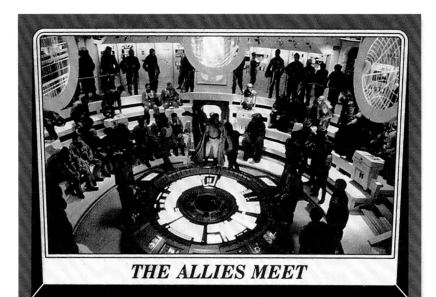

THE ALLIES MEET

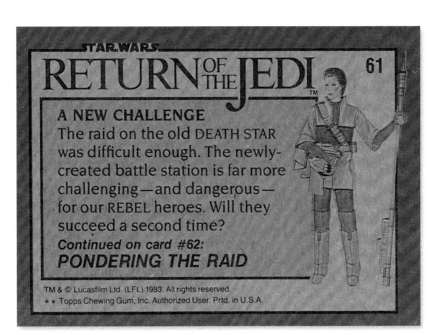

STAR WARS
RETURN OF THE JEDI

61

A NEW CHALLENGE
The raid on the old DEATH STAR was difficult enough. The newly-created battle station is far more challenging—and dangerous—for our REBEL heroes. Will they succeed a second time?
Continued on card #62:
PONDERING THE RAID

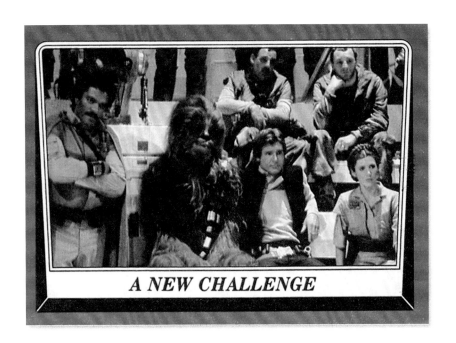

A NEW CHALLENGE

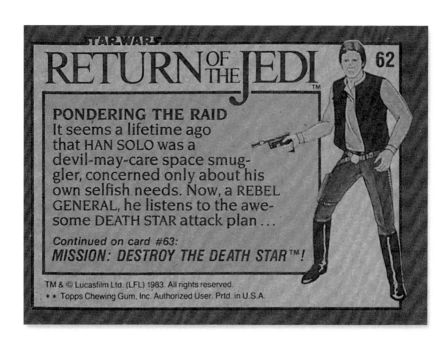

STAR WARS
RETURN OF THE JEDI

62

PONDERING THE RAID

It seems a lifetime ago that HAN SOLO was a devil-may-care space smuggler, concerned only about his own selfish needs. Now, a REBEL GENERAL, he listens to the awesome DEATH STAR attack plan ...

Continued on card #63:
MISSION: DESTROY THE DEATH STAR™!

PONDERING THE RAID

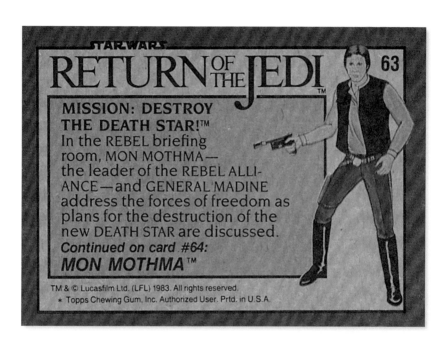

STAR WARS

RETURN OF THE JEDI ™

63

**MISSION: DESTROY
THE DEATH STAR!**™
In the REBEL briefing
room, MON MOTHMA—
the leader of the REBEL ALLI-
ANCE—and GENERAL MADINE
address the forces of freedom as
plans for the destruction of the
new DEATH STAR are discussed.
Continued on card #64:
MON MOTHMA™

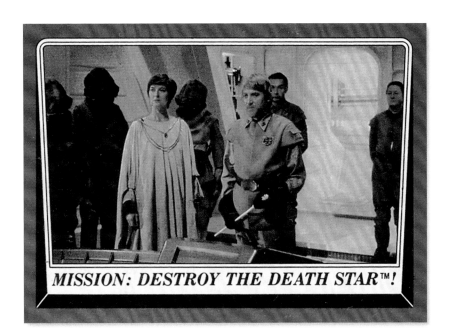

MISSION: DESTROY THE DEATH STAR™!

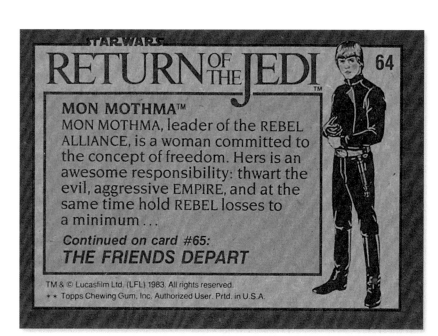

RETURN OF THE JEDI

64

MON MOTHMA™
MON MOTHMA, leader of the REBEL ALLIANCE, is a woman committed to the concept of freedom. Hers is an awesome responsibility: thwart the evil, aggressive EMPIRE, and at the same time hold REBEL losses to a minimum...

Continued on card #65:
THE FRIENDS DEPART

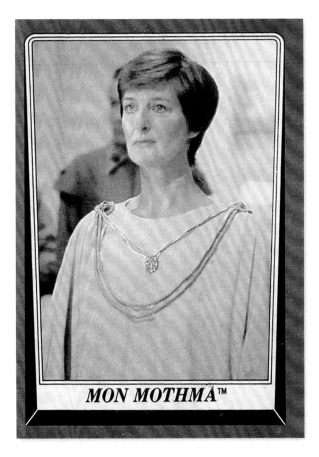

MON MOTHMA™

Mon Mothma, leader of the Rebel Alliance, earns her own trading card.

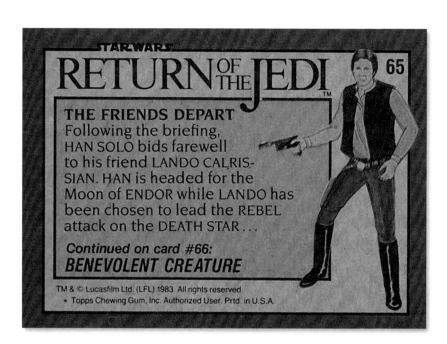

STAR WARS
RETURN OF THE JEDI

65

THE FRIENDS DEPART
Following the briefing, HAN SOLO bids farewell to his friend LANDO CALRIS-SIAN. HAN is headed for the Moon of ENDOR while LANDO has been chosen to lead the REBEL attack on the DEATH STAR...

Continued on card #66:
BENEVOLENT CREATURE

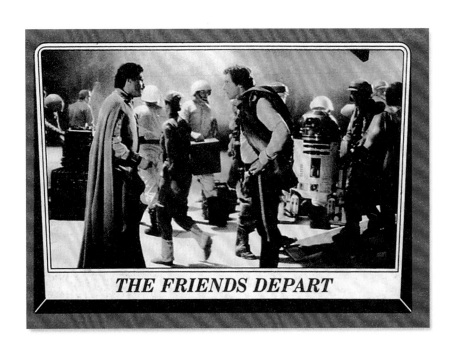

THE FRIENDS DEPART

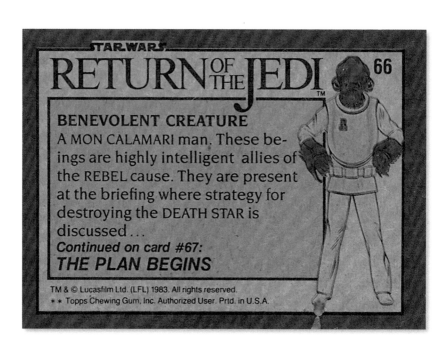

STAR WARS

RETURN OF THE JEDI

66

BENEVOLENT CREATURE

A MON CALAMARI man. These beings are highly intelligent allies of the REBEL cause. They are present at the briefing where strategy for destroying the DEATH STAR is discussed ...

Continued on card #67:
THE PLAN BEGINS

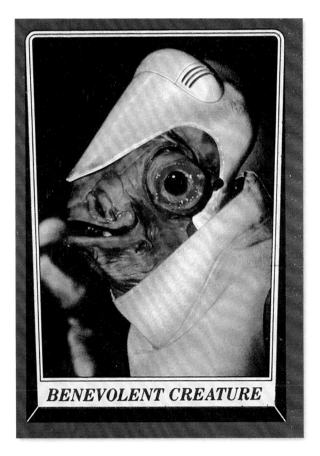

BENEVOLENT CREATURE

A revealing side view of a Mon Calamari, part of Admiral Ackbar's entourage. The admiral is visualized on the card back, in a line drawing.

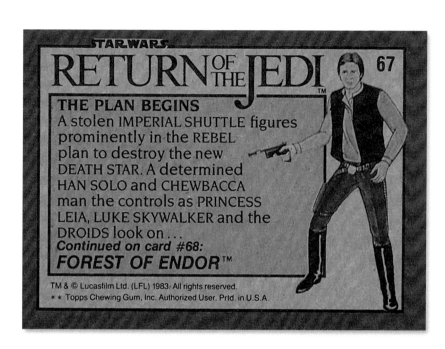

STAR.WARS.

RETURN OF THE JEDI

67

THE PLAN BEGINS
A stolen IMPERIAL SHUTTLE figures
prominently in the REBEL
plan to destroy the new
DEATH STAR. A determined
HAN SOLO and CHEWBACCA
man the controls as PRINCESS
LEIA, LUKE SKYWALKER and the
DROIDS look on...
Continued on card #68:
FOREST OF ENDOR™

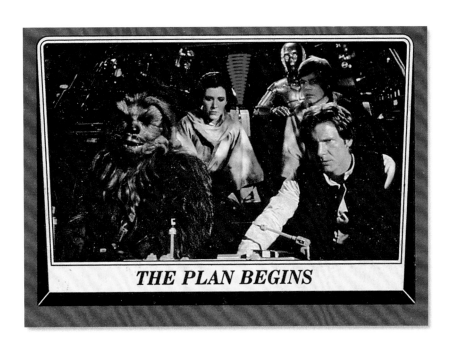

THE PLAN BEGINS

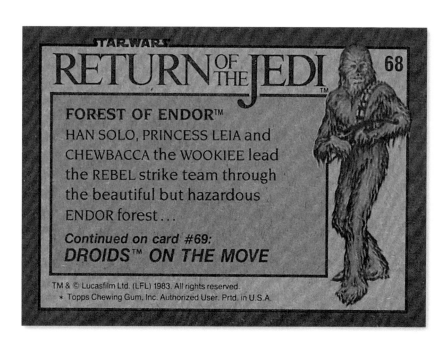

STAR WARS

RETURN OF THE JEDI

68

FOREST OF ENDOR™

HAN SOLO, PRINCESS LEIA and
CHEWBACCA the WOOKIEE lead
the REBEL strike team through
the beautiful but hazardous
ENDOR forest...

Continued on card #69:
DROIDS™ ON THE MOVE

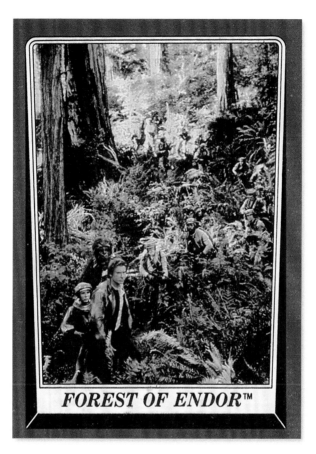

FOREST OF ENDOR™

We begin our visit to Endor's forest moon with this impressive establishing shot as a team of courageous rebels begins the mission. These outdoor scenes were shot in the dense, magical woods of Northern California.

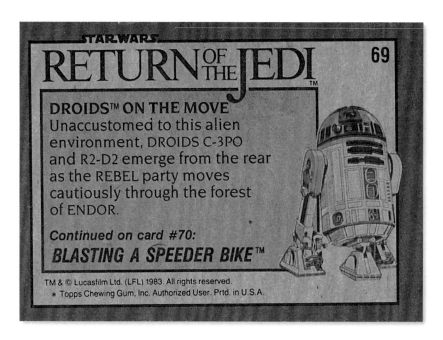

STAR WARS

RETURN OF THE JEDI

69

DROIDS™ ON THE MOVE
Unaccustomed to this alien environment, DROIDS C-3PO and R2-D2 emerge from the rear as the REBEL party moves cautiously through the forest of ENDOR.

Continued on card #70:

BLASTING A SPEEDER BIKE™

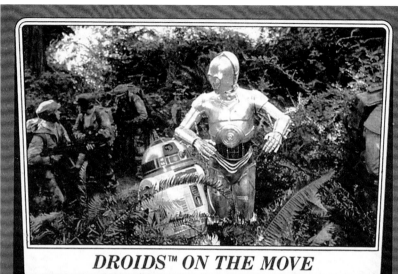

DROIDS™ ON THE MOVE

RETURN OF THE JEDI

70

BLASTING A SPEEDER BIKE™
On the forested Moon of ENDOR, a highly-dangerous IMPERIAL SPEEDER BIKE is knocked out by REBEL laser fire. The SPEEDER BIKES are incredibly fast vehicles used by the GALACTIC EMPIRE.

Continued on card #71:
APPROACHING THE
PRINCESS

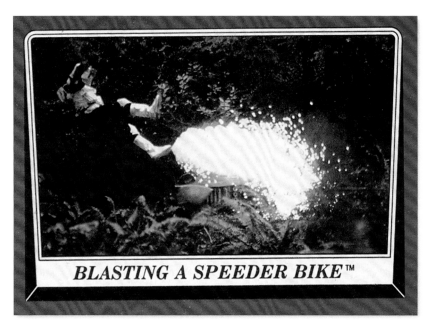

BLASTING A SPEEDER BIKE™

It's always cool when unit photography captures a moment like this. I marvel at how we were able to squeeze a rendering of the speeder bike and its rider onto the card back.

STAR.WARS

RETURN OF THE JEDI

71

APPROACHING THE PRINCESS
Knocked unconscious by a fall from a SPEEDER BIKE, PRINCESS LEIA is discovered in the ENDOR forest by a curious, pint-sized creature known as WICKET.

Continued on card #72:
A NEW FOUND FRIEND

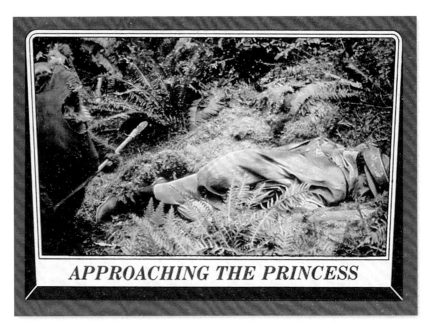

APPROACHING THE PRINCESS

An inquisitive Ewok named Wicket enters the picture—literally. The exciting speeder bike chase sequence was given little coverage in Series 1, as much of it involved miniatures and visual-effects work.

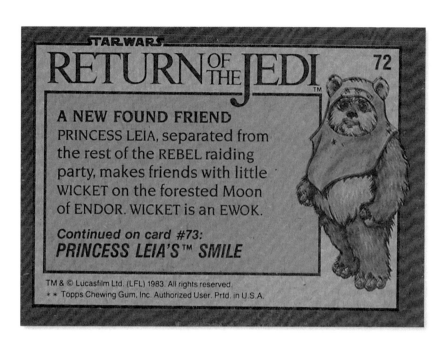

RETURN OF THE JEDI

72

A NEW FOUND FRIEND

PRINCESS LEIA, separated from the rest of the REBEL raiding party, makes friends with little WICKET on the forested Moon of ENDOR. WICKET is an EWOK.

Continued on card #73:
PRINCESS LEIA'S™ SMILE

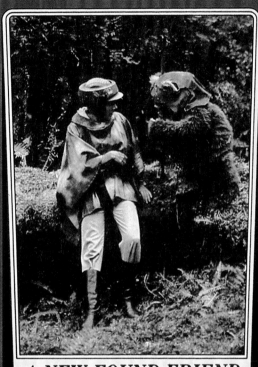

A NEW FOUND FRIEND

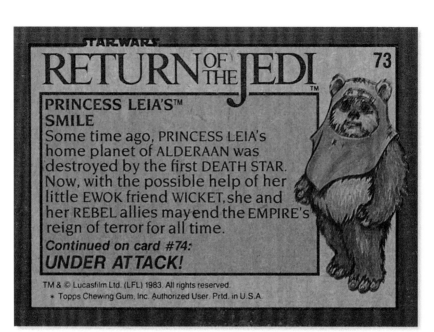

STAR WARS

RETURN OF THE JEDI

73

PRINCESS LEIA'S™ SMILE

Some time ago, PRINCESS LEIA's home planet of ALDERAAN was destroyed by the first DEATH STAR. Now, with the possible help of her little EWOK friend WICKET, she and her REBEL allies may end the EMPIRE's reign of terror for all time.

Continued on card #74:
UNDER ATTACK!

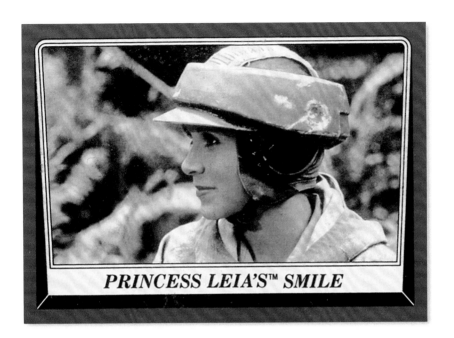

PRINCESS LEIA'S™ SMILE

STAR WARS

RETURN OF THE JEDI

74

UNDER ATTACK!
Attacked by an IMPERIAL SCOUT
on the forested Moon of ENDOR,
PRINCESS LEIA and her new EWOK
friend WICKET take cover behind
a fallen log...

Continued on card #75:
IMPERIAL SCOUT™ PERIL!

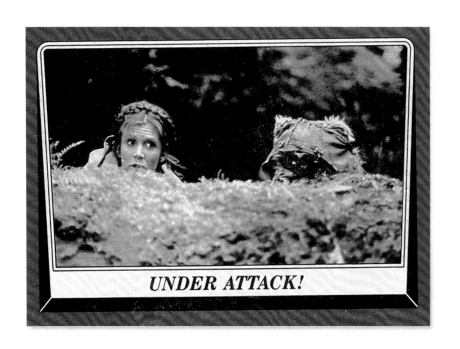

UNDER ATTACK!

RETURN OF THE JEDI

75

IMPERIAL SCOUT™ PERIL!
Courageous PRINCESS LEIA swings
into action after being ambushed
by an IMPERIAL SCOUT on the
Moon of ENDOR. A short time later
HAN SOLO, LUKE SKYWALKER and
the DROIDS find her crushed
SPEEDER BIKE and fear the worst.
Continued on card #76:
ENTERING THE THRONE ROOM™

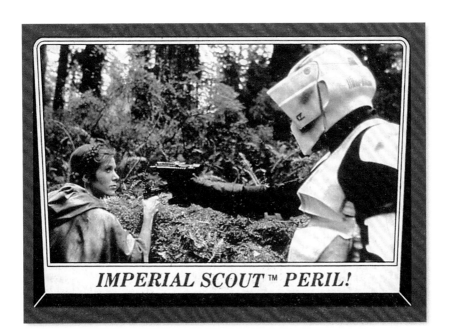

IMPERIAL SCOUT™ PERIL!

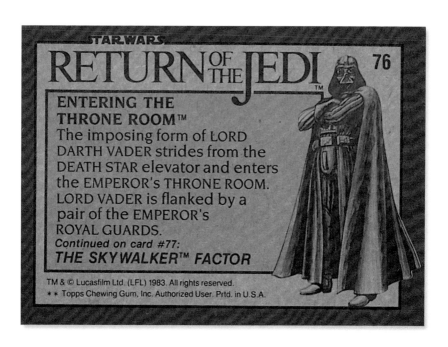

RETURN OF THE JEDI

76

ENTERING THE THRONE ROOM™

The imposing form of LORD DARTH VADER strides from the DEATH STAR elevator and enters the EMPEROR's THRONE ROOM. LORD VADER is flanked by a pair of the EMPEROR's ROYAL GUARDS.

Continued on card #77:
THE SKYWALKER™ FACTOR

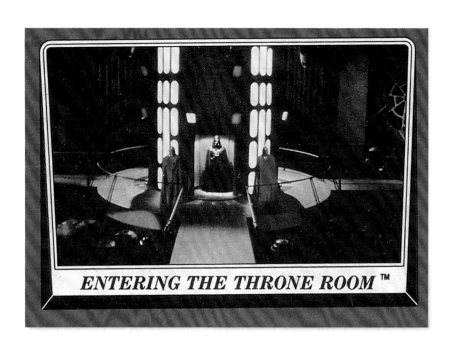

ENTERING THE THRONE ROOM ™

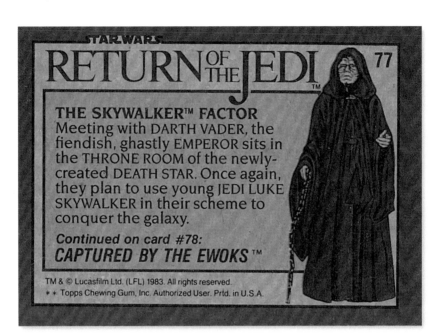

RETURN OF THE JEDI ™

77

THE SKYWALKER™ FACTOR

Meeting with DARTH VADER, the fiendish, ghastly EMPEROR sits in the THRONE ROOM of the newly-created DEATH STAR. Once again, they plan to use young JEDI LUKE SKYWALKER in their scheme to conquer the galaxy.

Continued on card #78:
CAPTURED BY THE EWOKS ™

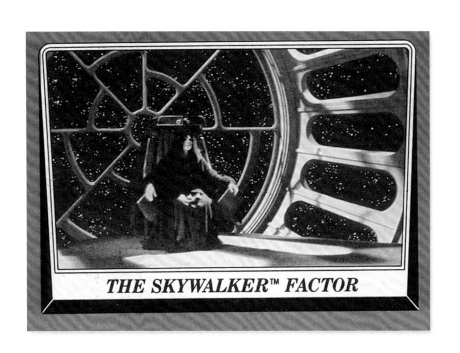

THE SKYWALKER™ FACTOR

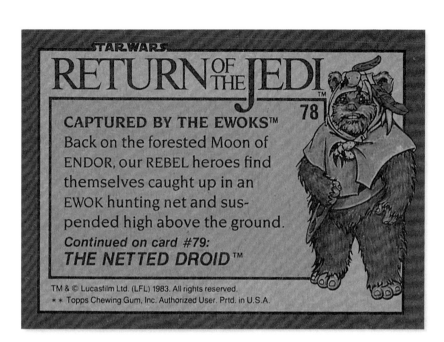

STAR WARS

RETURN OF THE JEDI

78

CAPTURED BY THE EWOKS™
Back on the forested Moon of
ENDOR, our REBEL heroes find
themselves caught up in an
EWOK hunting net and sus-
pended high above the ground.
Continued on card #79:
THE NETTED DROID™

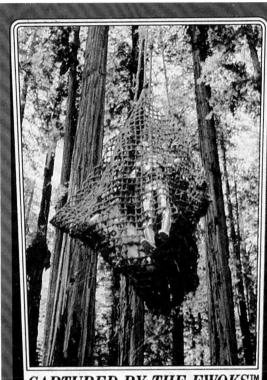

CAPTURED BY THE EWOKS™

RETURN OF THE JEDI

79

THE NETTED DROID™

SEE-THREEPIO, worried as usual, peers through the holes of an EWOK hunting net after he and his REBEL allies are captured by the forest creatures on the Moon of ENDOR.

Continued on card #80:
ALL HAIL SEE-THREEPIO ™!

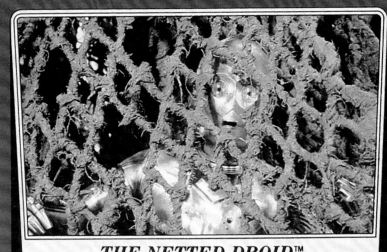

THE NETTED DROID™

STAR WARS

RETURN OF THE JEDI ™

80

ALL HAIL SEE-THREEPIO!™
Much to his great surprise,
SEE-THREEPIO is hailed as a god
by the EWOKS. Here, he finds
himself surrounded by dozens
of eager worshippers...
something HAN SOLO can't
quite believe!
Continued on card #81:
ROYAL TREATMENT

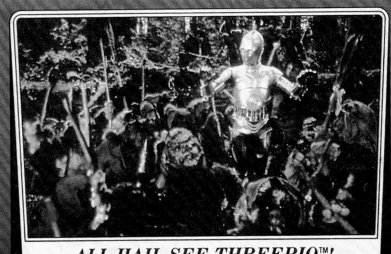

ALL HAIL SEE-THREEPIO™!

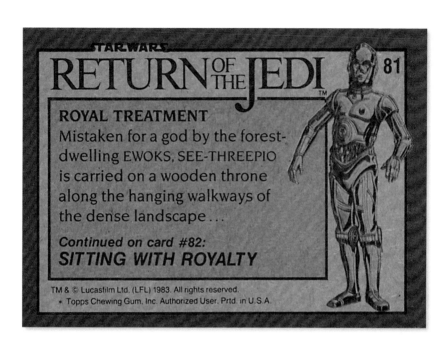

STAR WARS

RETURN OF THE JEDI

81

ROYAL TREATMENT

Mistaken for a god by the forest-dwelling EWOKS, SEE-THREEPIO is carried on a wooden throne along the hanging walkways of the dense landscape...

Continued on card #82:
SITTING WITH ROYALTY

ROYAL TREATMENT

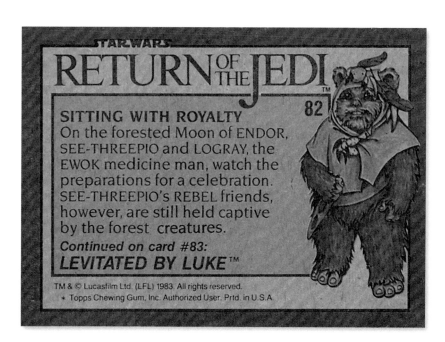

STAR WARS

RETURN OF THE JEDI™

82

SITTING WITH ROYALTY

On the forested Moon of ENDOR, SEE-THREEPIO and LOGRAY, the EWOK medicine man, watch the preparations for a celebration. SEE-THREEPIO's REBEL friends, however, are still held captive by the forest creatures.

Continued on card #83:
LEVITATED BY LUKE™

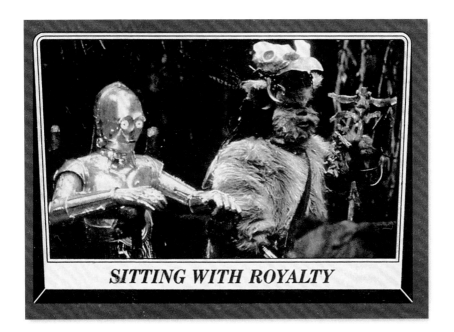

SITTING WITH ROYALTY

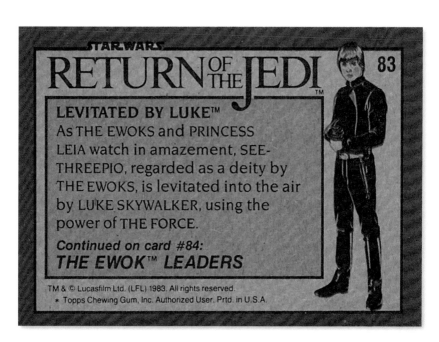

★STAR WARS★

RETURN OF THE JEDI

83

LEVITATED BY LUKE™
As THE EWOKS and PRINCESS LEIA watch in amazement, SEE-THREEPIO, regarded as a deity by THE EWOKS, is levitated into the air by LUKE SKYWALKER, using the power of THE FORCE.

Continued on card #84:
THE EWOK™ LEADERS

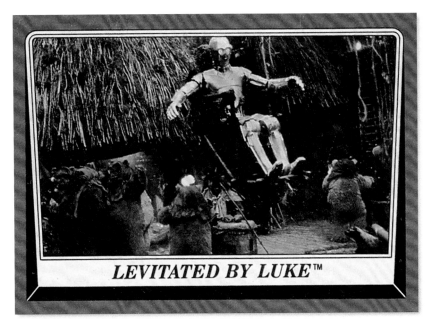

LEVITATED BY LUKE™

The usually disrespected and ignored C-3PO is finally treated with great reverence . . . he's a gleaming god to the primitive Ewoks, especially after being levitated by Luke Skywalker, now a full-fledged Jedi in command of the Force.

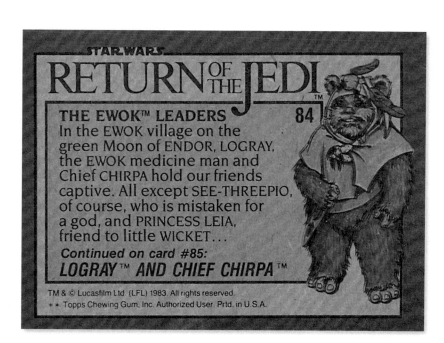

STAR WARS

RETURN OF THE JEDI™

THE EWOK™ LEADERS 84

In the EWOK village on the green Moon of ENDOR, LOGRAY, the EWOK medicine man and Chief CHIRPA hold our friends captive. All except SEE-THREEPIO, of course, who is mistaken for a god, and PRINCESS LEIA, friend to little WICKET…

Continued on card #85:
LOGRAY™ AND CHIEF CHIRPA™

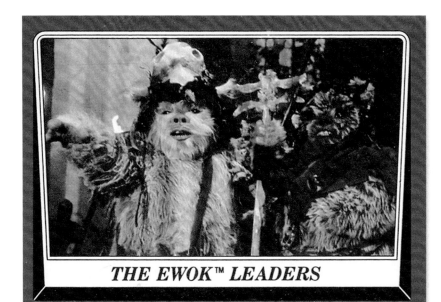

THE EWOK™ LEADERS

STAR WARS

RETURN OF THE JEDI ™

LOGRAY™ AND CHIEF CHIRPA™

85

Another view of LOGRAY, the EWOK medicine man; behind him is CHIEF CHIRPA. C-3PO, of course, arrived at the EWOK village in triumphal procession, while his friends were treated as simple trespassers.

Continued on card #86:
HELP FROM PRINCESS LEIA ™

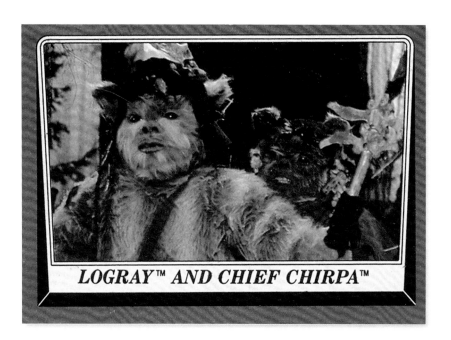

LOGRAY™ AND CHIEF CHIRPA™

STAR WARS.

RETURN OF THE JEDI

86

™

HELP FROM PRINCESS LEIA™
On the Moon of ENDOR, PRINCESS LEIA, believed missing but actually cared for by WICKET and the EWOKS, tries to intercede on behalf of her captured friends.

Continued on card #87:
WILL HAN SOLO™ BE DINNER?

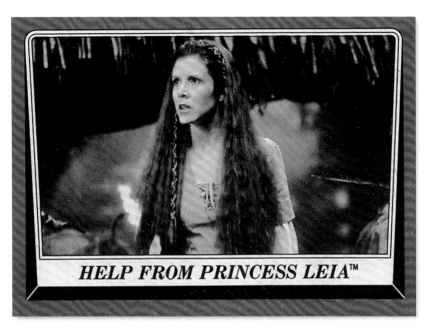

HELP FROM PRINCESS LEIA™

Princess Leia looks quite lovely in her forest outfit. We had a line drawing to match, printed on the card back.

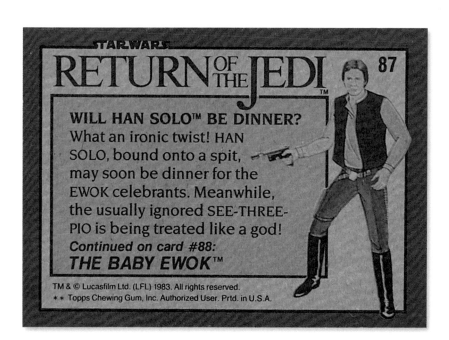

RETURN OF THE JEDI™

87

WILL HAN SOLO™ BE DINNER?

What an ironic twist! HAN SOLO, bound onto a spit, may soon be dinner for the EWOK celebrants. Meanwhile, the usually ignored SEE-THREE-PIO is being treated like a god!
Continued on card #88:
THE BABY EWOK™

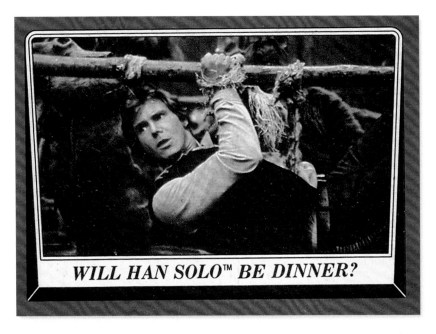

WILL HAN SOLO™ BE DINNER?

A funny shot of Han about to be barbecued. Actor Harrison Ford contributed some of his most memorable "mug" responses in his dealings with the Ewoks.

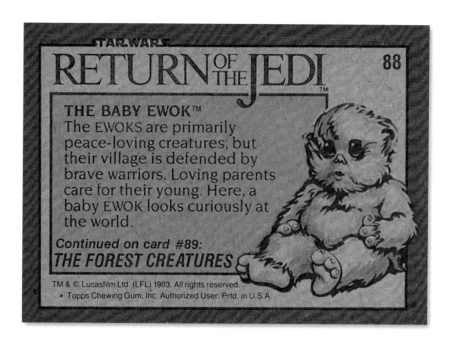

STAR.WARS

RETURN OF THE JEDI

88

THE BABY EWOK™
The EWOKS are primarily peace-loving creatures, but their village is defended by brave warriors. Loving parents care for their young. Here, a baby EWOK looks curiously at the world.

Continued on card #89:
THE FOREST CREATURES

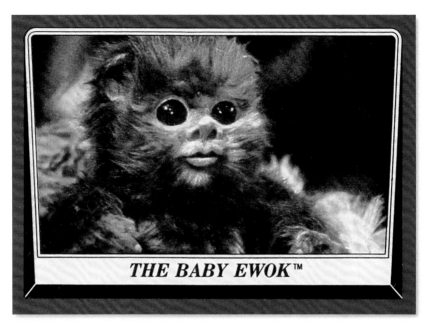

THE BABY EWOK™

Here's the shot of the infant Ewok that so delighted Abe Morgenstern, the product manager at Topps. Lucasfilm even provided us with a corresponding line rendering for this pint-sized scene stealer.

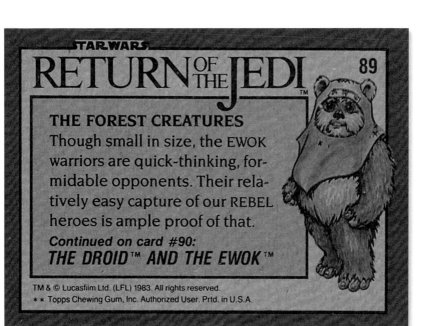

STAR WARS

RETURN OF THE JEDI

89

THE FOREST CREATURES

Though small in size, the EWOK warriors are quick-thinking, formidable opponents. Their relatively easy capture of our REBEL heroes is ample proof of that.

Continued on card #90:
THE DROID™ AND THE EWOK™

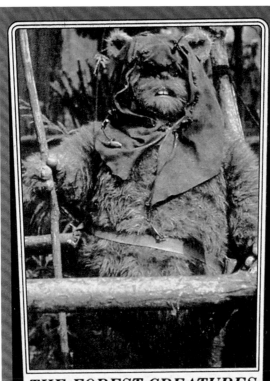

THE FOREST CREATURES

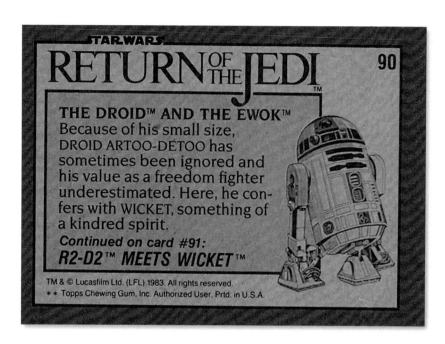

STAR WARS

RETURN OF THE JEDI

90

™

THE DROID™ AND THE EWOK™
Because of his small size,
DROID ARTOO-DETOO has
sometimes been ignored and
his value as a freedom fighter
underestimated. Here, he con-
fers with WICKET, something of
a kindred spirit.
Continued on card #91:
R2-D2™ MEETS WICKET™

TM & © Lucasfilm Ltd. (LFL) 1983. All rights reserved.
＊＊ Topps Chewing Gum, Inc. Authorized User. Prtd. in U.S.A.

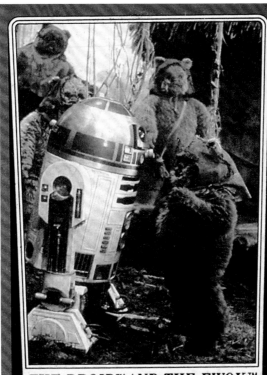

THE DROID™ AND THE EWOK™

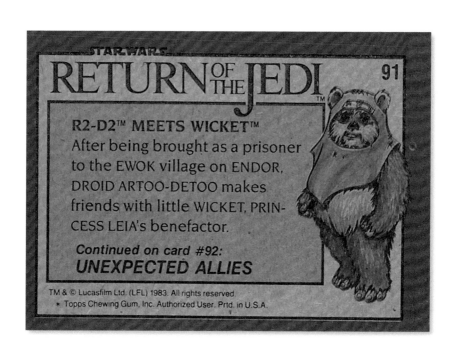

STAR WARS

RETURN OF THE JEDI

91

™

R2-D2™ MEETS WICKET™

After being brought as a prisoner to the EWOK village on ENDOR, DROID ARTOO-DETOO makes friends with little WICKET, PRINCESS LEIA's benefactor.

Continued on card #92:
UNEXPECTED ALLIES

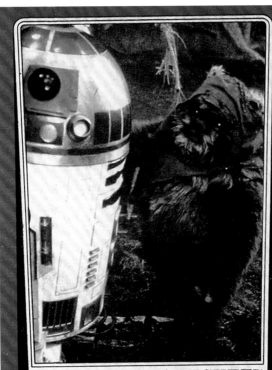

R2-D2™ MEETS WICKET™

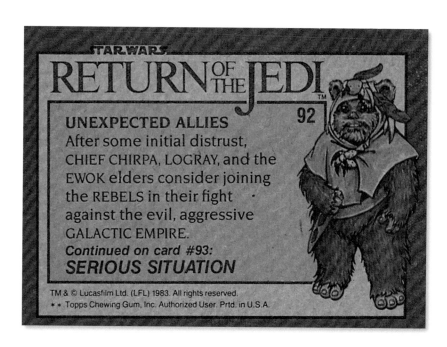

STAR.WARS

RETURN OF THE JEDI™

UNEXPECTED ALLIES

92

After some initial distrust, CHIEF CHIRPA, LOGRAY, and the EWOK elders consider joining the REBELS in their fight against the evil, aggressive GALACTIC EMPIRE.
Continued on card #93:
SERIOUS SITUATION

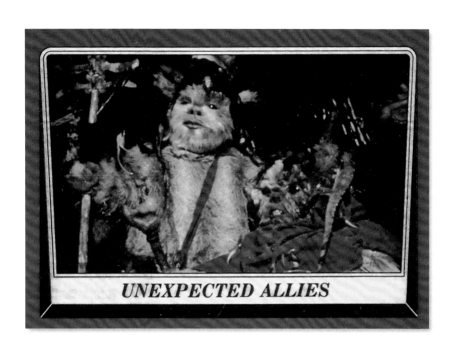

UNEXPECTED ALLIES

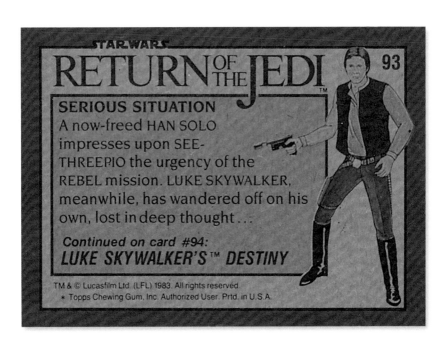

STAR WARS
RETURN OF THE JEDI

93

SERIOUS SITUATION
A now-freed HAN SOLO impresses upon SEE-THREEPIO the urgency of the REBEL mission. LUKE SKYWALKER, meanwhile, has wandered off on his own, lost in deep thought …

Continued on card #94:
LUKE SKYWALKER'S™ DESTINY

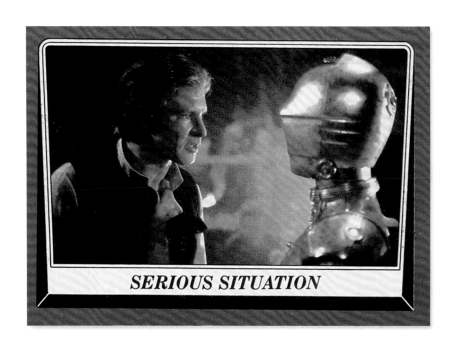

SERIOUS SITUATION

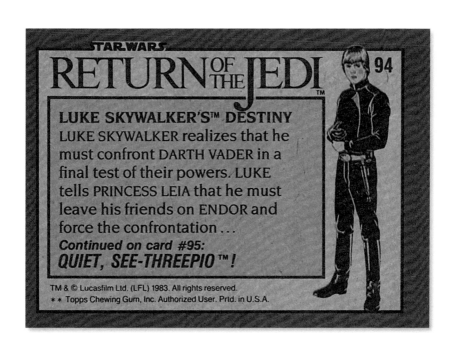

STAR.WARS

RETURN OF THE JEDI

94

LUKE SKYWALKER'S™ DESTINY
LUKE SKYWALKER realizes that he must confront DARTH VADER in a final test of their powers. LUKE tells PRINCESS LEIA that he must leave his friends on ENDOR and force the confrontation . . .
Continued on card #95:
QUIET, SEE-THREEPIO™!

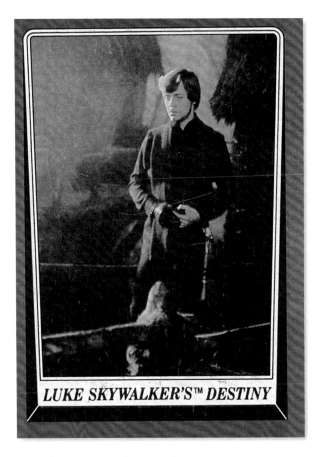

LUKE SKYWALKER'S™ DESTINY

Return of the Jedi introduced a more confident Luke Skywalker, now a young Jedi with much to deal with—his relationships with both Leia and Darth Vader taking curious turns.

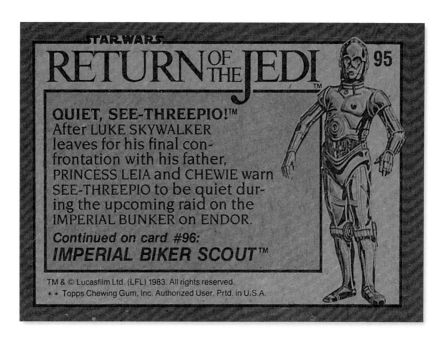

STAR WARS

RETURN OF THE JEDI™

95

QUIET, SEE-THREEPIO!™
After LUKE SKYWALKER
leaves for his final con-
frontation with his father,
PRINCESS LEIA and CHEWIE warn
SEE-THREEPIO to be quiet dur-
ing the upcoming raid on the
IMPERIAL BUNKER on ENDOR.

Continued on card #96:
IMPERIAL BIKER SCOUT™

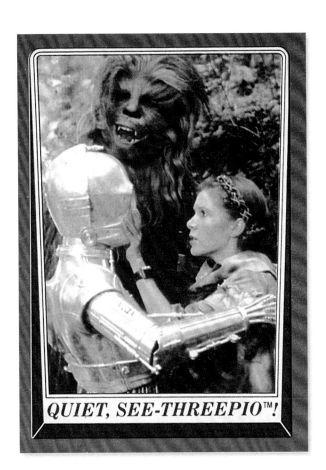

QUIET, SEE-THREEPIO™!

STAR WARS
RETURN OF THE JEDI

96

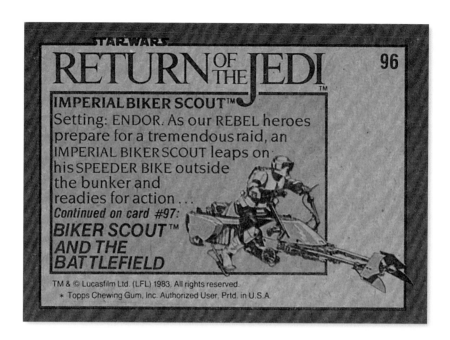

IMPERIAL BIKER SCOUT™
Setting: ENDOR. As our REBEL heroes
prepare for a tremendous raid, an
IMPERIAL BIKER SCOUT leaps on
his SPEEDER BIKE outside
the bunker and
readies for action ...
Continued on card #97:
BIKER SCOUT™
AND THE
BATTLEFIELD

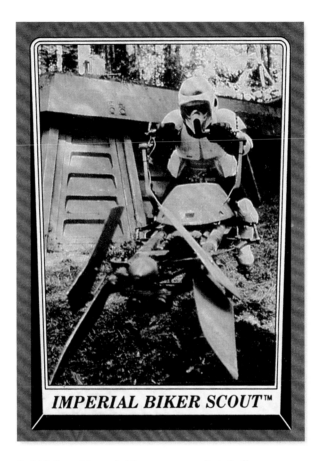

IMPERIAL BIKER SCOUT™

A mistake here—this speeder bike scene occurs earlier in the film.

RETURN OF THE JEDI

97

BIKER SCOUT™ AND THE BATTLEFIELD

The beautiful and magnificent forest of ENDOR is about to become a battlefield as an IMPERIAL BIKER SCOUT prepares to speed away and the REBEL freedom fighters launch their daring raid...

Continued on card #98:
HAN SOLO'S™ APPROACH

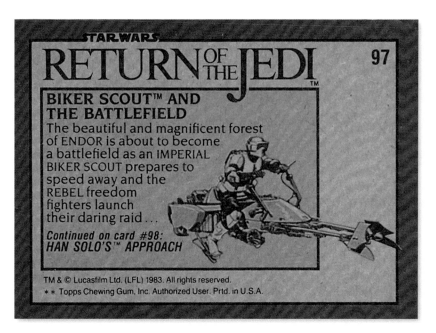

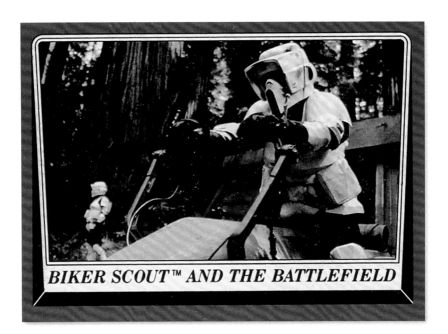

BIKER SCOUT™ AND THE BATTLEFIELD

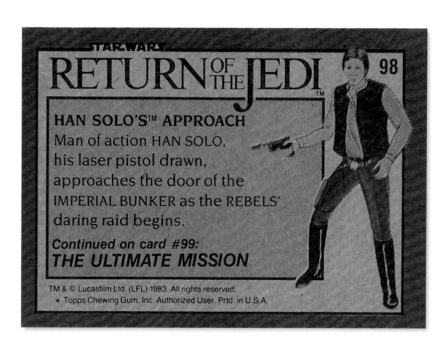

STAR WARS

RETURN OF THE JEDI

98

HAN SOLO'S™ APPROACH
Man of action HAN SOLO,
his laser pistol drawn,
approaches the door of the
IMPERIAL BUNKER as the REBELS'
daring raid begins.

Continued on card #99:
THE ULTIMATE MISSION

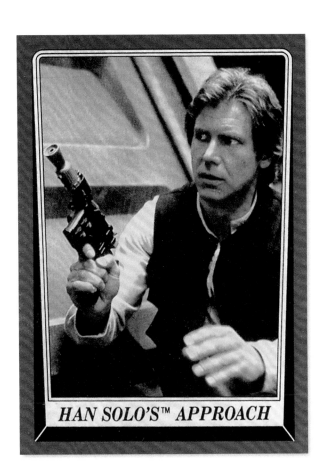

HAN SOLO'S™ APPROACH

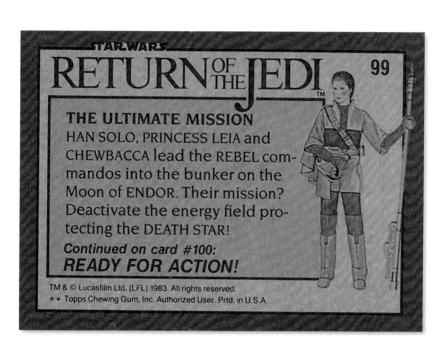

RETURN OF THE JEDI

99

™

THE ULTIMATE MISSION
HAN SOLO, PRINCESS LEIA and
CHEWBACCA lead the REBEL com-
mandos into the bunker on the
Moon of ENDOR. Their mission?
Deactivate the energy field pro-
tecting the DEATH STAR!
Continued on card #100:
READY FOR ACTION!

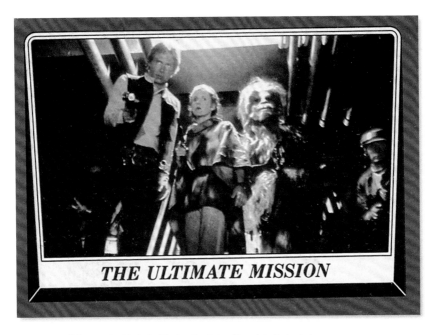

THE ULTIMATE MISSION

There's a lot of character in this shot of the heroic rebels midway into their mission.

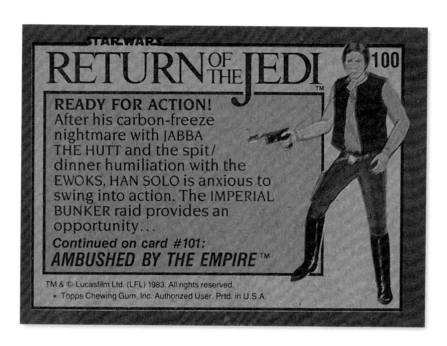

STAR WARS

RETURN OF THE JEDI 100

READY FOR ACTION!
After his carbon-freeze
nightmare with JABBA
THE HUTT and the spit/
dinner humiliation with the
EWOKS, HAN SOLO is anxious to
swing into action. The IMPERIAL
BUNKER raid provides an
opportunity...

Continued on card #101:
AMBUSHED BY THE EMPIRE™

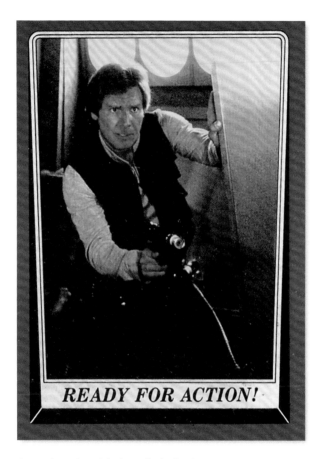

READY FOR ACTION!

A great photo of Han Solo doing what he does best!

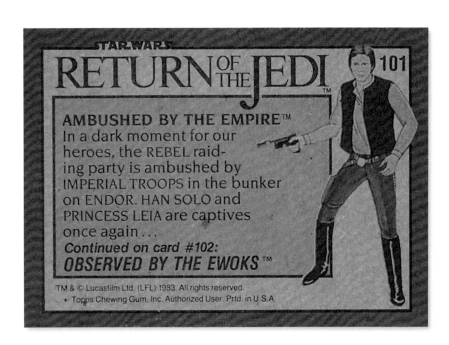

STAR.WARS

RETURN OF THE JEDI™ 101

AMBUSHED BY THE EMPIRE™
In a dark moment for our
heroes, the REBEL raid-
ing party is ambushed by
IMPERIAL TROOPS in the bunker
on ENDOR. HAN SOLO and
PRINCESS LEIA are captives
once again . . .
Continued on card #102:
OBSERVED BY THE EWOKS™

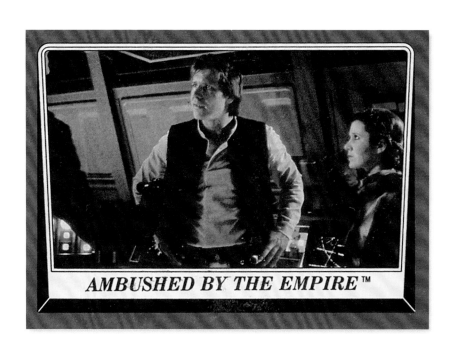

AMBUSHED BY THE EMPIRE™

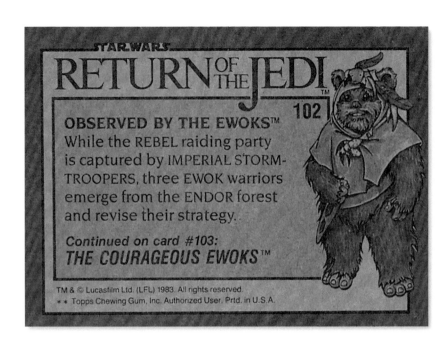

STAR WARS

RETURN OF THE JEDI

102

OBSERVED BY THE EWOKS™
While the REBEL raiding party
is captured by IMPERIAL STORM-
TROOPERS, three EWOK warriors
emerge from the ENDOR forest
and revise their strategy.

Continued on card #103:
THE COURAGEOUS EWOKS™

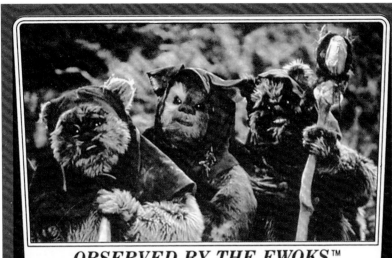

OBSERVED BY THE EWOKS™

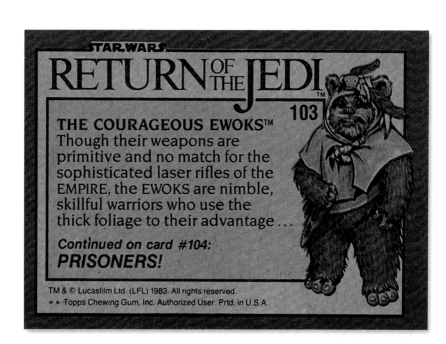

STAR WARS

RETURN OF THE JEDI

™

103

THE COURAGEOUS EWOKS™
Though their weapons are
primitive and no match for the
sophisticated laser rifles of the
EMPIRE, the EWOKS are nimble,
skillful warriors who use the
thick foliage to their advantage...

Continued on card #104:
PRISONERS!

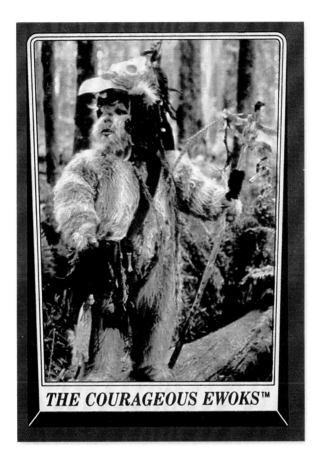

THE COURAGEOUS EWOKS™

A nice vertical study of an Ewok. Lucasfilm clearly believed in the potential of these childlike primitives, using them again in TV movies and an animated series.

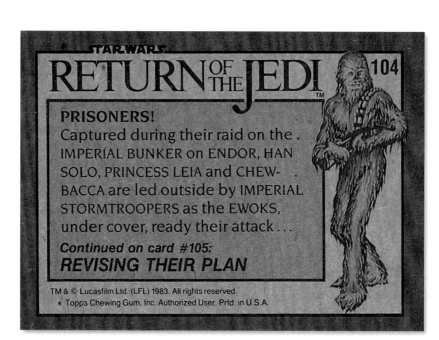

STAR WARS

RETURN OF THE JEDI

104

PRISONERS!
Captured during their raid on the
IMPERIAL BUNKER on ENDOR, HAN
SOLO, PRINCESS LEIA and CHEW-
BACCA are led outside by IMPERIAL
STORMTROOPERS as the EWOKS,
under cover, ready their attack...

Continued on card #105:
REVISING THEIR PLAN

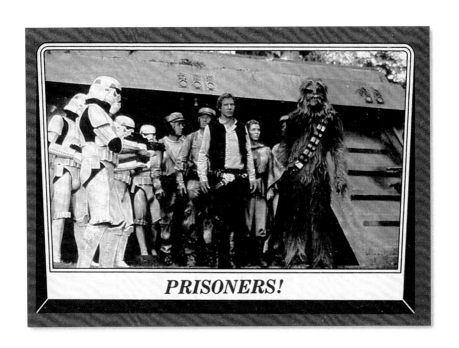

PRISONERS!

STAR WARS

RETURN OF THE JEDI

105

REVISING THEIR PLAN
Outnumbered by soldiers
of the EMPIRE, our REBEL
heroes ponder their next
move as they are led out of the
IMPERIAL BUNKER into the forest
of ENDOR.
Continued on card #106:
AT-ST (ALL TERRAIN
SCOUT TRANSPORT)™

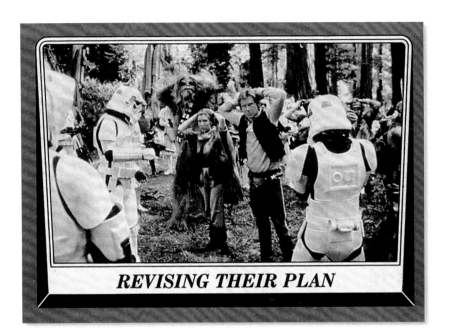

REVISING THEIR PLAN

STAR WARS

RETURN OF THE JEDI ™

AT-ST (ALL TERRAIN SCOUT TRANSPORT)™ **106**
A squad of IMPERIAL STORM-
TROOPERS fans out along the for-
est floor on the Moon of ENDOR. An
AT-ST (ALL TERRAIN SCOUT TRANSPORT),
equipped with turnstile guns and
laser cannons, protects their relent-
less search for the REBELS and their
allies... *Continued on card #107:*
THE FOREST FIGHTERS!

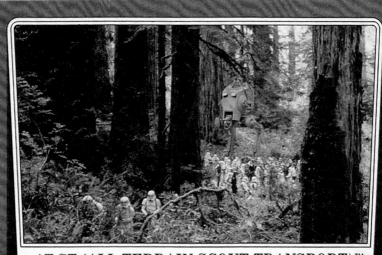

AT-ST (ALL TERRAIN SCOUT TRANSPORT) ™

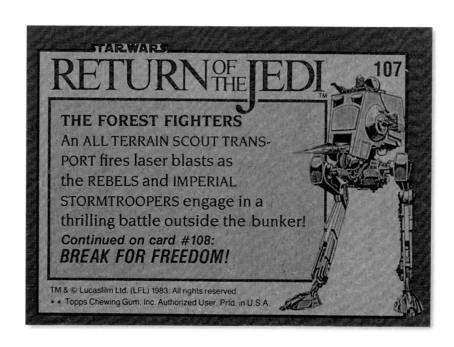

STAR WARS

RETURN OF THE JEDI

107

THE FOREST FIGHTERS

An ALL TERRAIN SCOUT TRANS-
PORT fires laser blasts as
the REBELS and IMPERIAL
STORMTROOPERS engage in a
thrilling battle outside the bunker!
Continued on card #108:
BREAK FOR FREEDOM!

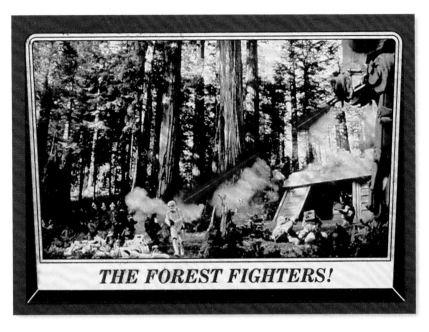

THE FOREST FIGHTERS!

More airbrushed magic from Lucasfilm as the All Terrain Scout Transport (AT-ST) bears down on courageous rebels.

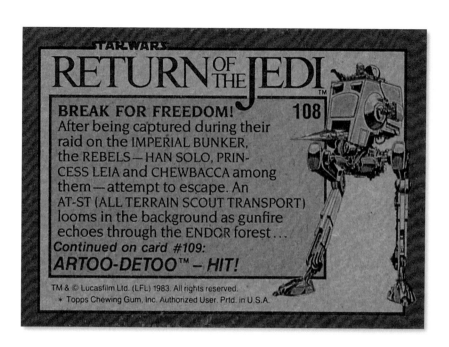

BREAK FOR FREEDOM! 108

After being captured during their raid on the IMPERIAL BUNKER, the REBELS—HAN SOLO, PRINCESS LEIA and CHEWBACCA among them—attempt to escape. An AT-ST (ALL TERRAIN SCOUT TRANSPORT) looms in the background as gunfire echoes through the ENDOR forest...

Continued on card #109:

ARTOO-DETOO™ – HIT!

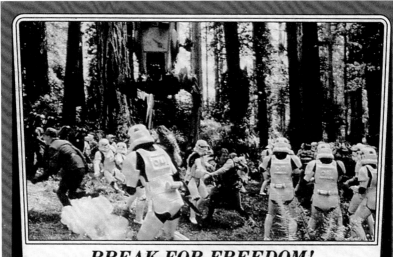

BREAK FOR FREEDOM!

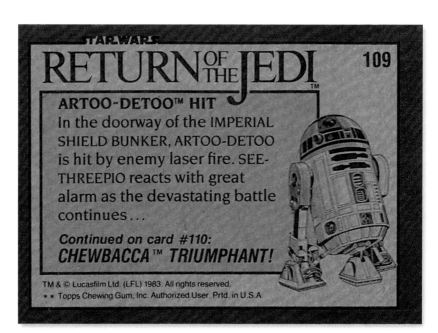

STAR WARS

RETURN OF THE JEDI

109

ARTOO-DETOO™ HIT
In the doorway of the IMPERIAL SHIELD BUNKER, ARTOO-DETOO is hit by enemy laser fire. SEE-THREEPIO reacts with great alarm as the devastating battle continues...

Continued on card #110:
CHEWBACCA™ TRIUMPHANT!

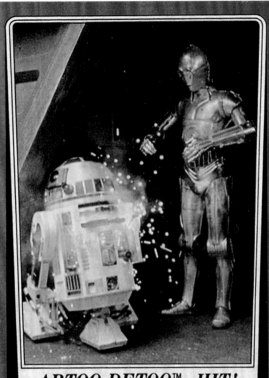

ARTOO-DETOO™—HIT!

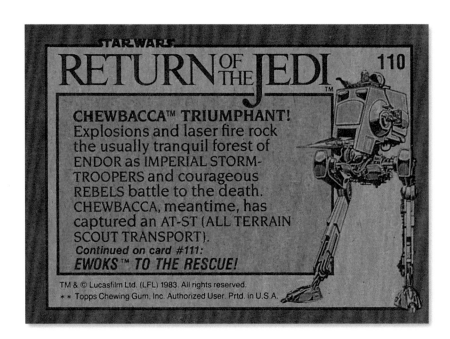

RETURN OF THE JEDI

110

CHEWBACCA™ TRIUMPHANT!
Explosions and laser fire rock
the usually tranquil forest of
ENDOR as IMPERIAL STORM-
TROOPERS and courageous
REBELS battle to the death.
CHEWBACCA, meantime, has
captured an AT-ST (ALL TERRAIN
SCOUT TRANSPORT).
Continued on card #111:
EWOKS™ TO THE RESCUE!

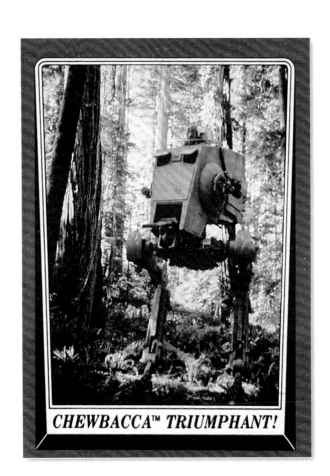

CHEWBACCA™ TRIUMPHANT!

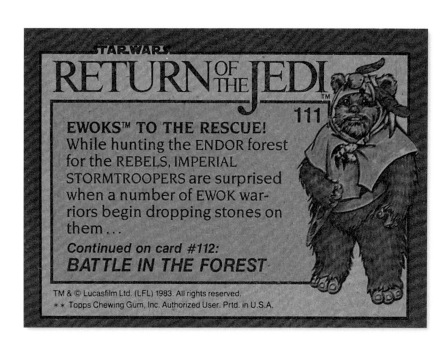

STAR WARS

RETURN OF THE JEDI™

111

EWOKS™ TO THE RESCUE!
While hunting the ENDOR forest
for the REBELS, IMPERIAL
STORMTROOPERS are surprised
when a number of EWOK war-
riors begin dropping stones on
them...
Continued on card #112:
BATTLE IN THE FOREST

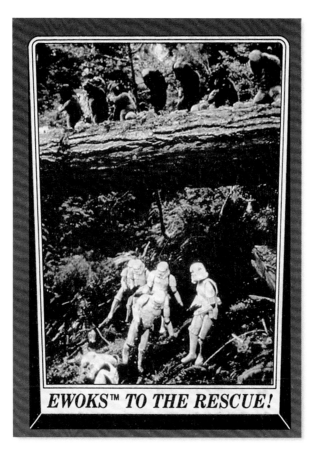

EWOKS™ TO THE RESCUE!

This appropriate vertical shot does justice to the Ewoks' stone attack on Imperial troops from above.

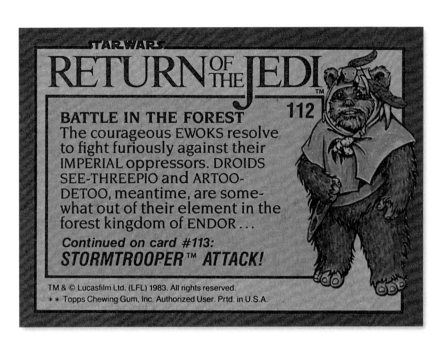

STAR WARS

RETURN OF THE JEDI™

112

BATTLE IN THE FOREST
The courageous EWOKS resolve to fight furiously against their IMPERIAL oppressors. DROIDS SEE-THREEPIO and ARTOO-DETOO, meantime, are some-what out of their element in the forest kingdom of ENDOR...

Continued on card #113:
STORMTROOPER™ ATTACK!

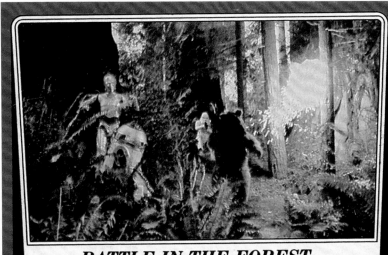

BATTLE IN THE FOREST

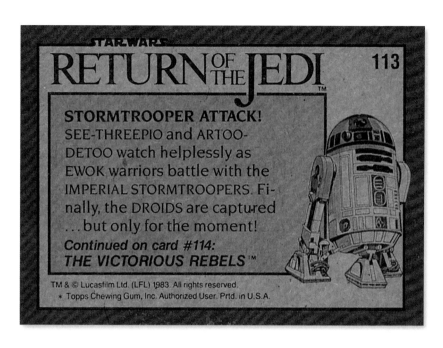

STAR WARS
RETURN OF THE JEDI

113

STORMTROOPER ATTACK!
SEE-THREEPIO and ARTOO-DETOO watch helplessly as EWOK warriors battle with the IMPERIAL STORMTROOPERS. Finally, the DROIDS are captured ...but only for the moment!

Continued on card #114:
THE VICTORIOUS REBELS™

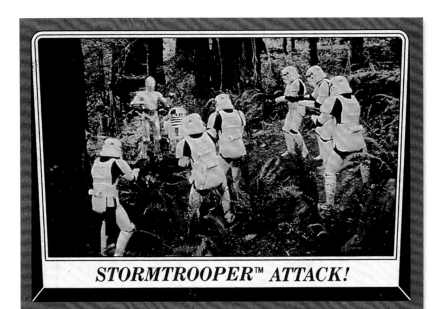

STORMTROOPER™ ATTACK!

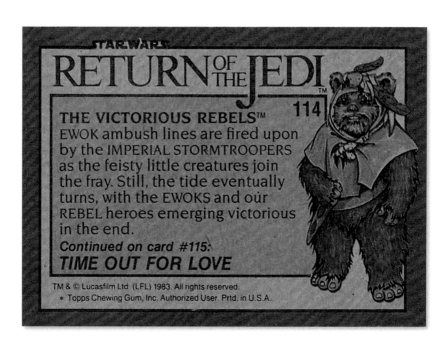

STAR WARS

RETURN OF THE JEDI™

THE VICTORIOUS REBELS™ **114**
EWOK ambush lines are fired upon
by the IMPERIAL STORMTROOPERS
as the feisty little creatures join
the fray. Still, the tide eventually
turns, with the EWOKS and our
REBEL heroes emerging victorious
in the end.

Continued on card #115:
TIME OUT FOR LOVE

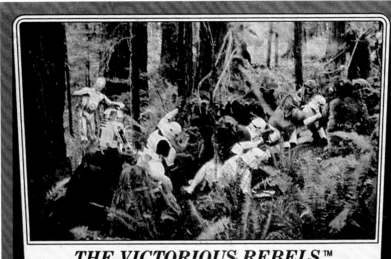

THE VICTORIOUS REBELS™

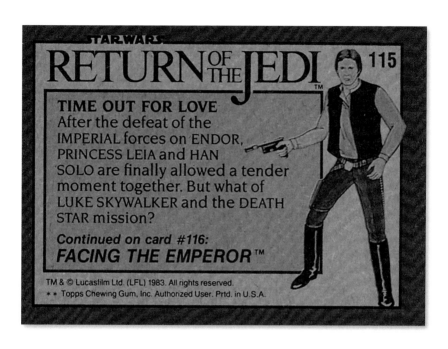

STAR WARS
RETURN OF THE JEDI™

115

TIME OUT FOR LOVE
After the defeat of the
IMPERIAL forces on ENDOR,
PRINCESS LEIA and HAN
SOLO are finally allowed a tender
moment together. But what of
LUKE SKYWALKER and the DEATH
STAR mission?

Continued on card #116:
FACING THE EMPEROR™

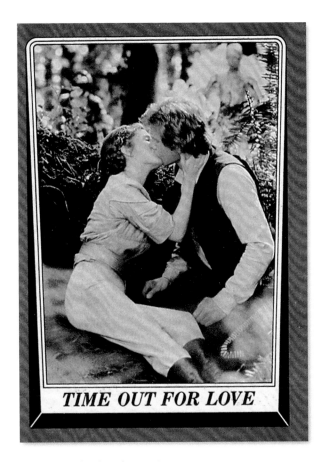

TIME OUT FOR LOVE

Nice. But I wonder what Luke's up to?

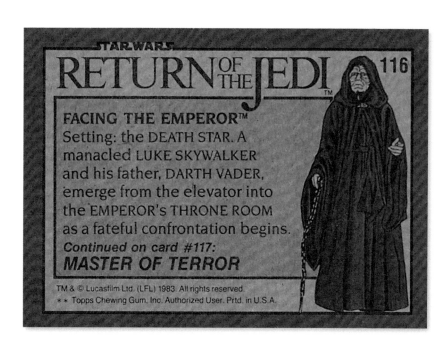

STAR WARS

RETURN OF THE JEDI

116

FACING THE EMPEROR™
Setting: the DEATH STAR. A manacled LUKE SKYWALKER and his father, DARTH VADER, emerge from the elevator into the EMPEROR's THRONE ROOM as a fateful confrontation begins.
Continued on card #117:
MASTER OF TERROR

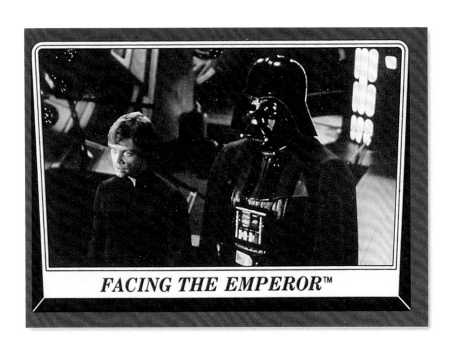

FACING THE EMPEROR™

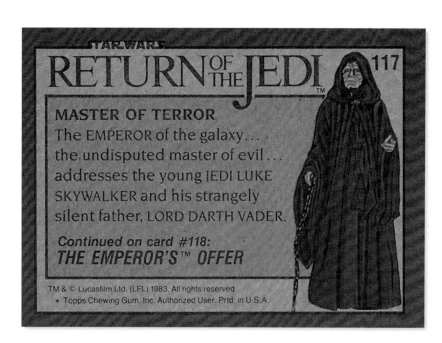

STAR WARS

RETURN OF THE JEDI

117

MASTER OF TERROR
The EMPEROR of the galaxy…
the undisputed master of evil …
addresses the young JEDI LUKE
SKYWALKER and his strangely
silent father, LORD DARTH VADER.

Continued on card #118:
THE EMPEROR'S™ OFFER

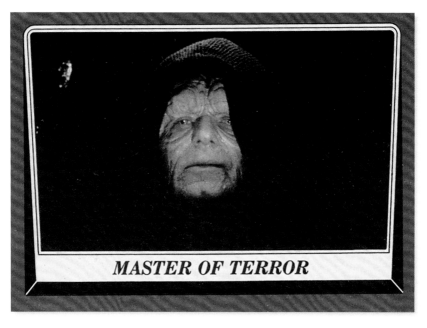

MASTER OF TERROR

An eerie, effective close-up of the misshapen Emperor. (The origin of his deformity at the hands of Mace Windu would be dramatized years later in *Star Wars*: Episode III *Revenge of the Sith*.)

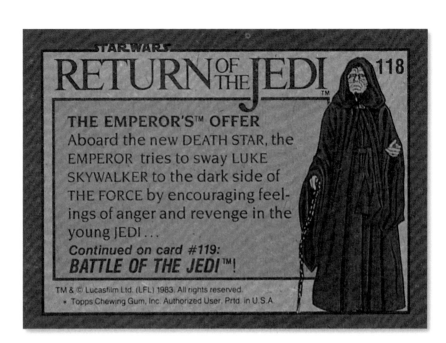

STAR WARS

RETURN OF THE JEDI 118

THE EMPEROR'S™ OFFER
Aboard the new DEATH STAR, the
EMPEROR tries to sway LUKE
SKYWALKER to the dark side of
THE FORCE by encouraging feel-
ings of anger and revenge in the
young JEDI . . .
Continued on card #119:
BATTLE OF THE JEDI™!

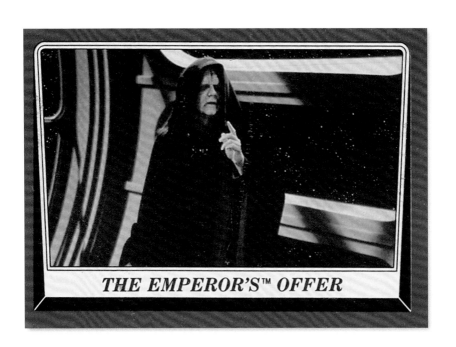

THE EMPEROR'S™ OFFER

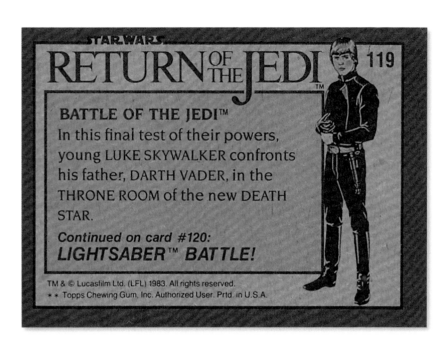

STAR WARS

RETURN OF THE JEDI™

119

BATTLE OF THE JEDI™
In this final test of their powers, young LUKE SKYWALKER confronts his father, DARTH VADER, in the THRONE ROOM of the new DEATH STAR.

Continued on card #120:
LIGHTSABER™ *BATTLE!*

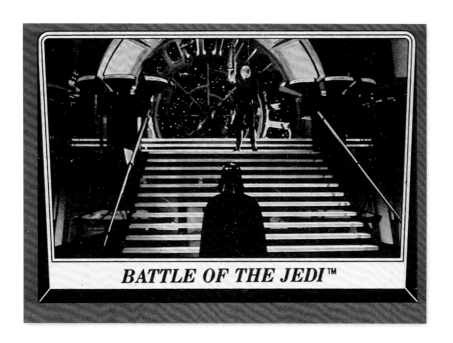

BATTLE OF THE JEDI™

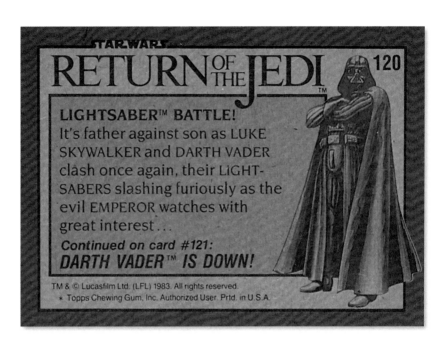

STAR WARS

RETURN OF THE JEDI 120

LIGHTSABER™ BATTLE!
It's father against son as LUKE
SKYWALKER and DARTH VADER
clash once again, their LIGHT-
SABERS slashing furiously as the
evil EMPEROR watches with
great interest...
Continued on card #121:
DARTH VADER™ IS DOWN!

TM & © Lucasfilm Ltd. (LFL) 1983. All rights reserved.
★ Topps Chewing Gum, Inc. Authorized User. Prtd. in U.S.A.

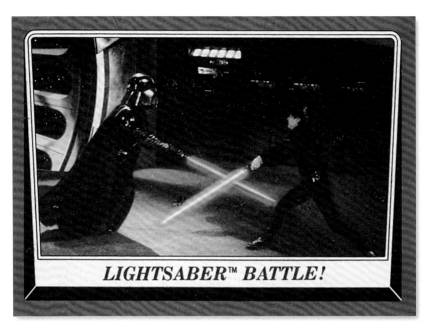

LIGHTSABER™ BATTLE!

Here's a beautiful shot of the principals in action, made slightly unreal by the airbrushed lightsabers.

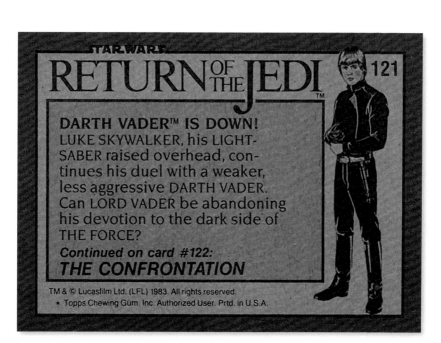

STAR WARS

RETURN OF THE JEDI

121

DARTH VADER™ IS DOWN!
LUKE SKYWALKER, his LIGHT-
SABER raised overhead, con-
tinues his duel with a weaker,
less aggressive DARTH VADER.
Can LORD VADER be abandoning
his devotion to the dark side of
THE FORCE?
Continued on card #122:
THE CONFRONTATION

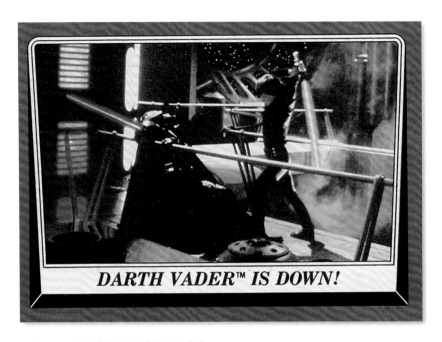

DARTH VADER™ IS DOWN!

Another great shot of this intense father-son duel.

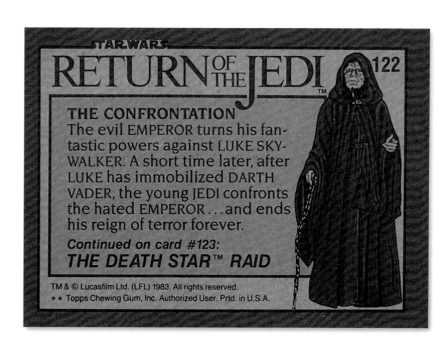

STAR WARS

RETURN OF THE JEDI 122

THE CONFRONTATION
The evil EMPEROR turns his fantastic powers against LUKE SKYWALKER. A short time later, after LUKE has immobilized DARTH VADER, the young JEDI confronts the hated EMPEROR...and ends his reign of terror forever.

Continued on card #123:
THE DEATH STAR™ RAID

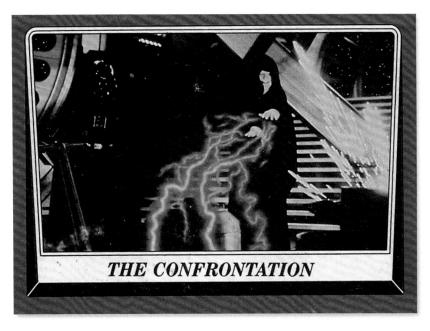

THE CONFRONTATION

A dramatic view of the Emperor's Force lightning onslaught, with Darth Vader beginning to have second thoughts about his son's imminent demise.

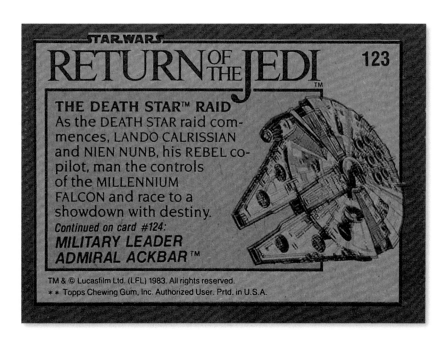

STAR.WARS.

RETURN OF THE JEDI

123

THE DEATH STAR™ RAID
As the DEATH STAR raid commences, LANDO CALRISSIAN and NIEN NUNB, his REBEL co-pilot, man the controls of the MILLENNIUM FALCON and race to a showdown with destiny.
Continued on card #124:
MILITARY LEADER
***ADMIRAL ACKBAR*™**

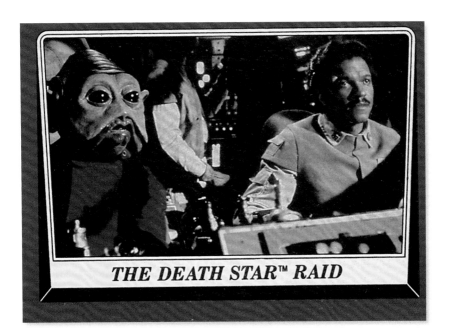

THE DEATH STAR™ RAID

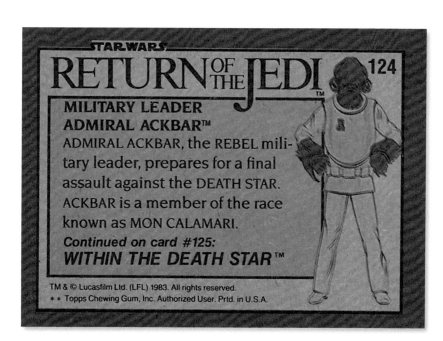

STAR WARS

RETURN OF THE JEDI™ 124

**MILITARY LEADER
ADMIRAL ACKBAR™**

ADMIRAL ACKBAR, the REBEL military leader, prepares for a final assault against the DEATH STAR. ACKBAR is a member of the race known as MON CALAMARI.

Continued on card #125:
WITHIN THE DEATH STAR™

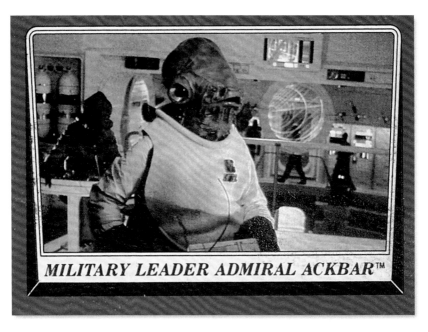

MILITARY LEADER ADMIRAL ACKBAR™

I always thought seasoned, no-nonsense Admiral Ackbar might have been inspired by Winston Churchill (he wasn't). Regardless, Ackbar certainly looks good on film and in our trading cards.

STAR WARS

RETURN OF THE JEDI

125

WITHIN THE DEATH STAR™

Deep inside the DEATH STAR, the
MILLENNIUM FALCON races to com-
plete the REBEL's attack plan. Mean-
while, LUKE SKYWALKER helps his
father, mortally wounded, out of
the THRONE ROOM. As his life
ends, DARTH VADER forsakes the
dark side of THE FORCE and is
reunited with his son.

Continued on card #126:
VICTORY CELEBRATION!

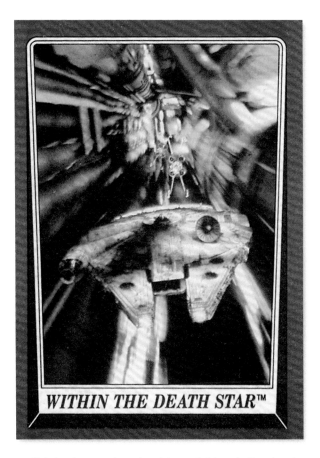

WITHIN THE DEATH STAR™

I stuffed a lot of text into this card. And the wonderful visual-effects shot of the *Millennium Falcon* inside the Death Star could be presented vertically or horizontally.

RETURN OF THE JEDI

126

VICTORY CELEBRATION!

The DEATH STAR has been destroyed! Many of the victorious REBELS join the EWOKS and the DROIDS in celebrating their spectacular victory over the IMPERIAL FORCES.

Continued on card #127:
***CONGRATULATING WEDGE*™**

VICTORY CELEBRATION!

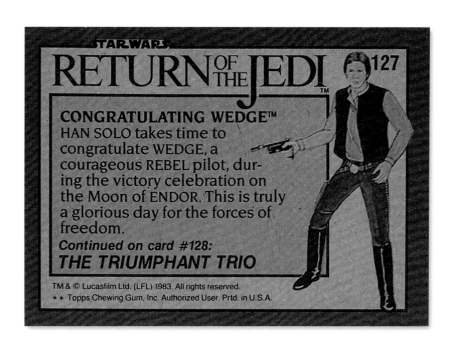

STAR WARS

RETURN OF THE JEDI 127

CONGRATULATING WEDGE™
HAN SOLO takes time to congratulate WEDGE, a courageous REBEL pilot, during the victory celebration on the Moon of ENDOR. This is truly a glorious day for the forces of freedom.
Continued on card #128:
THE TRIUMPHANT TRIO

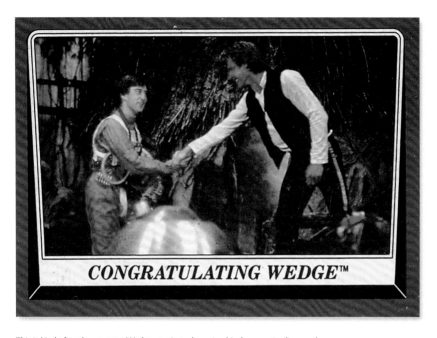

CONGRATULATING WEDGE™

This is kind of cool—we gave Wedge, a minor character, his due on a trading card.

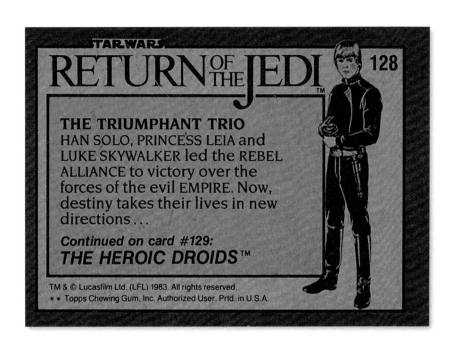

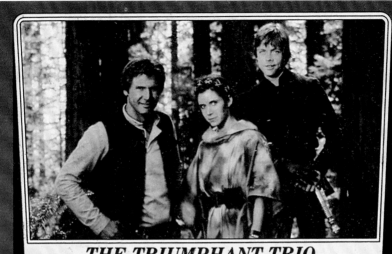

THE TRIUMPHANT TRIO

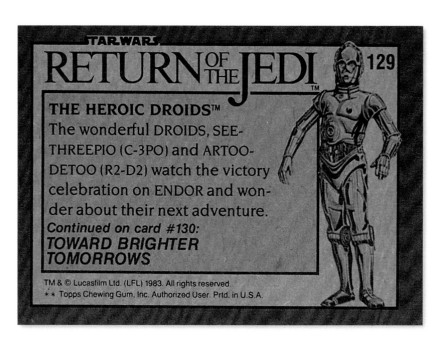

★STAR.WARS,

RETURN OF THE JEDI ™

129

THE HEROIC DROIDS™
The wonderful DROIDS, SEE-
THREEPIO (C-3PO) and ARTOO-
DETOO (R2-D2) watch the victory
celebration on ENDOR and won-
der about their next adventure.
Continued on card #130:
TOWARD BRIGHTER
TOMORROWS

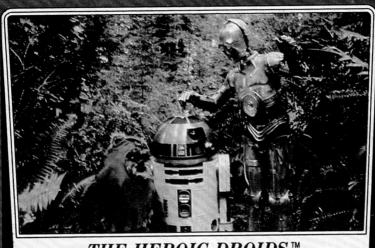

THE HEROIC DROIDS™

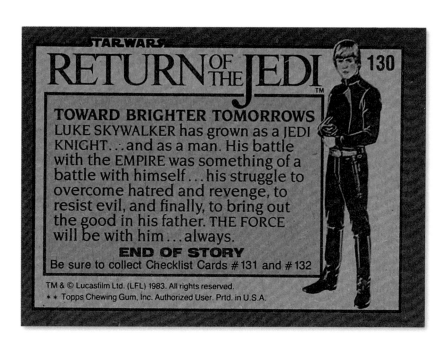

STAR WARS

RETURN OF THE JEDI ™

130

TOWARD BRIGHTER TOMORROWS
LUKE SKYWALKER has grown as a JEDI KNIGHT...and as a man. His battle with the EMPIRE was something of a battle with himself...his struggle to overcome hatred and revenge, to resist evil, and finally, to bring out the good in his father. THE FORCE will be with him...always.

END OF STORY

Be sure to collect Checklist Cards #131 and #132

TOWARD BRIGHTER TOMORROWS

Okay, so we didn't have the Jedi Force ghosts and Luke nodding in approval as a send-off image. But I think our young hero's expression in this close-up nicely conveys emotional closure . . . and faith in a better future.

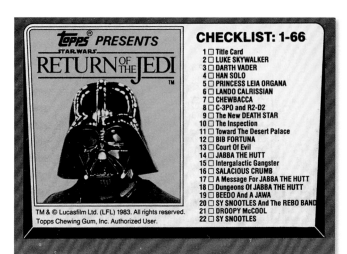

topps® PRESENTS

STAR WARS

RETURN OF THE JEDI™

CHECKLIST: 1-66

1 ☐ Title Card
2 ☐ LUKE SKYWALKER
3 ☐ DARTH VADER
4 ☐ HAN SOLO
5 ☐ PRINCESS LEIA ORGANA
6 ☐ LANDO CALRISSIAN
7 ☐ CHEWBACCA
8 ☐ C-3PO and R2-D2
9 ☐ The New DEATH STAR
10 ☐ The Inspection
11 ☐ Toward The Desert Palace
12 ☐ BIB FORTUNA
13 ☐ Court Of Evil
14 ☐ JABBA THE HUTT
15 ☐ Intergalactic Gangster
16 ☐ SALACIOUS CRUMB
17 ☐ A Message For JABBA THE HUTT
18 ☐ Dungeons Of JABBA THE HUTT
19 ☐ BEEDO And A JAWA
20 ☐ SY SNOOTLES And The REBO BAND
21 ☐ DROOPY McCOOL
22 ☐ SY SNOOTLES

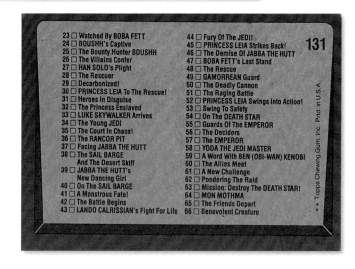

131

23 ☐ Watched By BOBA FETT
24 ☐ BOUSHH's Captive
25 ☐ The Bounty Hunter BOUSHH
26 ☐ The Villains Confer
27 ☐ HAN SOLO's Plight
28 ☐ The Rescuer
29 ☐ Decarbonized!
30 ☐ PRINCESS LEIA To The Rescue!
31 ☐ Heroes In Disguise
32 ☐ The Princess Enslaved
33 ☐ LUKE SKYWALKER Arrives
34 ☐ The Young JEDI
35 ☐ The Court In Chaos!
36 ☐ The RANCOR PIT
37 ☐ Facing JABBA THE HUTT
38 ☐ The SAIL BARGE
 And The Desert Skiff
39 ☐ JABBA THE HUTT's
 New Dancing Girl
40 ☐ On The SAIL BARGE
41 ☐ A Monstrous Fate!
42 ☐ The Battle Begins
43 ☐ LANDO CALRISSIAN's Fight For Life

44 ☐ Fury Of The JEDI!
45 ☐ PRINCESS LEIA Strikes Back!
46 ☐ The Demise Of JABBA THE HUTT
47 ☐ BOBA FETT's Last Stand
48 ☐ The Rescue
49 ☐ GAMORREAN Guard
50 ☐ The Deadly Cannon
51 ☐ The Raging Battle
52 ☐ PRINCESS LEIA Swings Into Action!
53 ☐ Swing To Safety
54 ☐ On The DEATH STAR
55 ☐ Guards Of The EMPEROR
56 ☐ The Deciders
57 ☐ The EMPEROR
58 ☐ YODA THE JEDI MASTER
59 ☐ A Word With BEN (OBI-WAN) KENOBI
60 ☐ The Allies Meet
61 ☐ A New Challenge
62 ☐ Pondering The Raid
63 ☐ Mission: Destroy The DEATH STAR!
64 ☐ MON MOTHMA
65 ☐ The Friends Depart
66 ☐ Benevolent Creature

Topps® PRESENTS

STAR WARS.

RETURN OF THE JEDI ™

CHECKLIST: 67-132

67 ☐ The Plan Begins
68 ☐ Forest Of ENDOR
69 ☐ DROIDS On The Move
70 ☐ Blasting A SPEEDER BIKE
71 ☐ Approaching The Princess
72 ☐ A New Found Friend
73 ☐ PRINCESS LEIA's Smile
74 ☐ Under Attack!
75 ☐ IMPERIAL Scout Peril!
76 ☐ Entering The THRONE ROOM
77 ☐ The SKYWALKER Factor
78 ☐ Captured By The EWOKS
79 ☐ The Netted DROID
80 ☐ All Hail SEE-THREEPIO!
81 ☐ Royal Treatment
82 ☐ Sitting With Royalty
83 ☐ Levitated By LUKE
84 ☐ The EWOK Leaders
85 ☐ LOGRAY and CHIEF CHIRPA
86 ☐ Help From PRINCESS LEIA
87 ☐ Will HAN SOLO Be Dinner?
88 ☐ The Baby EWOK

89 ☐ The Forest Creatures
90 ☐ The DROID And The EWOK
91 ☐ R2-D2 Meets WICKET
92 ☐ Unexpected Allies
93 ☐ Serious Situation
94 ☐ LUKE SKYWALKER's Destiny
95 ☐ Quiet, SEE-THREEPIO!
96 ☐ IMPERIAL BIKER SCOUT
97 ☐ BIKER SCOUT And The Battlefield
98 ☐ HAN SOLO's Approach
99 ☐ The Ultimate Mission
100 ☐ Ready For Action!
101 ☐ Ambushed By THE EMPIRE
102 ☐ Observed By The EWOKS
103 ☐ The Courageous EWOKS
104 ☐ Prisoners!
105 ☐ Revising Their Plan
106 ☐ AT-ST (ALL TERRAIN SCOUT TRANSPORT)
107 ☐ The Forest Fighters!
108 ☐ Break For Freedom!
109 ☐ ARTOO-DETOO — Hit!
110 ☐ CHEWBACCA Triumphant!

111 ☐ EWOKS To The Rescue!
112 ☐ Battle In The Forest
113 ☐ STORMTROOPER Attack!
114 ☐ The Victorious REBELS
115 ☐ Time Out For Love
116 ☐ Facing The EMPEROR
117 ☐ Master Of Terror
118 ☐ The EMPEROR's Offer
119 ☐ Battle Of The JEDI
120 ☐ LIGHTSABER Battle!
121 ☐ DARTH VADER Is Down!
122 ☐ The Confrontation
123 ☐ The DEATH STAR Raid
124 ☐ Military Leader ADMIRAL ACKBAR
125 ☐ Within The DEATH STAR
126 ☐ Victory Celebration!
127 ☐ Congratulating WEDGE
128 ☐ The Triumphant Trio
129 ☐ The Heroic DROIDS
130 ☐ Toward Brighter Tomorrows
131 ☐ Checklist I
132 ☐ Checklist II

132

The thirty-three stickers in Series 1 were available in six colors (yellow, purple, blue, red, orange, and green). The images were duplicated against these different border colors, so while there were only thirty-three unique images, there was a total of sixty-six sticker cards to collect. Shown here is a selection of the various colors.

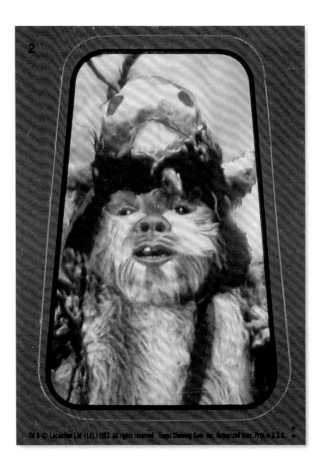

2

3

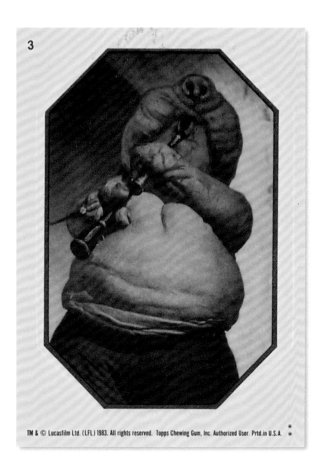

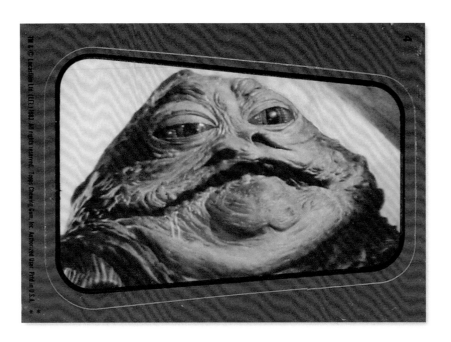

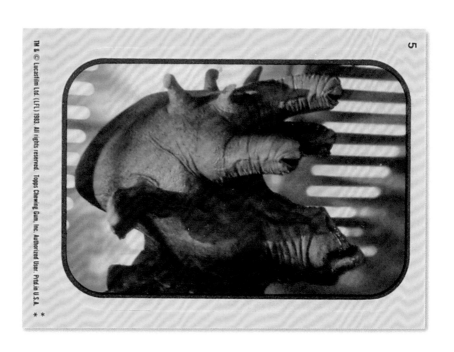

5

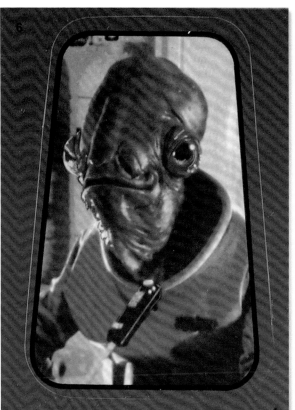

6

7

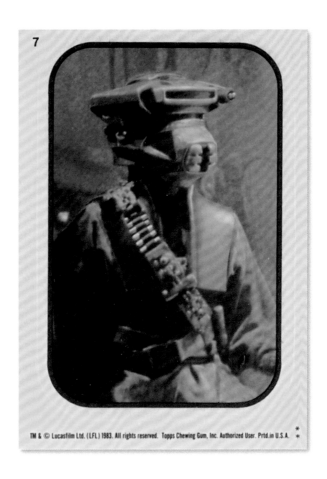

9

10

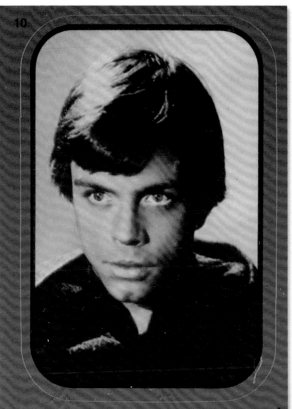

11

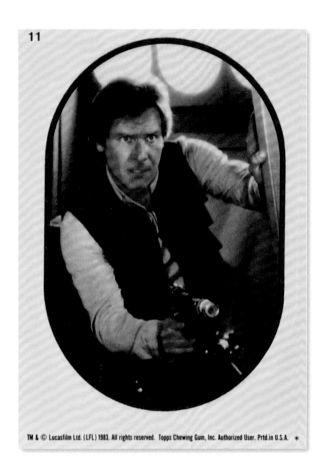

12

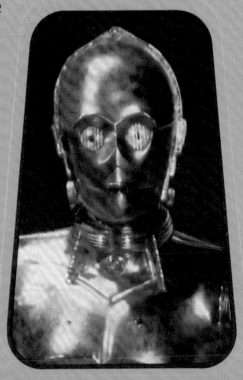

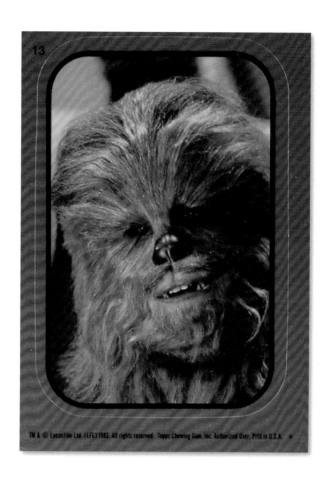

13

14

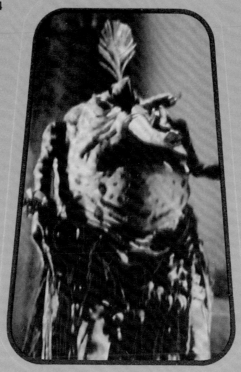

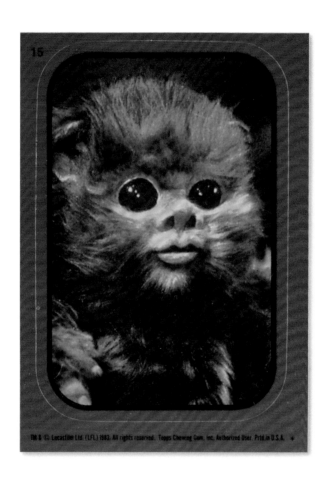

18

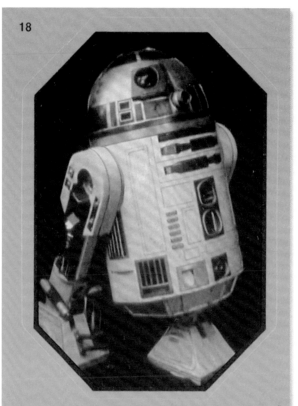

20

22

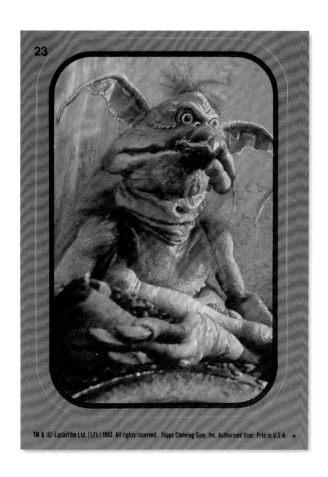

23

24

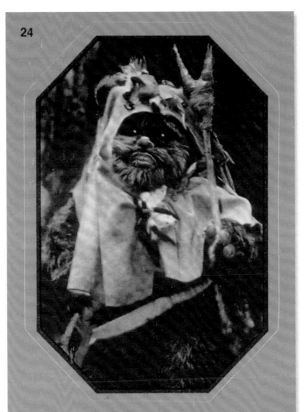

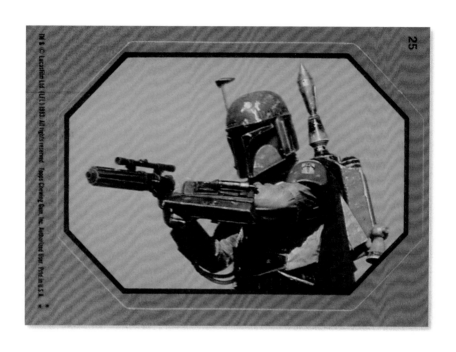

25

26

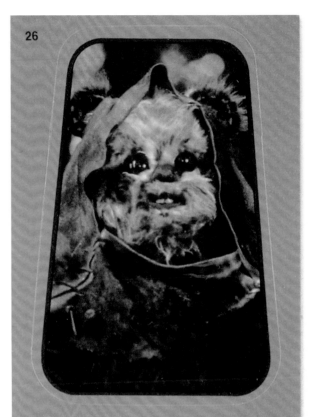

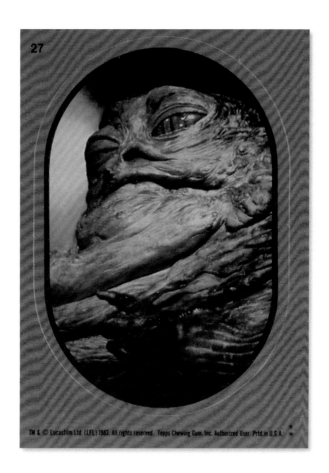

27

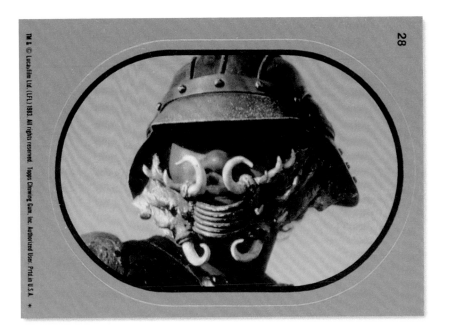

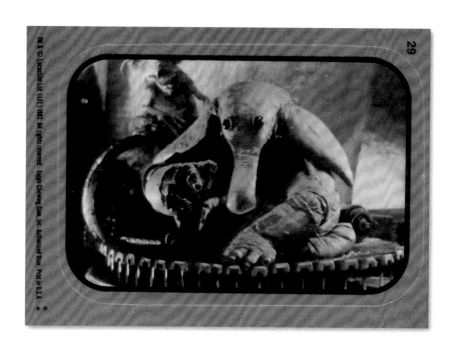

29

30

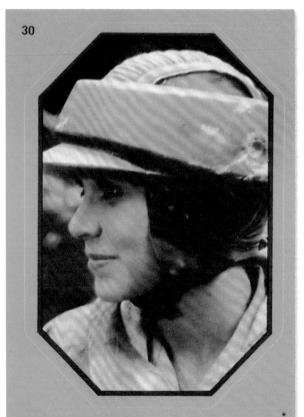

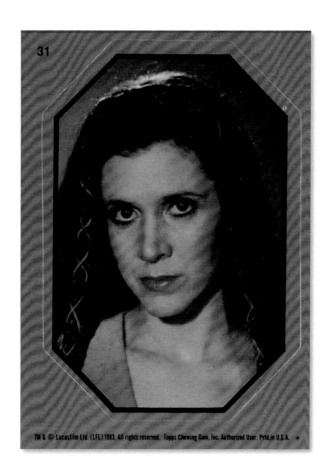

31

32

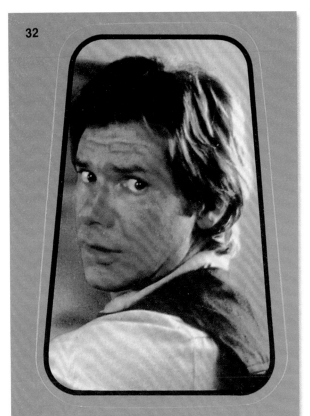

33

HERE IS WHAT YOUR COMPLETED
BLUE BORDER PICTURE WILL LOOK LIKE:

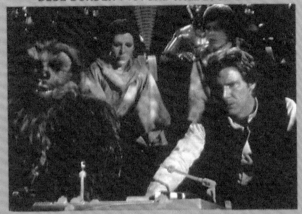

COLLECT ALL 15 CARDS OF PICTURE B.

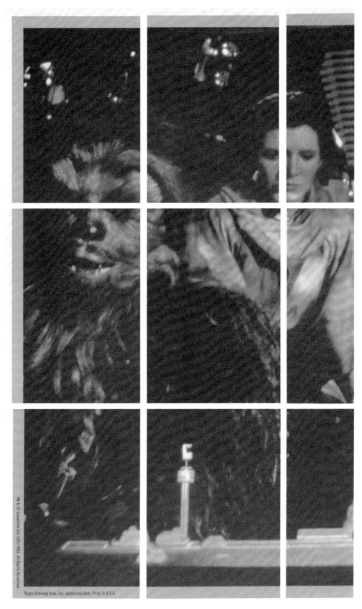

Our heroes prepare for adventure in this poster-like puzzle for Series 1.

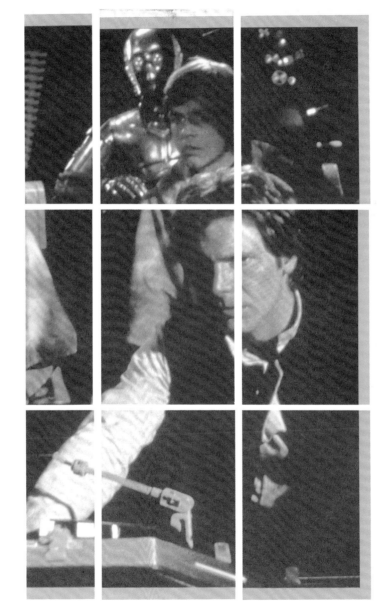

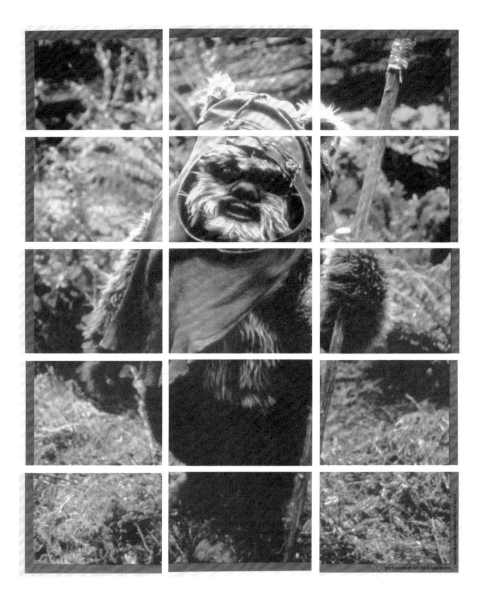

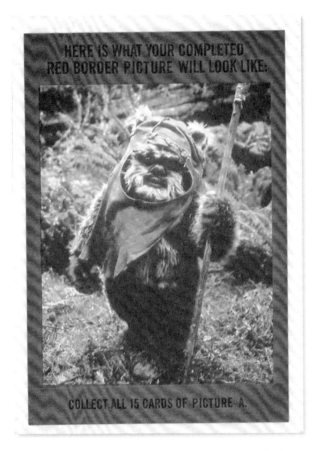

HERE IS WHAT YOUR COMPLETED
RED BORDER PICTURE WILL LOOK LIKE:

COLLECT ALL 15 CARDS OF PICTURE A.

The most well-known Ewok, Wicket would go on to appear in merchandise, comics, TV shows—and even this trading card puzzle!

NEW SERIES

topps®

STAR WARS

RETURN OF THE

JEDI

™

10 CARDS • 1 STICKER
1 STICK BUBBLE GUM

STAR WARS

RETURN OF THE JEDI

133

RETURN OF THE JEDI (Series Two)

Welcome to the second series of RETURN OF THE JEDI bubblegum cards and stickers. Join LUKE SKY-WALKER, HAN SOLO, PRINCESS LEIA and their REBEL allies as the excitement continues.

Starting next card . . . STAR QUIZ!

Another preapproved movie poster, featuring art by Tim Reamer, was pressed into service for our Series 2 title card. Looking back, this picture shape border didn't exactly do justice to the elegant vertical painting.

STAR·WARS

RETURN OF THE JEDI

134

™

STAR QUIZ ("RETURN OF THE JEDI")

What is the name of the monster LUKE SKYWALKER battles in JABBA THE HUTT's pit? (answer on next card)

Good luck with the STAR QUIZ. MAY THE FORCE BE WITH YOU!

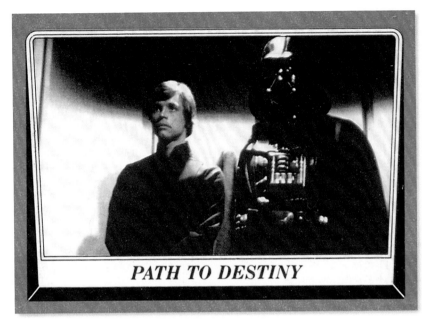

PATH TO DESTINY

Just the sight of these two together—now acknowledged as father and son—got us instantly interested in the central conflict of *Star Wars*. An image resembling this one was used to get the movie trailer off to an exciting start.

I never thought much of our Star Quiz questions—way too easy—but younger fans seemed to enjoy them.

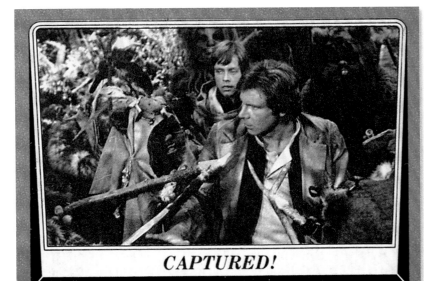

CAPTURED!

STAR WARS
RETURN OF THE JEDI

136

STAR QUIZ
("RETURN OF THE JEDI")

In the SAIL BARGE battle, who provides LUKE SKYWALKER with his LIGHTSABER?
(answer on next card)

Answer to Card #135:
LUKE SKYWALKER's face.

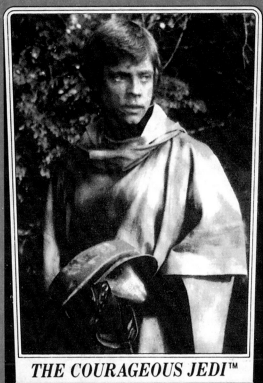

THE COURAGEOUS JEDI™

STAR WARS

RETURN OF THE JEDI™

137

STAR QUIZ ("STAR WARS")

In the beginning of STAR WARS, what sort of craft do the DROIDS use to escape from the invaded REBEL BLOCKADE RUNNER? (answer on next card)

Answer to Card #136:
ARTOO-DETOO.

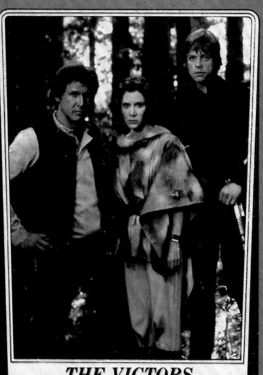

THE VICTORS

STAR.WARS

RETURN OF THE JEDI

138

™

STAR QUIZ
("RETURN OF THE JEDI")

Name the three members of
JABBA THE HUTT's
rock group.
(answer on next
card)

Answer to Card
#137:
A LIFE POD.

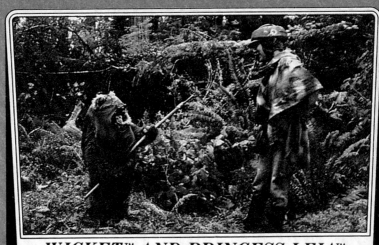

WICKET™ AND PRINCESS LEIA™

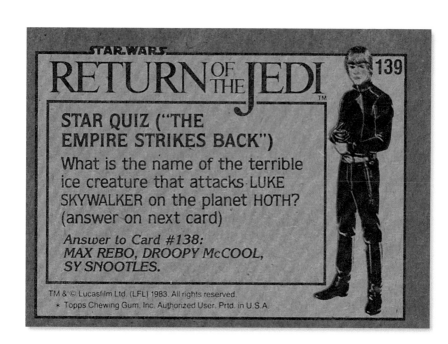

STAR.WARS

RETURN OF THE JEDI

139

STAR QUIZ ("THE EMPIRE STRIKES BACK")

What is the name of the terrible ice creature that attacks LUKE SKYWALKER on the planet HOTH? (answer on next card)

Answer to Card #138:
MAX REBO, DROOPY McCOOL,
SY SNOOTLES.

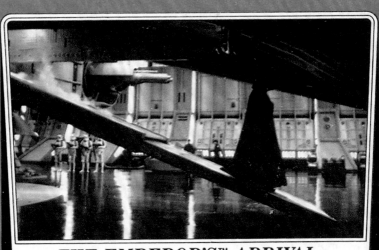

THE EMPEROR'S™ ARRIVAL

RETURN OF THE JEDI

140

STAR QUIZ ("STAR WARS")

In the original STAR WARS, what type of craft does LUKE SKY-WALKER use to zoom across the deserts of TATOOINE? (answer on next card)

Answer to Card #139:
The WAMPA.

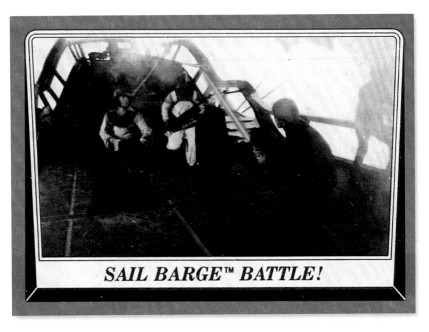

SAIL BARGE™ BATTLE!

Luke once again takes on Jabba's bodyguards aboard the sail barge, using his (airbrushed) green lightsaber.

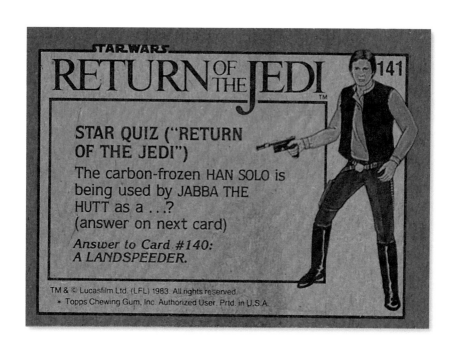

STAR WARS

RETURN OF THE JEDI

141

STAR QUIZ ("RETURN OF THE JEDI")

The carbon-frozen HAN SOLO is being used by JABBA THE HUTT as a . . .?
(answer on next card)

Answer to Card #140:
A LANDSPEEDER.

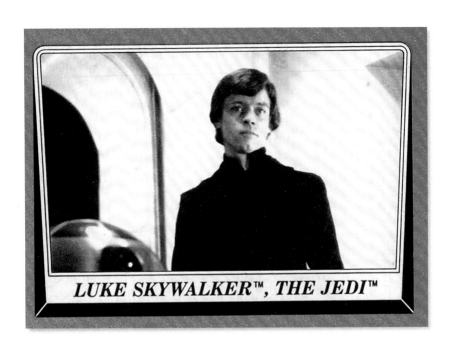

LUKE SKYWALKER™, *THE JEDI*™

RETURN OF THE JEDI

142

STAR QUIZ ("THE EMPIRE STRIKES BACK")

What color are CHEWBACCA's
eyes? (answer
on next card)

Answer to Card #141:
wall decoration.

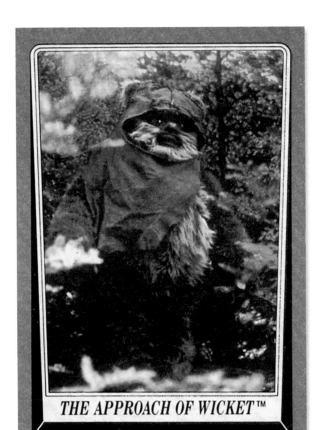

THE APPROACH OF WICKET™

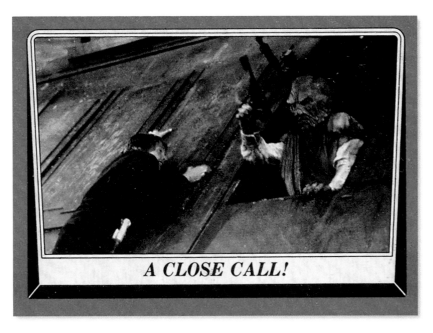

A CLOSE CALL!

Watch out, Luke! The barge sequence allowed most of the film's heroic principals (including a semiblind Han Solo and the chained Princess Leia) to turn things around and work in tandem.

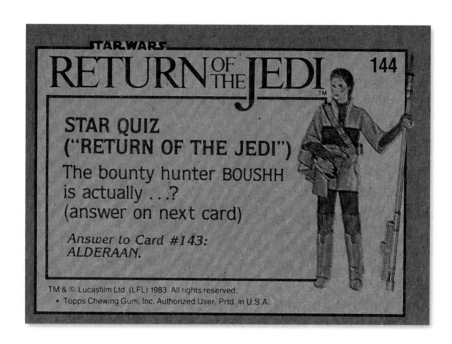

STAR WARS

RETURN OF THE JEDI

144

STAR QUIZ ("RETURN OF THE JEDI")

The bounty hunter BOUSHH is actually ...?
(answer on next card)

Answer to Card #143: ALDERAAN.

ABOVE THE SARLACC PIT™

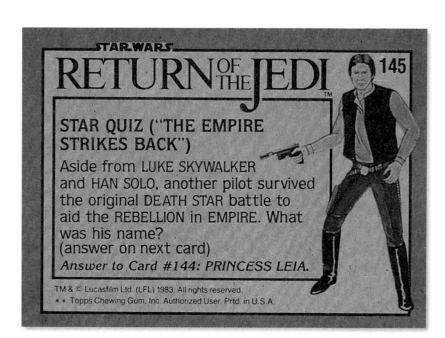

STAR.WARS

RETURN OF THE JEDI

145

STAR QUIZ ("THE EMPIRE STRIKES BACK")

Aside from LUKE SKYWALKER and HAN SOLO, another pilot survived the original DEATH STAR battle to aid the REBELLION in EMPIRE. What was his name?
(answer on next card)
Answer to Card #144: PRINCESS LEIA.

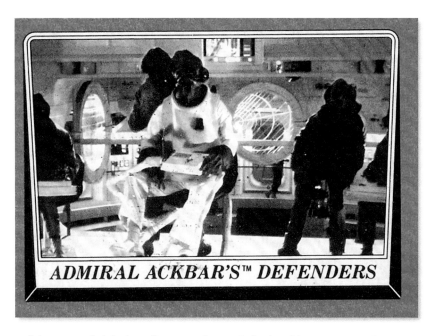

ADMIRAL ACKBAR'S™ DEFENDERS

Well, they're not really defending Ackbar in particular—just the freedom of the cosmos in general. Nice view of the admiral's busy bridge.

STAR WARS
RETURN OF THE JEDI

146

STAR QUIZ ("STAR WARS")

The SAND PEOPLE are also known as . . .? (answer on next card)

Answer to Card #145: WEDGE.

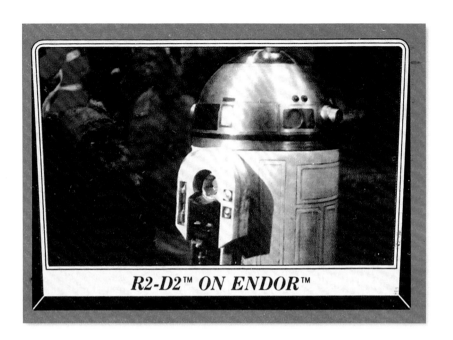

R2-D2™ *ON ENDOR*™

STAR WARS

RETURN OF THE JEDI

147

STAR QUIZ ("RETURN OF THE JEDI")

What is the goal of the REBEL mission on the Moon of ENDOR? (answer on next card)

Answer to Card #146: TUSKEN RAIDERS.

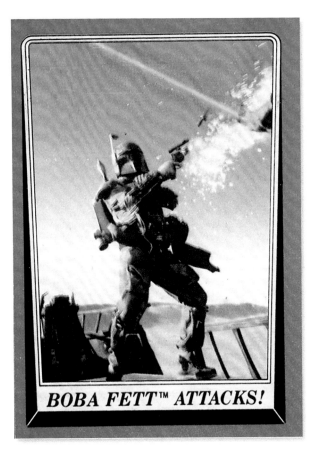

BOBA FETT™ ATTACKS!

Here's a spectacular shot of Boba Fett firing his weapon aboard the sail barge, squaring off against the lightsaber-wielding Luke Skywalker (who is mostly off-camera in this card).

STAR·WARS

RETURN OF THE JEDI

148

™

STAR QUIZ ("THE EMPIRE STRIKES BACK")

What was the military objective of the AT-AT (IMPERIAL ALL TERRAIN ARMORED TRANSPORT) on the planet HOTH? (answer on next card)

Answer to Card #147:
To destroy the energy shield
protecting the DEATH STAR.

DEADLY PLUNGE!

STAR.WARS.

RETURN OF THE JEDI

149

STAR QUIZ ("STAR WARS")

What was the name of LUKE SKY-
WALKER's uncle on TATOOINE?
(answer on next card)

Answer to Card #148:
The destruction of the REBEL
POWER GENERATORS.

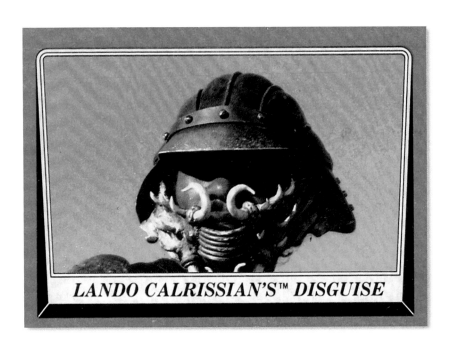

LANDO CALRISSIAN'S™ DISGUISE

RETURN OF THE JEDI

150

™

STAR QUIZ ("RETURN OF THE JEDI")

Before he became DARTH VADER, LUKE SKYWALKER's father was known as . . .? (answer on next card)

Answer to Card #149:
Uncle OWEN LARS.

SOLDIERS OF THE EMPIRE™

STAR.WARS

RETURN OF THE JEDI

151

™

STAR QUIZ ("THE EMPIRE STRIKES BACK")

What weapon does LUKE SKY-WALKER use to climb underneath the AT-AT (IMPERIAL ALL TERRAIN ARMORED TRANSPORT) on HOTH? (answer on next card)

Answer to Card #150:
ANAKIN SKYWALKER

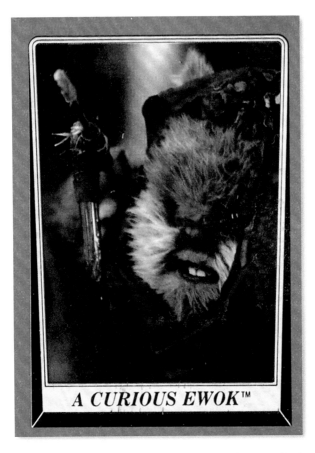

A CURIOUS EWOK™

This tight, striking close-up of an Ewok works extremely well as a vertical card.

STAR QUIZ ("STAR WARS")

Who was the master of ARTOO-DETOO and SEE-THREEPIO before LUKE SKYWALKER? (answer on next card)

Answer to Card #151:
A harpoon gun.

A PENSIVE LUKE SKYWALKER™

STAR.WARS.

RETURN OF THE JEDI

™

153

STAR QUIZ ("RETURN OF THE JEDI")

The leader of the EWOKS is . . .? (answer on next card)

Answer to Card #152:
CAPTAIN ANTILLES.

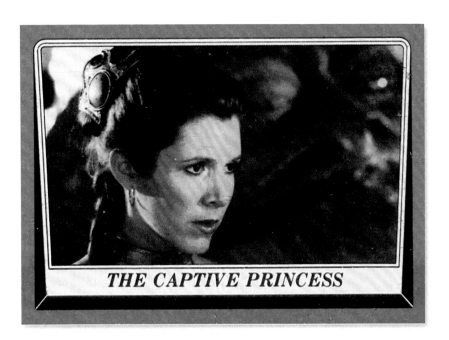

THE CAPTIVE PRINCESS

STAR WARS

RETURN OF THE JEDI

™

154

STAR QUIZ ("THE EMPIRE STRIKES BACK")

After escaping from the ice creature on HOTH, LUKE SKYWALKER sees a mysterious vision of ...? (answer on next card)

Answer to Card #153:
CHIEF CHIRPA.

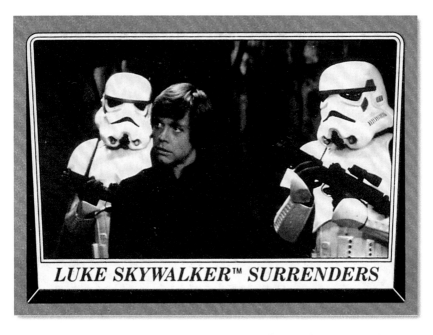

LUKE SKYWALKER™ SURRENDERS

This is the first time in our *Return of the Jedi* card sets that we cover the scene where a solemn yet hopeful Luke surrenders to his father.

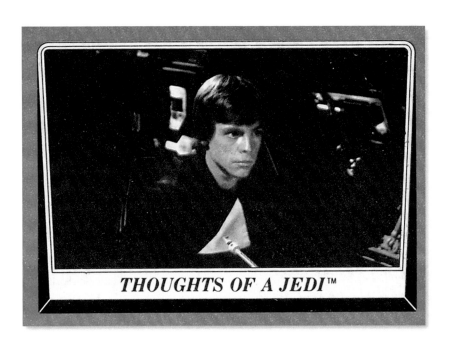

THOUGHTS OF A JEDI™

RETURN OF THE JEDI

156

STAR QUIZ ("RETURN OF THE JEDI")

ADMIRAL ACKBAR's race is known as . . . ? (answer on next card)

Answer to Card #155: BANTHAS.

TM & © Lucasfilm Ltd. (LFL) 1983. All rights reserved.
* * Topps Chewing Gum, Inc. Authorized User. Prtd. in U.S.A.

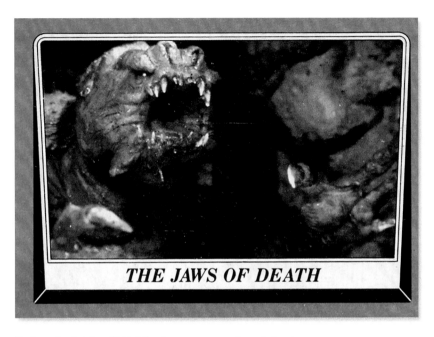

THE JAWS OF DEATH

Finally . . . the first view of Jabba's ferocious rancor appears in our *Jedi* cards.

STAR·WARS

RETURN OF THE JEDI

157

STAR QUIZ ("THE EMPIRE STRIKES BACK")

What planet does the
vision in the snow tell
LUKE SKYWALKER
to journey to?
(answer on next card)

Answer to Card #156:
MON CALAMARI.

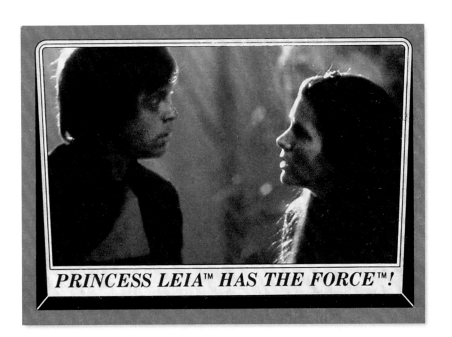

PRINCESS LEIA™ HAS THE FORCE™!

STAR·WARS

RETURN OF THE JEDI

158

™

STAR QUIZ ("STAR WARS")

What wars did LUKE SKYWALKER's father and a younger BEN (OBI-WAN) KENOBI fight in before the EMPIRE came into power? (answer on next card)

Answer to Card #157: DAGOBAH.

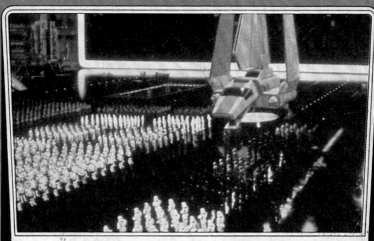

ARRIVAL OF THE EMPEROR™

STAR WARS

RETURN OF THE JEDI

159

STAR QUIZ ("RETURN OF THE JEDI")

In his dealings with JABBA THE HUTT's creatures, SEE-THREEPIO's _____ is damaged. (answer on next card)

Answer to Card #158:
The CLONE WARS.

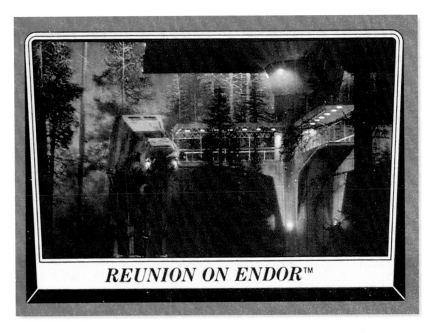

REUNION ON ENDOR™

The four-legged metallic walkers that made such an impression in *The Empire Strikes Back* make a return appearance (one of them, anyway) in this doctored visual-effects shot from ILM.

STAR·WARS

RETURN OF THE JEDI

160

STAR QUIZ ("THE
EMPIRE STRIKES
BACK")

To escape from the STAR
DESTROYERS after fleeing HOTH,
HAN SOLO sends the MILLENNIUM
FALCON straight into a field of ...?
(answer on next card)

Answer to Card #159: eye.

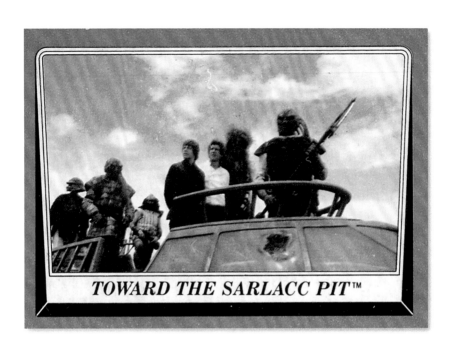

TOWARD THE SARLACC PIT™

STAR WARS

RETURN OF THE JEDI

161

STAR QUIZ ("STAR WARS")

What did the GRAND MOFF TARKIN command? (answer on next card)

Answer to Card #160: asteroids.

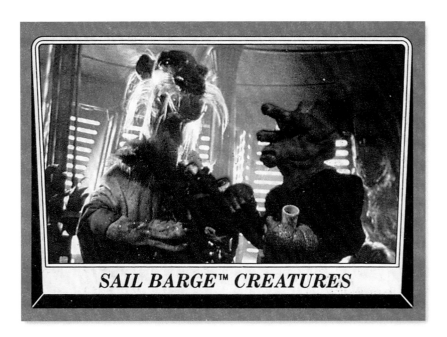

SAIL BARGE™ CREATURES

STAR.WARS

RETURN OF THE JEDI

™

162

STAR QUIZ ("RETURN OF THE JEDI")

What is the name of LANDO CALRISSIAN's co-pilot in the MILLEN-NIUM FALCON? (answer on next card)

Answer to Card #161:
The (original) DEATH STAR.

FRIENDS OF THE ALLIANCE™!

RETURN OF THE JEDI

163

STAR QUIZ ("THE EMPIRE STRIKES BACK")

Here's a tough one. What is the object that YODA and ARTOO-DETOO struggle over on DAGOBAH when they first meet? (answer on next card)

Answer to Card #162: NIEN NUNB.

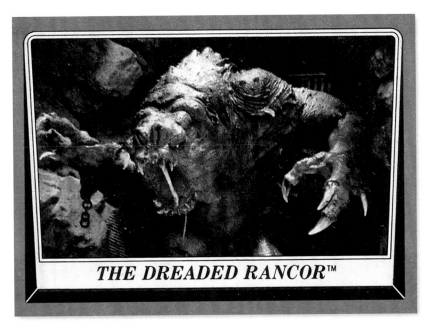

THE DREADED RANCOR™

Here's a picture-perfect shot of the rancor, Jabba's monstrous and ever-hungry "pet," who is kept below the Hutt's throne room.

RETURN OF THE JEDI

164

STAR QUIZ ("STAR WARS")

What planet does PRINCESS LEIA claim the REBEL base is located on in order to throw GRAND MOFF TARKIN off the track? (answer on next card)

Answer to Card #163: a power lamp (congratulations!!)

FACE OF TERROR

STAR QUIZ ("RETURN OF THE JEDI")

JABBA THE HUTT's righthand man is named ...? (answer on next card)

Answer to Card #164:
DANTOOINE.

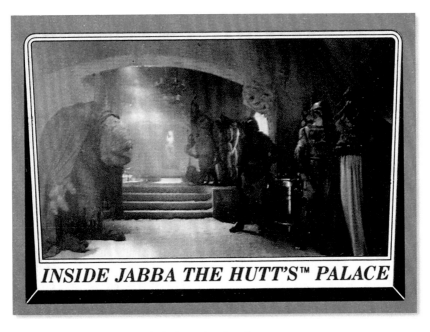

INSIDE JABBA THE HUTT'S™ PALACE

Notice Han Solo in carbonite way in the background on the wall.

STAR QUIZ ("THE EMPIRE STRIKES BACK")

What are the creatures that crawl along the hull of the MILLENNIUM FALCON inside the asteroid cave? (answer on next card)

Answer to Card #165: BIB FORTUNA.

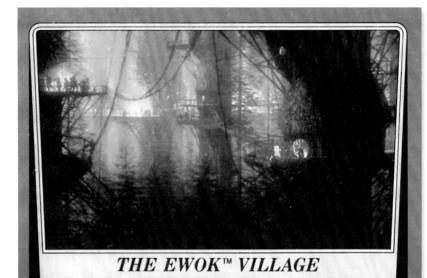

THE EWOK™ VILLAGE

STAR.WARS.

RETURN OF THE JEDI

™

167

STAR QUIZ ("STAR WARS")

Using his LIGHTSABER aboard the MILLENNIUM FALCON, LUKE SKY-WALKER practices with a small, shooting object called a . . .? (answer on next card)

Answer to Card #166: MYNOCKS.

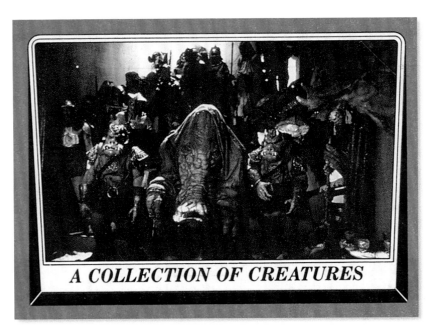

A COLLECTION OF CREATURES

Here's an amusing group shot of Jabba's throne-room denizens. There was a Muppet-like flavoring to these proceedings, which isn't surprising, given the creative alliance between George Lucas and Jim Henson in the 1980s.

RETURN OF THE JEDI

168

STAR QUIZ ("RETURN OF THE JEDI")

How is JABBA THE HUTT killed?
(answer on next card)

*Answer to
Card #167:
REMOTE.*

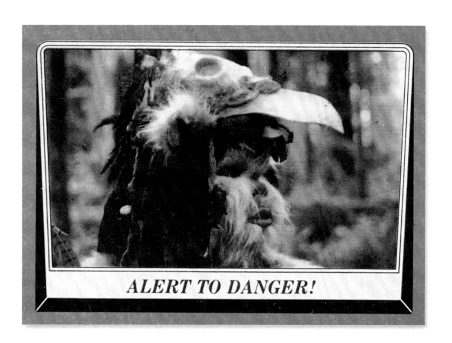

ALERT TO DANGER!

STAR WARS

RETURN OF THE JEDI

™

169

STAR QUIZ ("THE EMPIRE STRIKES BACK")

Using THE FORCE, YODA raises what object from the swamp of DAGOBAH? (answer on next card)

Answer to Card #168: PRINCESS LEIA strangles him with her chain.

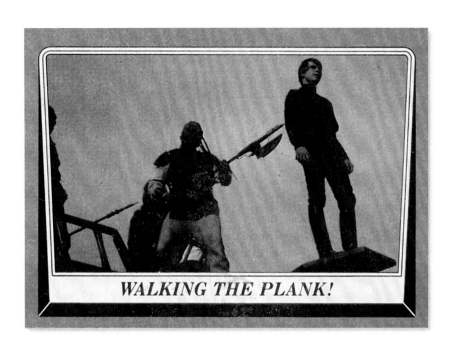

WALKING THE PLANK!

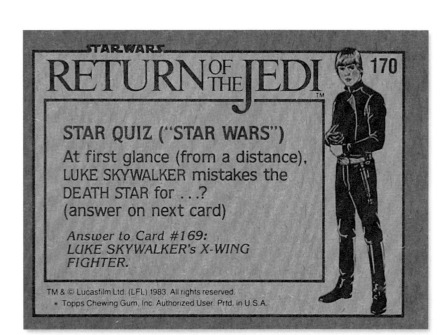

STAR WARS

RETURN OF THE JEDI

170

STAR QUIZ ("STAR WARS")

At first glance (from a distance), LUKE SKYWALKER mistakes the DEATH STAR for . . .? (answer on next card)

Answer to Card #169: LUKE SKYWALKER's X-WING FIGHTER.

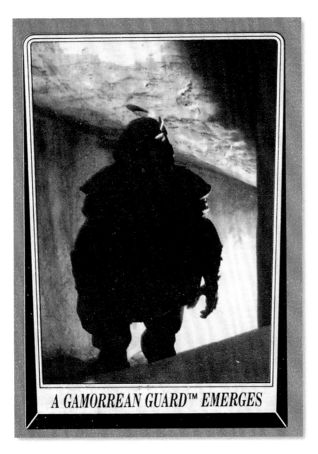

A GAMORREAN GUARD™ EMERGES

I love this evocative mood shot of a Gamorrean guard in Jabba's palace. Sometimes the less you see of something sinister, the more frightening it appears.

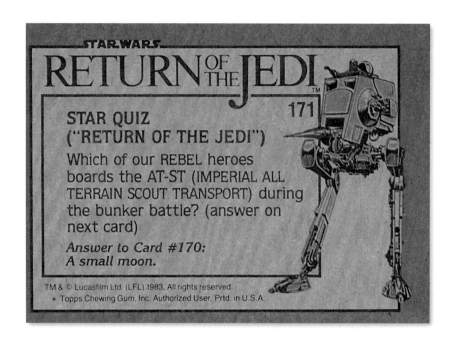

STAR·WARS·

RETURN OF THE JEDI™

171

STAR QUIZ ("RETURN OF THE JEDI")

Which of our REBEL heroes boards the AT-ST (IMPERIAL ALL TERRAIN SCOUT TRANSPORT) during the bunker battle? (answer on next card)

Answer to Card #170:
A small moon.

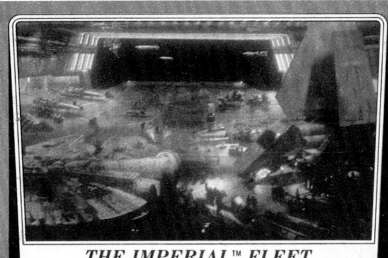

THE IMPERIAL™ FLEET

STAR.WARS

RETURN OF THE JEDI

172

™

STAR QUIZ ("THE EMPIRE STRIKES BACK")

What device frequently needs to be repaired on the MILLENNIUM FALCON? (answer on next card)

Answer to Card #171: CHEWBACCA.

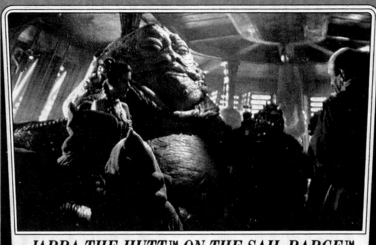

JABBA THE HUTT™ ON THE SAIL BARGE™

STAR WARS

RETURN OF THE JEDI

173

STAR QUIZ ("STAR WARS")

What does the DEATH STAR use to draw the MILLEN-NIUM FALCON to itself? (answer on next card)

Answer to Card #172: the HYPERDRIVE system.

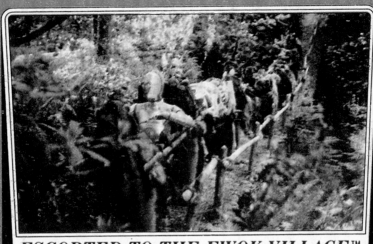

ESCORTED TO THE EWOK VILLAGE™

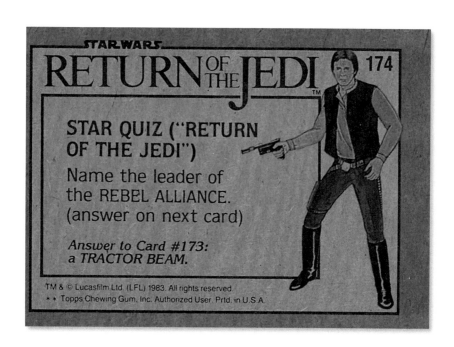

STAR WARS

RETURN OF THE JEDI

174

STAR QUIZ ("RETURN OF THE JEDI")

Name the leader of the REBEL ALLIANCE. (answer on next card)

Answer to Card #173: a TRACTOR BEAM.

A MONSTROUS GUEST!

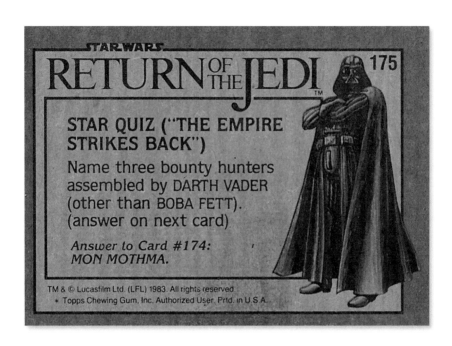

STAR WARS

RETURN OF THE JEDI

175

STAR QUIZ ("THE EMPIRE STRIKES BACK")

Name three bounty hunters assembled by DARTH VADER (other than BOBA FETT). (answer on next card)

Answer to Card #174: MON MOTHMA.

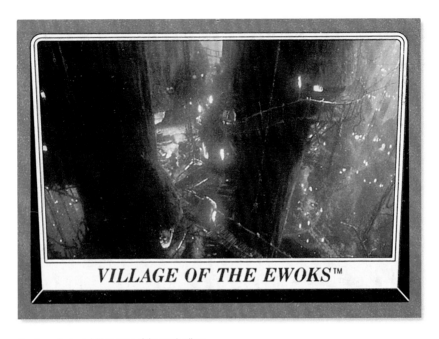

VILLAGE OF THE EWOKS™

An atmospheric nighttime view of the Ewok village.

STAR WARS

RETURN OF THE JEDI ™

176

STAR QUIZ ("STAR WARS")

What device does LUKE SKY-
WALKER use to communicate
with SEE-THREEPIO when they
are separated on the DEATH STAR?
(answer on next card)

Answer to Card #175:
BOSSK, DENGAR, IG-88, ZUCKUSS
(any three)

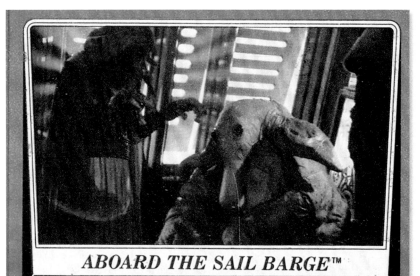

ABOARD THE SAIL BARGE™

STAR.WARS

RETURN OF THE JEDI

177

STAR QUIZ ("RETURN OF THE JEDI")

What is the name of the bizarre, cackling little creature by JABBA THE HUTT's side? (answer on next card)

Answer to Card #176: a COMLINK.

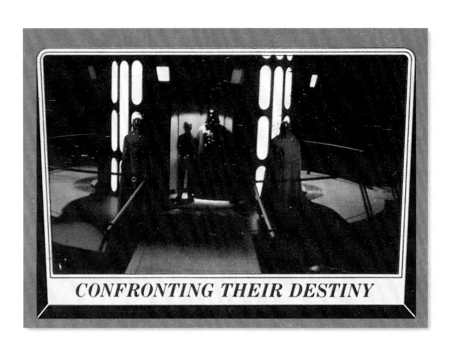

CONFRONTING THEIR DESTINY

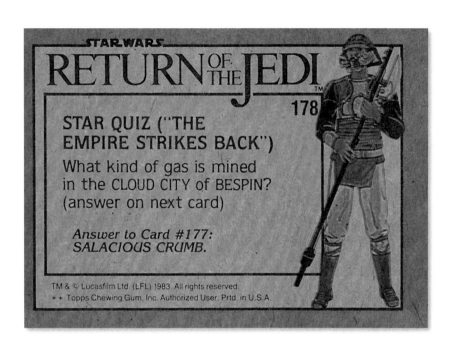

STAR WARS

RETURN OF THE JEDI ™

178

STAR QUIZ ("THE EMPIRE STRIKES BACK")

What kind of gas is mined in the CLOUD CITY of BESPIN? (answer on next card)

Answer to Card #177: SALACIOUS CRUMB.

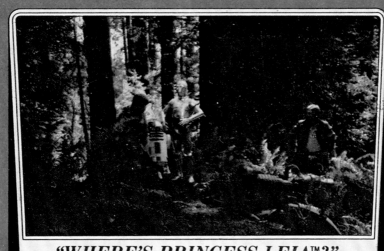

"WHERE'S PRINCESS LEIA™?"

STAR QUIZ ("STAR WARS")

A short while after they first meet, what is PRINCESS LEIA's less-than-flattering nickname for CHEWBACCA? (answer on next card)

Answer to Card #178:
TIBANNA GAS.

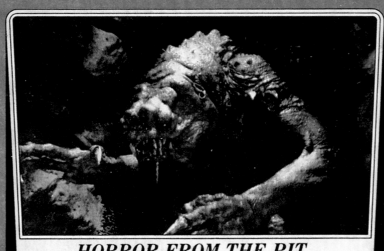

HORROR FROM THE PIT

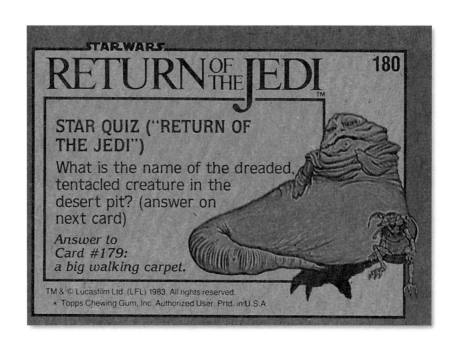

STAR WARS

RETURN OF THE JEDI

180

STAR QUIZ ("RETURN OF THE JEDI")

What is the name of the dreaded, tentacled creature in the desert pit? (answer on next card)

Answer to Card #179: a big walking carpet.

"GIVE IN TO YOUR HATE!"

The evil Emperor exhorts Luke to renounce his Jedi ethics, even as young Skywalker tries to resurrect the humanity of father-turned-despot Darth Vader.

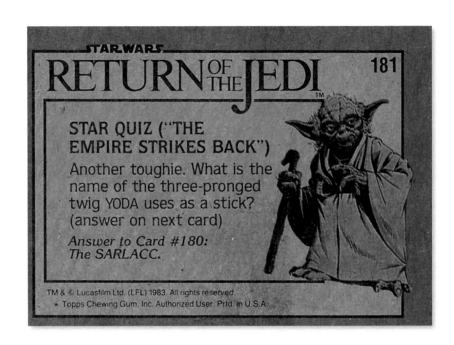

STAR.WARS

RETURN OF THE JEDI

181

STAR QUIZ ("THE EMPIRE STRIKES BACK")

Another toughie. What is the name of the three-pronged twig YODA uses as a stick? (answer on next card)

Answer to Card #180:
The SARLACC.

AWAITING HIS MAJESTY

STAR WARS

RETURN OF THE JEDI

182

STAR QUIZ ("STAR WARS")

What device does GRAND MOFF TARKIN use to track the MILLENNIUM FALCON after it escapes from the DEATH STAR? (answer on next card)

Answer to Card #181: a GIMER STICK (if you got this one, consider yourself a STAR WARS Expert Supreme).

A MOTHER EWOK™ AND CHILD

STAR WARS

RETURN OF THE JEDI

183

™

STAR QUIZ ("RETURN OF THE JEDI")

On what planet is JABBA THE HUTT's castle? (answer on next card)

Answer to Card #182: A homing beacon.

A CONCERNED PRINCESS LEIA™

STAR WARS

RETURN OF THE JEDI

™

184

STAR QUIZ ("THE EMPIRE STRIKES BACK")

Who serves as personal aide to LANDO CALRISSIAN on BESPIN?
(answer on next card)

Answer to Card #183: TATOOINE.

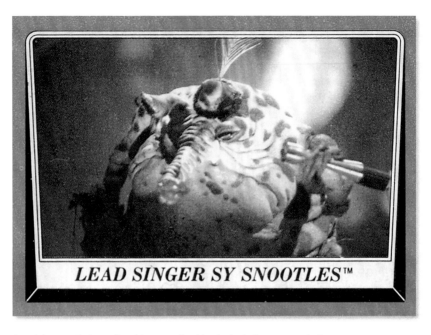

LEAD SINGER SY SNOOTLES™

A cool close-up of crimson-lipped Sy, unquestionably a looker in the proper context.

STAR WARS

RETURN OF THE JEDI

185

STAR QUIZ ("STAR WARS")

The REBEL BASE is located on a moon orbiting what planet? (answer on next card)

Answer to Card #184: LOBOT.

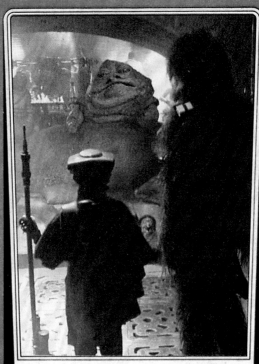

THE ARRIVAL OF BOUSHH™

STAR.WARS.

RETURN OF THE JEDI

™

186

STAR QUIZ ("RETURN OF THE JEDI")

What evil enemy uses a lasso in the desert battle? (answer on next card)

Answer to Card #185: YAVIN.

MASTER OF HIS COURT

STAR WARS

RETURN OF THE JEDI

187

STAR QUIZ ("THE EMPIRE STRIKES BACK")
Scavenging, piglike creatures dwell in BESPIN CLOUD CITY. They are called . . .? (answer on next card)

Answer to Card #186: BOBA FETT.

STAR LOVERS

RETURN OF THE JEDI

188

STAR QUIZ ("STAR WARS")

What sort of creatures did LUKE·SKYWALKER "bull's eye" on TATOOINE while flying his T-SIXTEEN?

(answer on next card)

Answer to Card #187: UGNAUGHTS.

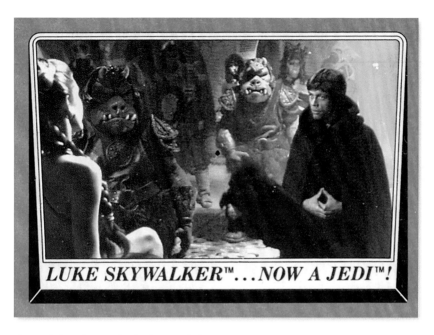

LUKE SKYWALKER™...NOW A JEDI™!

Slave-garbed Leia keeps a lid on her fury as soul of composure Luke Skywalker tries to reason with Jabba. In just a few minutes these negotiations will cease, and the Jedi warrior will be grappling with the Hutt's ferocious pet monster, a rancor.

STAR WARS
RETURN OF THE JEDI
™

189

STAR QUIZ
("RETURN OF
THE JEDI")

Who is nearly barbecued
by the EWOKS?
(answer on next card)

Answer to Card #188:
WOMP RATS.

BATTLE OF THE BUNKER!

STAR·WARS

RETURN OF THE JEDI

™

190

STAR QUIZ ("THE EMPIRE STRIKES BACK")

Where are our heroes going when DARTH VADER surprises them on BESPIN?
(answer on next card)

Answer to Card #189:
HAN SOLO.

PORTRAIT OF WICKET™

RETURN OF THE JEDI

191

STAR QUIZ ("STAR WARS")

What is HAN SOLO's reaction after he receives his medal from PRINCESS LEIA? (answer on next card)

Answer to Card #190: to a feast.

TRAPPED BY THE EMPIRE™

STAR WARS.

RETURN OF THE JEDI

192

™

STAR QUIZ
("RETURN OF THE JEDI")
How does LUKE SKYWALKER
demonstrate the power of
THE FORCE to the EWOKS?
(answer on next card)

Answer to Card #191:
he winks at her.

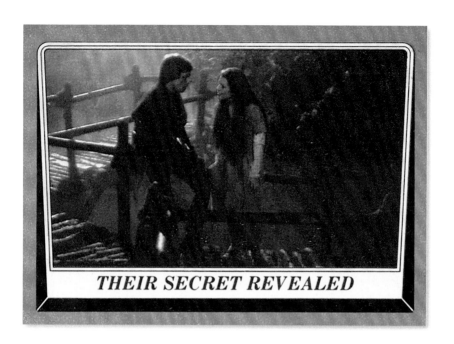

THEIR SECRET REVEALED

STAR WARS

RETURN OF THE JEDI

193

STAR QUIZ ("THE EMPIRE STRIKES BACK")

Who blasts SEE-THREEPIO to pieces on BESPIN? (answer on next card)

Answer to Card #192: He levitates SEE-THREEPIO.

RETHINKING THE PLAN

STAR WARS

RETURN OF THE JEDI

194

STAR QUIZ ("STAR WARS")

What is the first spaceship ever to be seen in a STAR WARS movie? (answer on next card)

Answer to Card #193: STORMTROOPERS.

SNAGGED BY THE EWOKS™

STAR WARS

RETURN OF THE JEDI

195

STAR QUIZ ("RETURN OF THE JEDI")

After he is released from carbon-freeze, HAN SOLO asks, "Who are you?" PRINCESS LEIA replies:? (answer on next card)

Answer to Card #194:
A REBEL BLOCKADE RUNNER.

HAN SOLO™'S IN TROUBLE!

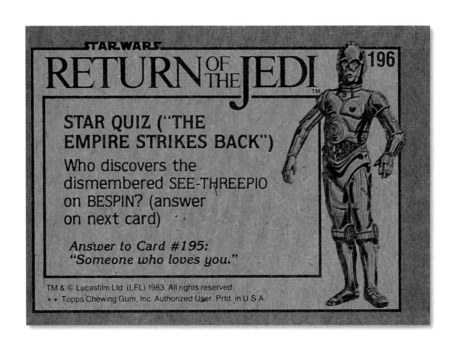

STAR·WARS

RETURN OF THE JEDI

196

™

STAR QUIZ ("THE EMPIRE STRIKES BACK")

Who discovers the dismembered SEE-THREEPIO on BESPIN? (answer on next card)

Answer to Card #195: "Someone who loves you."

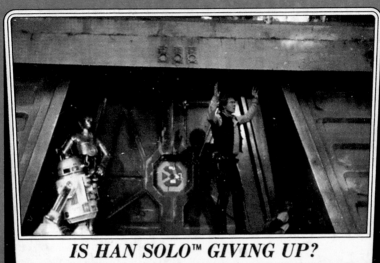

IS HAN SOLO™ GIVING UP?

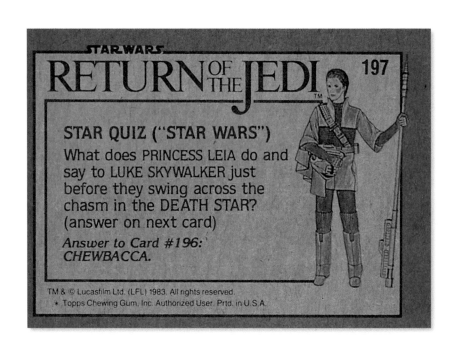

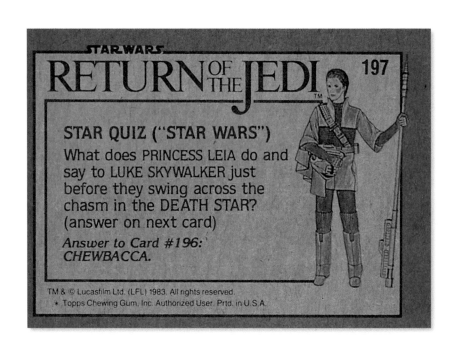**STAR·WARS·**

RETURN OF THE JEDI

197

STAR QUIZ ("STAR WARS")

What does PRINCESS LEIA do and say to LUKE SKYWALKER just before they swing across the chasm in the DEATH STAR? (answer on next card)

Answer to Card #196:
CHEWBACCA.

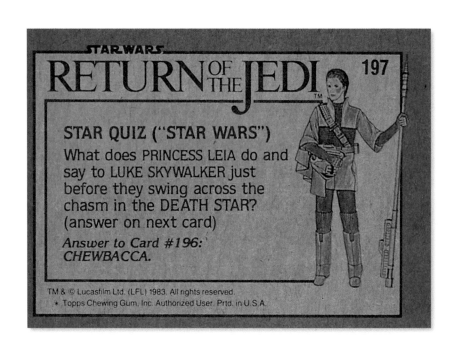

THE ROYAL DROID™

STAR WARS

RETURN OF THE JEDI™

198

STAR QUIZ ("RETURN OF THE JEDI")

What is the name of the EWOK medicine man? (answer on next card)

Answer to Card #197:
She kisses him and says, "for luck!"

PRINCESS LEIA™ INTERCEDES

STAR WARS

RETURN OF THE JEDI

199

STAR QUIZ ("THE EMPIRE STRIKES BACK")

How is the half-assembled SEE-THREEPIO transported on BESPIN?
(answer on next card)

Answer to Card #198: LOGRAY.

RESCUING HAN SOLO™

One heroic turn deserves another: Han Solo has rescued Princess Leia in past movies, so it's only natural for Leia (here disguised as bounty hunter Boushh) to return the favor in *Jedi*.

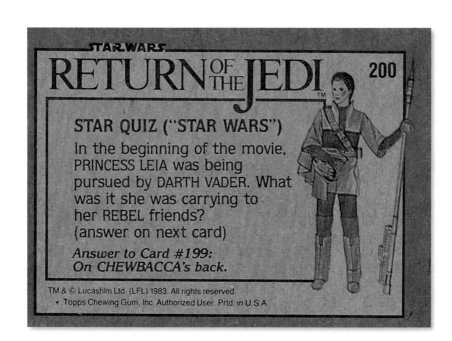

STAR·WARS

RETURN OF THE JEDI

200

STAR QUIZ ("STAR WARS")

In the beginning of the movie, PRINCESS LEIA was being pursued by DARTH VADER. What was it she was carrying to her REBEL friends? (answer on next card)

Answer to Card #199: On CHEWBACCA's back.

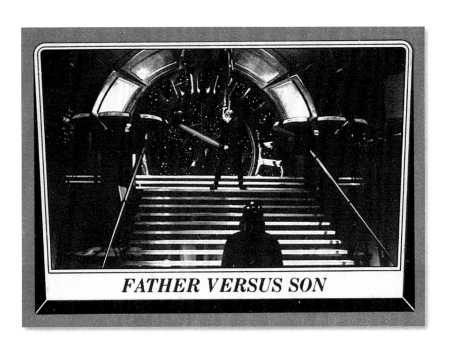

FATHER VERSUS SON

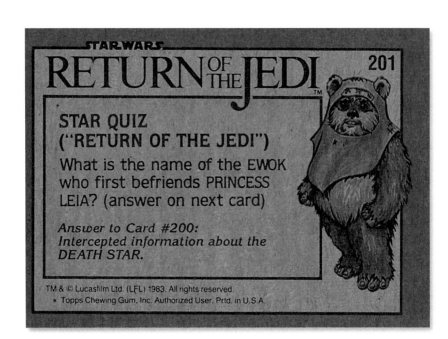

STAR WARS

RETURN OF THE JEDI

201

STAR QUIZ ("RETURN OF THE JEDI")

What is the name of the EWOK who first befriends PRINCESS LEIA? (answer on next card)

Answer to Card #200:
Intercepted information about the
DEATH STAR.

LUKE SKYWALKER™, JEDI WARRIOR™

Luke Skywalker, seen as a full-fledged Jedi for the first time, has a ghostly appearance as he enters Jabba's palace. In some ways Luke resembles his dignified mentor, Obi-Wan Kenobi.

RETURN OF THE JEDI

202

STAR QUIZ ("THE EMPIRE STRIKES BACK")

When PRINCESS LEIA tells HAN SOLO she loves him, what is his reply? (answer on next card)

Answer to Card #201: WICKET.

THE YOUNG JEDI KNIGHT™

STAR.WARS.

RETURN OF THE JEDI

203

STAR QUIZ ("STAR WARS")

DARTH VADER is also known
as the DARK LORD OF
THE . . .? (answer
on next card)

Answer to Card #202:
"I know."

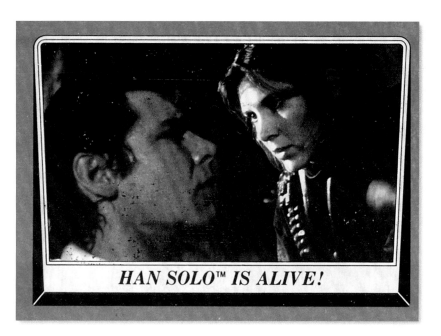

HAN SOLO™ IS ALIVE!

STAR.WARS

RETURN OF THE JEDI

204

™

STAR QUIZ
("RETURN OF THE JEDI")

When HAN SOLO tells PRINCESS
LEIA he loves her, what
is her reply?
(answer on next card)

Answer to Card #203:
SITH.

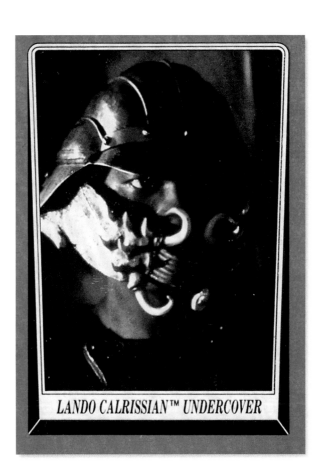

LANDO CALRISSIAN™ UNDERCOVER

STAR WARS

RETURN OF THE JEDI

205

STAR QUIZ ("THE EMPIRE STRIKES BACK")

In the climactic confrontation scene, what does DARTH VADER implore LUKE SKYWALKER to use against him? (answer on next card)

Answer to Card #204: "I know."

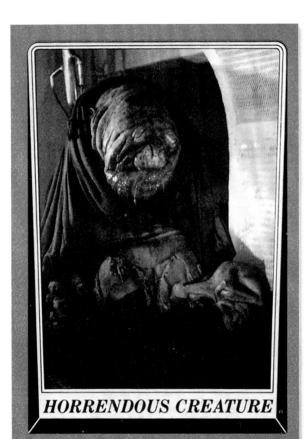

HORRENDOUS CREATURE

STAR WARS

RETURN OF THE JEDI
™

206

STAR QUIZ ("STAR WARS")

Who is the creator of the
STAR WARS saga? (answer
on next card)

Answer to Card #205:
LUKE SKYWALKER's hatred.

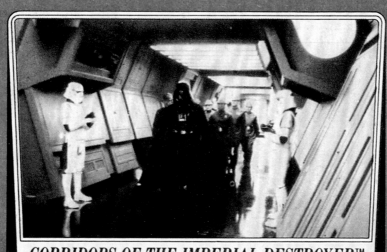

CORRIDORS OF THE IMPERIAL DESTROYER™

RETURN OF THE JEDI

207

STAR QUIZ ("RETURN OF THE JEDI")

What does JABBA THE HUTT do with PRINCESS LEIA after he captures her? (answer on next card)

Answer to Card #206: George Lucas.

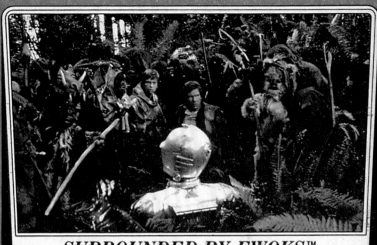

SURROUNDED BY EWOKS™

STAR WARS

RETURN OF THE JEDI

208

STAR QUIZ ("THE EMPIRE STRIKES BACK")

What structure does LUKE SKY-
WALKER hold onto for dear life
at the end of EMPIRE? (answer on
next card)

Answer to Card #207:
he turns her into a dancing girl and
chains her.

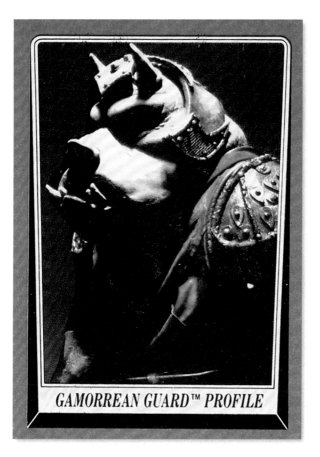

GAMORREAN GUARD™ PROFILE

Here's an especially nice portrait of a Gamorrean guard.

RETURN OF THE JEDI

STAR QUIZ ("STAR WARS")

Who composed the music
for STAR WARS and its
two sequels?
(answer on next card)

*Answer to Card #208:
an electronic weather
vane.*

HULKING GAMORREAN GUARD™

RETURN OF THE JEDI

210

STAR QUIZ ("RETURN OF THE JEDI")

What kind of guard is killed by JABBA THE HUTT's pit creature (in his palace)? (answer on next card)

Answer to Card #209:
John Williams

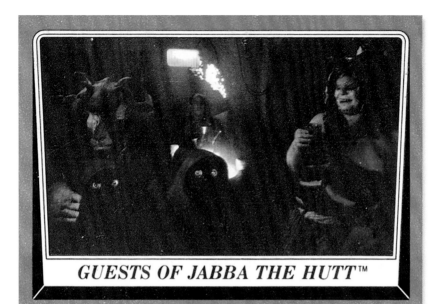

GUESTS OF JABBA THE HUTT™

STAR WARS
RETURN OF THE JEDI

211

STAR QUIZ ("THE EMPIRE STRIKES BACK")

How many years has YODA instructed young JEDI WARRIORS? (answer on next card)

Answer to Card #210: A GAMORREAN GUARD.

A FULL-FLEDGED JEDI™!

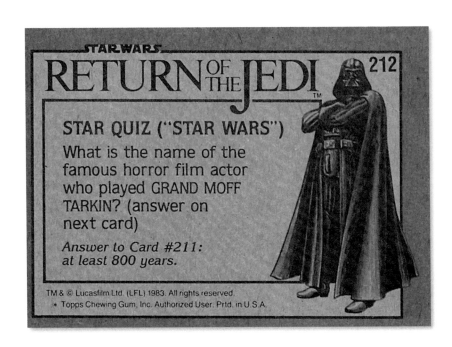

RETURN OF THE JEDI

212

STAR QUIZ ("STAR WARS")

What is the name of the famous horror film actor who played GRAND MOFF TARKIN? (answer on next card)

Answer to Card #211: at least 800 years.

BIZARRE ALIEN CREATURES

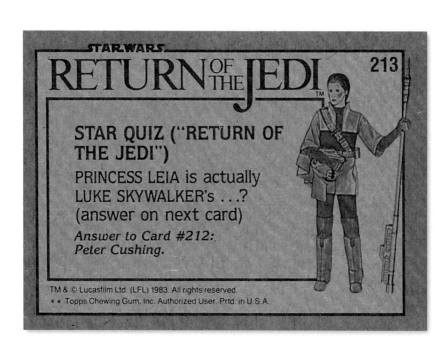

HEADQUARTERS FRIGATE

For the next six cards, model shots of the various spaceships and vehicles are superimposed over a starfield.

STAR.WARS

RETURN OF THE JEDI

214

™

STAR QUIZ ("THE EMPIRE STRIKES BACK")
Who eventually fixes the HYPERDRIVE SYSTEM on the MILLENNIUM FALCON in the nick of time? (answer on next card)

Answer to Card #213:
twin sister

TIE INTERCEPTOR™ (3/4 VIEW)

STAR·WARS

RETURN OF THE JEDI

™

215

STAR QUIZ ("STAR WARS")

What is the name
of LUKE SKYWALKER's aunt
on TATOOINE?
(answer on next card)

Answer to Card #214:
ARTOO-DETOO.

TM & © Lucasfilm Ltd. (LFL) 1983. All rights reserved.
★★ Topps Chewing Gum, Inc. Authorized User. Prtd. in U.S.A.

THE NEARLY COMPLETED DEATH STAR™

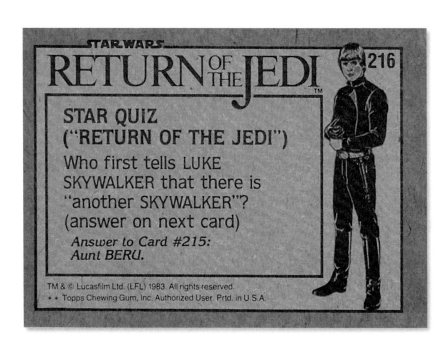

STAR.WARS.

RETURN OF THE JEDI

216

STAR QUIZ ("RETURN OF THE JEDI")

Who first tells LUKE SKYWALKER that there is "another SKYWALKER"? (answer on next card)

Answer to Card #215: Aunt BERU.

REBEL CRUISER™

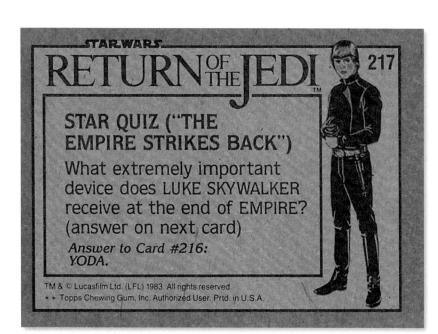

RETURN OF THE JEDI

™

217

STAR QUIZ ("THE EMPIRE STRIKES BACK")

What extremely important device does LUKE SKYWALKER receive at the end of EMPIRE? (answer on next card)

Answer to Card #216: YODA.

TIE INTERCEPTOR™ (FRONT VIEW)

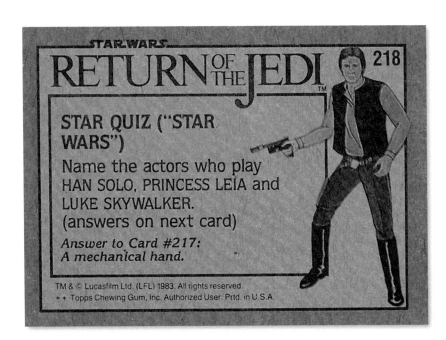

STAR WARS

RETURN OF THE JEDI

218

STAR QUIZ ("STAR WARS")

Name the actors who play
HAN SOLO, PRINCESS LEIA and
LUKE SKYWALKER.
(answers on next card)

Answer to Card #217:
A mechanical hand.

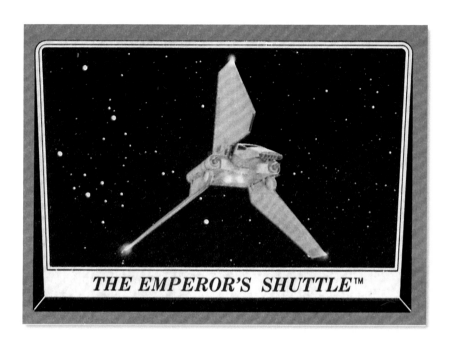

THE EMPEROR'S SHUTTLE™

RETURN OF THE JEDI

219

WHERE DO
THEY GO FROM HERE?

Although the adventures of HAN SOLO, PRINCESS LEIA and the young LUKE SKY-WALKER are over, the STAR WARS saga is not. Future films in the series will explore the rise of the evil EMPIRE and the eventual destiny of the galaxy ...

Answer to Card #218:
Harrison Ford, Carrie Fisher, Mark Hamill.

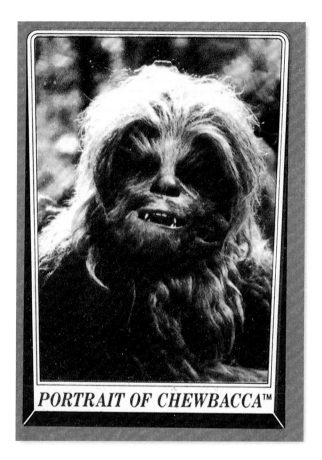

PORTRAIT OF CHEWBACCA™

A handsome close-up of Chewbacca ends our *Return of the Jedi* series and Topps' *Star Wars* cards in general . . . at least from this era. We'd be back with an ambitious trading card relaunch of the property almost a decade later.

tOPPS® PRESENTS

STAR WARS

RETURN OF THE JEDI™

CHECKLIST: 133-220

133 ☐ Title Card
134 ☐ Path To Destiny
135 ☐ Captured!
136 ☐ The Courageous JEDI
137 ☐ The Victors
138 ☐ WICKET And PRINCESS LEIA
139 ☐ The EMPEROR'S Arrival
140 ☐ SAIL BARGE Battle!
141 ☐ LUKE SKYWALKER, THE JEDI
142 ☐ The Approach Of WICKET
143 ☐ A Close Call!
144 ☐ Above The SARLACC PIT
145 ☐ ADMIRAL ACKBAR'S Defenders
146 ☐ R2-D2 On ENDOR
147 ☐ BOBA FETT Attacks!
148 ☐ Deadly Plunge!

149 ☐ LANDO CALRISSIAN'S Disguise
150 ☐ Soldiers Of The EMPIRE
151 ☐ A Curious EWOK
152 ☐ A Pensive LUKE SKYWALKER
153 ☐ The Captive Princess
154 ☐ LUKE SKYWALKER Surrenders
155 ☐ Thoughts Of A JEDI
156 ☐ The Jaws Of Death
157 ☐ PRINCESS LEIA Has The Force!
158 ☐ Arrival Of THE EMPEROR
159 ☐ Reunion On ENDOR
160 ☐ Toward The SARLACC PIT
161 ☐ SAIL BARGE Creatures
162 ☐ Friends of THE ALLIANCE!
163 ☐ The Dreaded RANCOR
164 ☐ Face Of Terror
165 ☐ Inside JABBA THE HUTT'S Palace
166 ☐ THE EWOK Village
167 ☐ A Collection Of Creatures
168 ☐ Alert To Danger!
169 ☐ Walking The Plank!
170 ☐ A GAMORREAN GUARD Emerges
171 ☐ THE IMPERIAL Fleet
172 ☐ JABBA THE HUTT On THE SAIL BARGE

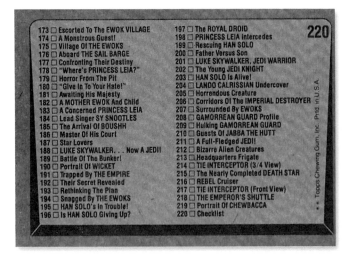

220

173 ☐ Escorted To The EWOK VILLAGE
174 ☐ A Monstrous Guest!!
175 ☐ Village Of THE EWOKS
176 ☐ Aboard THE SAIL BARGE
177 ☐ Confronting Their Destiny
178 ☐ "Where's PRINCESS LEIA?"
179 ☐ Horror From The Pit
180 ☐ "Give In To Your Hate!"
181 ☐ Awaiting His Majesty
182 ☐ A MOTHER EWOK And Child
183 ☐ A Concerned PRINCESS LEIA
184 ☐ Lead Singer SY SNOOTLES
185 ☐ The Arrival Of BOUSHH
186 ☐ Master Of His Court
187 ☐ Star Lovers
188 ☐ LUKE SKYWALKER. . . Now A JEDI!
189 ☐ Battle Of The Bunker!
190 ☐ Portrait Of WICKET
191 ☐ Trapped By THE EMPIRE
192 ☐ Their Secret Revealed
193 ☐ Rethinking The Plan
194 ☐ Snagged By THE EWOKS
195 ☐ HAN SOLO's In Trouble!
196 ☐ Is HAN SOLO Giving Up?

197 ☐ The ROYAL DROID
198 ☐ PRINCESS LEIA Intercedes
199 ☐ Rescuing HAN SOLO
200 ☐ Father Versus Son
201 ☐ LUKE SKYWALKER, JEDI WARRIOR
202 ☐ The Young JEDI KNIGHT
203 ☐ HAN SOLO Is Alive!
204 ☐ LANDO CALRISSIAN Undercover
205 ☐ Horrendous Creature
206 ☐ Corridors Of The IMPERIAL DESTROYER
207 ☐ Surrounded By EWOKS
208 ☐ GAMORREAN GUARD Profile
209 ☐ Hulking GAMORREAN GUARD
210 ☐ Guests Of JABBA THE HUTT
211 ☐ A Full-Fledged JEDI!!
212 ☐ Bizarre Alien Creatures
213 ☐ Headquarters Frigate
214 ☐ TIE INTERCEPTOR (3/4 View)
215 ☐ The Nearly Completed DEATH STAR
216 ☐ REBEL Cruiser
217 ☐ TIE INTERCEPTOR (Front View)
218 ☐ THE EMPEROR'S SHUTTLE
219 ☐ Portrait Of CHEWBACCA
220 ☐ Checklist

DARTH VADER™

LUKE SKYWALKER™ *

HAN SOLO™

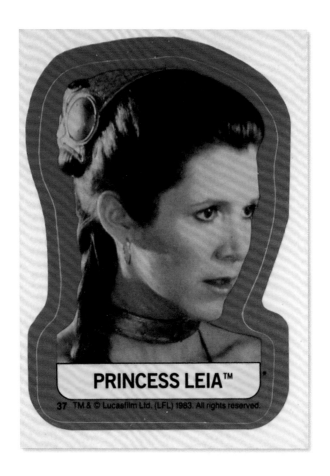

PRINCESS LEIA™

37 TM & © Lucasfilm Ltd. (LFL) 1983. All rights reserved.

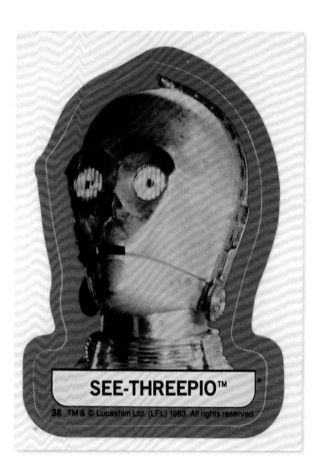

SEE-THREEPIO™

ARTOO-DETOO™

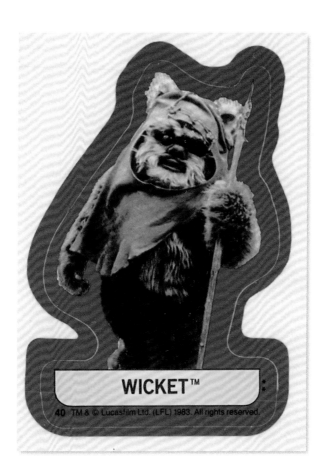

WICKET™

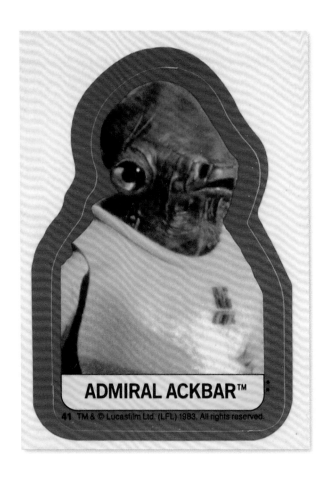

ADMIRAL ACKBAR™

41 TM & © Lucasfilm Ltd. (LFL) 1983. All rights reserved.

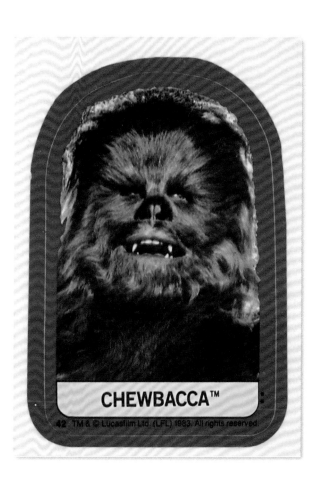

CHEWBACCA™

THE EMPEROR™

43 TM & © Lucasfilm Ltd. (LFL) 1983. All rights reserved.

MILLENNIUM FALCON™

44

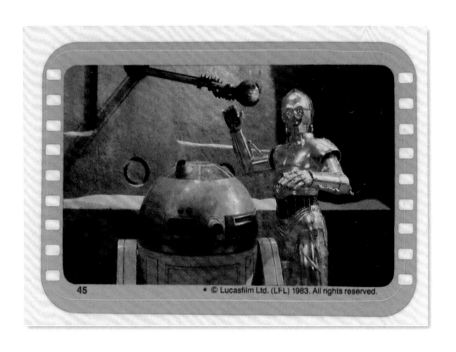

45

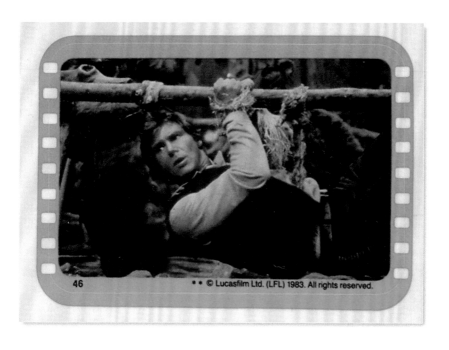

46

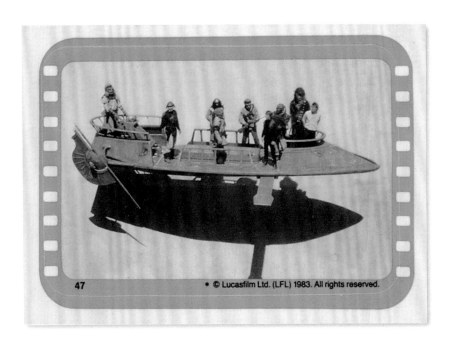

47

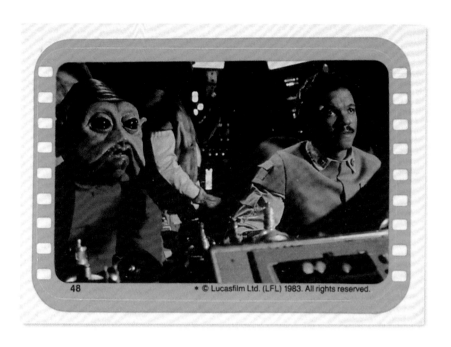

48

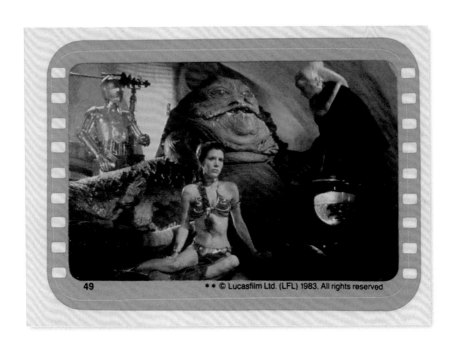

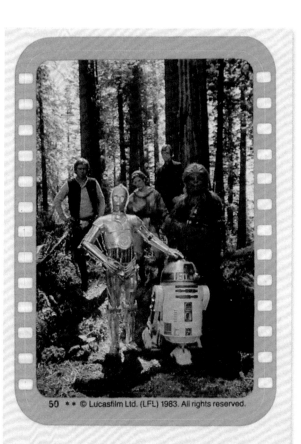

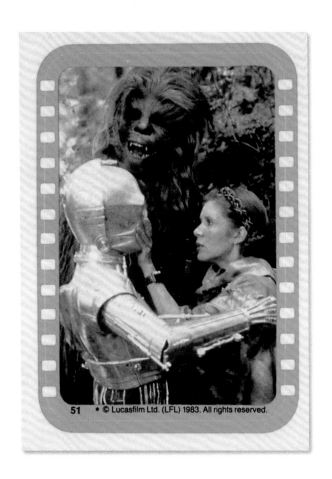

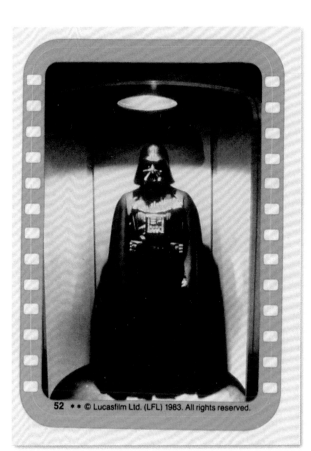

52 ★ ★

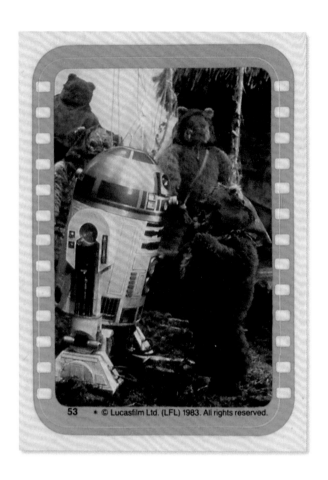

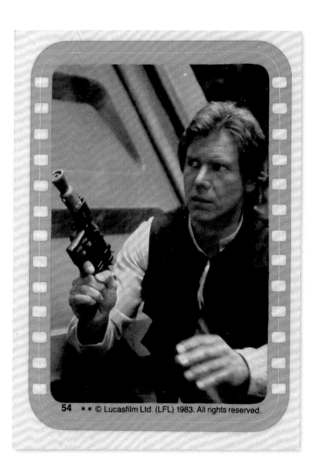

54 • •

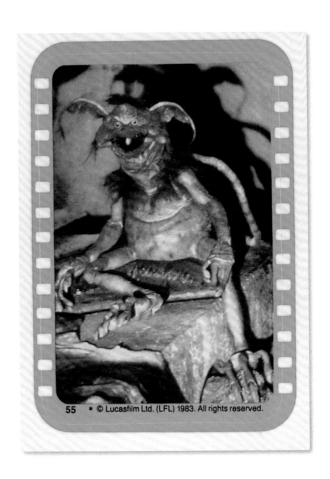

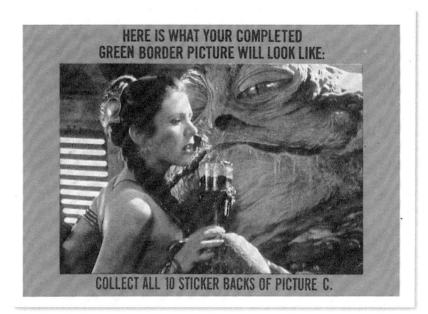

HERE IS WHAT YOUR COMPLETED
GREEN BORDER PICTURE WILL LOOK LIKE:

COLLECT ALL 10 STICKER BACKS OF PICTURE C.

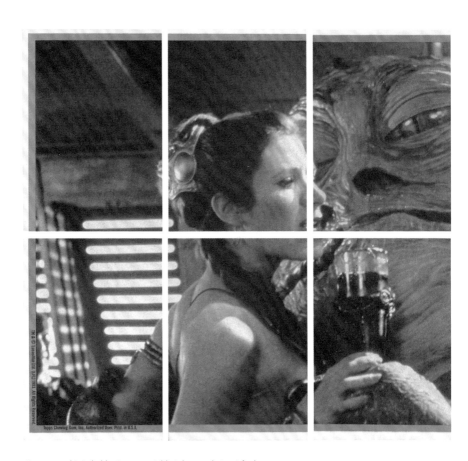

A concerned Leia held prisoner on Jabba's barge—but not for long.

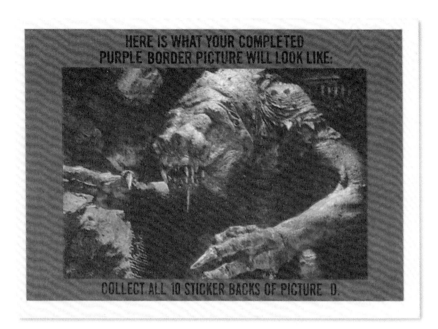

HERE IS WHAT YOUR COMPLETED
PURPLE BORDER PICTURE WILL LOOK LIKE:

COLLECT ALL 10 STICKER BACKS OF PICTURE D.

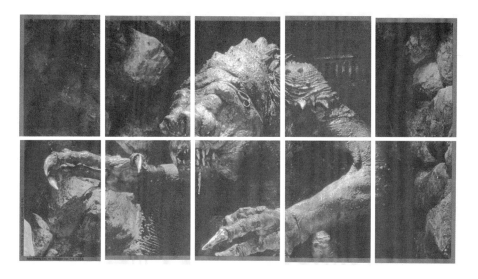

Jabba's deadly rancor, moments before Luke defeats the beast.

Topps®

STAR WARS
RETURN OF THE
J E D I ™

MOVIE PHOTO CARDS
BUBBLE GUM

36 STICKS OF GUM